# THE LANGUAGE OF ART

# THE
# LANGUAGE
## OF ART

## Inquiry-Based Studio Practices
## in Early Childhood Settings

### ANN PELO

Redleaf Press®
www.redleafpress.org
800-423-8309

Published by Redleaf Press
10 Yorkton Court
St. Paul, MN 55117
www.redleafpress.org

First edition 2007
Cover and interior design by Percolator
Interior typeset in Chaparral Pro
All photos by Ann Pelo except on page 34, photos by Kirstin Rasmussen; on pages 60 and 61, photos by Molly Peach Matter; on pages 121 and 122, photos by Emily Viehauser; and on page 132, photos by Sandra Floyd.
Printed in China by Pettit Network, Inc.

17  16  15  14  13  12  11  10      3  4  5  6  7  8  9  10

Library of Congress Cataloging-in-Publication Data

Pelo, Ann, 1965-
    The language of art : Inquiry-based studio practices in early childhood settings / Ann Pelo. — 1st ed.
        p. cm.
    Includes bibliographical references.
    ISBN 978-1-929610-99-0
  1. Art—Study and teaching (Early childhood) 2.  Early childhood education—Italy—Reggio Emilia.  I. Title.
    LB1139.5.A78P45 2006
    372.5—dc22

                                2006034666

Printed on acid-free paper

*To the teachers at Hilltop,*
*companions on the journey*

# THE LANGUAGE OF ART

# ACKNOWLEDGMENTS

This book began humbly, as a simple workbook to help teachers in the child care program where I teach who felt immobilized by the idea of studio work. I don't think of myself as an artist by any means; the ideas I initially put to paper were simply the strategies I'd figured out as a classroom teacher determined to explore art as a language for learning.

The funky, handmade workbook grew into this book—and I'm still not an artist! But my thinking about art and its role in early childhood programs has deepened and expanded, nurtured by collaborative relationships that have helped me uncover my questions and clarify my thinking. I'm grateful to Bev Moncrief, Ezra Stoker-Graham, Heather Floyd, Vanessa Maanao, and the teachers in Supported Explorations at Highline Head Start; Betty Fink, Brenda Sottler, and Catherine Wilson, and teachers and learning coaches in Independence, Missouri, Head Start; John Nimmo and the staff at the University of New Hampshire's Child Study and Development Center; Patricia McGrath at Evergreen Community School; Laurie Kocher and Iris Berger from the Institute for Early Childhood Education and Research at the University of British Columbia; Cristina Delgado, Darlene O'Krainetz, and Jen Moses at Capilano College; Christina Aubel, Julie Garrett, Kristin Brown, Michael Koetje, Peter Blair, and the Reggio Roundtable; and my Seattle compatriots, Deadru Hilliard, Gina Lewis, Fran Davidson, and Wanda Bilheimer.

My collaborations with Deb Curtis and Margie Carter have shaped who I am and how I understand teaching and learning; their influence can be felt all through this book.

Teachers at Hilltop Children's Center have mentored me as much as I've mentored them. Particular thanks to Emily Viehauser, Jill Loreto, John Benner, Kendra PeloJoaquin, Kirstin Rasmussen, Molly Peach Matter, Nick Terrones, and Sandra Floyd, who allowed me to journey with them on grand adventures into joyful inquiry. Hilltop families have challenged and supported me in my learning, especially Alice Shobe and Eric Svaren, Annie Phalen and Peter Moser, Daphne Guericke and Axel Schweiger, Genna Gormley, Kathryn Keller, Linda Higgins, and Nancy Norman.

Megan Arnim coached me about clay, Flint Crumpacker coached me about oil and chalk pastels, Christina Aubel coached me about everything and anything related to art—and life. My editor at Redleaf, Amanda Hane, offered important insight and challenge. Bill Bigelow continues to teach me about writing, teaching, and living with integrity.

My brother, John, took me kayaking when I couldn't bear to be writing, and then stepped in at the eleventh hour to help with final bits of research. My parents, Carol and Ken, set me up on their sunny deck for the final push, bringing me peaches and encouragement when I needed them most.

For generous encouragement and patience during the writing, I thank Amanda Abarbanel-Rice, Corey Duefield, David Pelo, Erik Nordstrom, John Benner, Jonathan Shapiro, Julie Bisson, Lisa Holtby, Melissa Parson, Sarah Felstiner, and Susan Alexander. Richard Burton helped with financial support that opened time for the writing. Stella was a constant, dear companion. Margie held me and this book, urging me forward, staying up late talking about writing and teaching, luring me away for a swim when I didn't realize I needed a break; she is companion for mind, body, and soul.

# INTRODUCTION

## A NEW WAY TO UNDERSTAND "ART"

"Art" is a tricky word. Often, "art" is seen as static, a word describing a finished product made of paint and paper, or clay, or collage materials. Sometimes, teachers of young children use "art" to refer to spontaneous, open-ended, and often messy explorations of color or texture, with little or no teacher direction or involvement. As we explore new possibilities for ourselves as teachers, however, we begin to use the word "art" to describe a lively process of engagement with a range of materials—an engagement that is sensual and reflective, creative and deliberate, and that deepens and extends children's learning.

Through encounters with a wide range of media and materials, children explore the sensuousness and beauty of color, texture, movement, lines, and space. They learn to look carefully and discern nuances, to move with thoughtful intention, and to follow their intuition. They also learn to find joy in the play of their senses. As children become more comfortable and skillful with these media, they are able to use them to communicate their understandings, emotions, and questions. Their fluency in a range of art "languages," in turn, opens new possibilities for collaboration and dialogue, for taking new perspectives, and for deepening their relationships with each other.

At Hilltop Children's Center, where I am the mentor teacher, these understandings of the power of art shape our daily practices with children. Our teaching and learning at Hilltop are inspired by the pedagogy of the schools in Reggio Emilia, Italy, and its emphasis on "the hundred languages," or the ways in which art media can be used to "speak" about experiences, observations, feelings, and theories.

My fellow teachers and I first began to learn about the schools in Reggio Emilia in the early 1990s. At the time, we were using a fairly traditional theme-based curriculum with an overlay of High/Scope teaching practices. But during a staff meeting one day, we watched the video *To Make a Portrait of a Lion,* which traces the efforts of children in one of the schools in Reggio Emilia to create a portrait of one of the large marble lions in the town square. That video left us shaken and unsettled, challenged to reconsider our teaching practices, and eager to learn more.

We began a journey of change, first as just a handful of teachers experimenting with ideas from Reggio Emilia, and then, eventually, as a whole program. When we committed to exploring ideas from Reggio in a formal way, we created a half-time position, the mentor teacher, to guide our professional development; that's the position I currently hold at Hilltop.

## START WHERE YOU ARE

The preschools in Reggio Emilia have full-scale art studios in each school building, as well as mini-studios in each classroom. The physical spaces are shockingly beautiful—in fact, when I visited them, I wept. The schools have *atelieristi,* which are full-time teachers based in the art studios who are masterful artists and teachers of young children. Children are immersed in a culture of drawing, painting, sculpting, and writing, as they represent and reflect on their encounters with the world and each other.

At Hilltop, we have only makeshift studio spaces, and no art teacher. Most of our studio spaces don't have sinks, and the spaces are small, with every bit of space at a premium. Our studio spaces double as eating and napping spaces during the course of our days with children. Our physical space is like the physical space of most child care programs in the United States—space not initially designed for young children, space carved out of church basements, elemen-

tary schools, and office buildings. We're a full-time, year-round child care program, with the typical challenges and struggles and improvised spaces that come with being that.

But within our space, we aim to create a community of children, families, and teachers engaged together in collaborative inquiry and joyful play. We aim to embrace beauty and full-bodied sensory experiences. And we aim to use art media to anchor these inquiries and to bring beauty into our lives.

We are still inventing our way into this vision for our work. We read about the philosophical and pedagogical underpinnings of the schools in Reggio Emilia, and we watch videos from the schools; we attend workshops and seminars that stir our imaginations and inspire our dedication. In all these resources, however, we have not found any concrete guidance about "how to do" the work we feel called to do. So, day by day, we experiment with how to bring our values, beliefs, and commitments to life. Through mistakes and satisfactions, through reflection, collaboration, and celebration, we invent our way—just as you can, to bring the language of art into your program.

As you begin your own journey into these practices, you can start by making some simple changes in your thinking and in your teaching:

- Take a closer look at the role of art in your life and in the lives of children. Pay attention to the ways in which art invites children to look closely, to ask questions, to take new perspectives, to explore emotions, to examine thinking, and to communicate and listen.

- Watch children draw. What subjects do they choose to draw about? What details do they include in their drawings? What frustrates them as they draw? What fuels their determination? As they draw, do they tell stories related to their drawing?

- Notice how children interact with each other while they draw. Does one child's drawing inspire another child's work? Do children point out mistakes in each other's drawings, offering suggestions about how an image ought to look?

- Listen to how children talk about each other as artists. Do they identify a child as a "good drawer," knowing that certain skills and knowledge are important for artists to have? Your growing insight into the way children approach

art might inspire you to make tangible changes in your classroom environments and teaching practices.

- Experiment with expanding the supplies in your art area to include materials such as fine-tip black drawing markers, oil pastels, chalk pastels, and colored pencils; a range of paper sizes and textures; many varieties of tape and glue; and scissors and other tools for cutting. You might add watercolor and tempera paints, and paintbrushes in a range of sizes and bristle firmness. You might include clay and clay tools, and collage and construction materials. As children gain mastery with art materials, you might move those materials onto shelves that are accessible to the children so that they can use them when they need them. Try making a simple shift in your language, calling your art area an art studio. Does that shift in language influence what you think belongs in that space and what sort of work should be done in that space?

- Consider the art activities you offer children. Rather than planning product-oriented art activities, try offering children an art medium such as watercolor paint, inviting them to get to know the paint and paintbrushes well. Provide coaching about techniques for using art media to help children build skills. Offer them repeated encounters with an art medium rather than one-shot activities. Emphasize the process of creation rather than the goal of finished products.

You can create a culture of investigation in which children build relationships over time with art media and turn to art media when they have an important idea to communicate, an experience to record, or a memory or emotion to honor. "Art" becomes a verb, and "studio" becomes a way of being rather than a specific place.

## HOW TO USE THIS BOOK

The sequence of this book follows the rhythm of a year with children. The year begins simply, with initial art explorations. We introduce the children to an art medium, as we would introduce two of our dear friends to each other, launching a relationship that will be built over time with many encounters.

We invite children to explore a new art medium with all their senses so that they come to know it intimately in their bodies.

> *What does tempera paint feel like on your hands?*

> *How does it move on rough paper? On smooth paper?*

> *What sound does tempera paint make when you spread it with your hands? With a big paintbrush? With a toothpick?*

From this intimate, sense-based knowledge, we invite children to explore ways in which an art medium can be used for representation.

> *How might you use tempera paint to make a portrait of your sweet, silly dog?*

> *How might you use tempera paint to tell the story of your birthday party?*

As children's repertoires expand, we invite them to compare the usefulness of media.

> *To add color to your drawing, do you think tempera paint or watercolor paint would be the best choice?*

Drawing on children's increasing skill with a range of media, we begin to invite children to use art media for communication and for critical thinking.

> *Let's draw the city that you built with Legos so that you can remember your work when you come back to school tomorrow.*

> *Can you sketch your idea of how the pulley in the loft would work, so that we can all see what you're thinking?*

> *Can you use wire to show how the lines of a leaf are like its bones?*

In this book, you'll find guidelines and strategies to help you bring the language of art into the heart of your teaching. The book is divided into two parts. The first part, "Studio Explorations," offers guidelines for setting up a studio space and fifteen explorations related to texture and movement, color, sculpting and building, and representational drawing and painting. These explorations give children fluency in the language of art, which they need before they can use art for communication and for critical thinking.

Art as a tool for investigation is the focus of the second part of the book. In "Moving Art from the Studio to the Classroom," you'll find principles and guidelines for using art in both short-term and long-term investigations, illustrated with stories from Hilltop to give you a feel for what doing so looks and sounds like in action. The final chapter tells the story of an in-depth, long-term investigation into the identity of leaves, in which art was the primary language for our study.

We don't expect all children to become poets or novelists or essayists, but we teach all children to read and write because we want them to be confident, expressive communicators. Similarly, we don't expect all children to become professional artists, making their living through painting or sculpture. We do, however, teach children how to use a range of art media so that they may communicate their ideas, experiences, emotions, questions, and insights in many languages. And, we want all children to know beauty, creativity, and expressive emotion.

# STUDIO EXPLORATIONS

In part 1, we introduce children to art media through open-ended, full-bodied explorations. Through these explorations, children come to fully understand a medium: how it behaves, how it feels on their bodies, how it can be used, and what skills and tools are needed to work with it. This knowledge provides the foundation for using art as a tool for thinking in the classroom.

Chapter 1 provides general guidelines for setting up a studio space in your child care environment and introducing materials to children. Building on these general guidelines, we dive into explorations with art media. In chapters 2 through 5, you'll find explorations related to texture and movement, color, sculpting and building, and representational drawing and painting.

# GENERAL GUIDELINES FOR STUDIO EXPLORATIONS

To learn to speak a language, we begin with the foundational sounds. We experiment with how to shape our mouths and tongues; we play with tone and inflection. We listen to other people, mimicking the sounds we hear. We begin to weave sounds together—vowels and consonants forged into words. After time, we no longer feel clumsy and this new language becomes familiar. Eventually, our dreams unfold in this new language. We've claimed it as our own.

In just this way, we learn the language of art. We explore the physical qualities of a particular medium: how it feels on our hands, how it moves across paper, how it holds its shape. We experiment with tools and with techniques. Through many encounters and engaged exploration, we become comfortable with this new art medium. We begin to think in terms of color, texture, movement, and sculptural image. We've claimed the language of art as our own.

To learn the language of art, we create studio spaces, or areas set aside for art exploration. We develop practices that guide our exploration. We collect notes and photos and samples of children's work to use in written documentation, displays, and portfolios. We make time to reflect on our studio work with families, with teachers, and with ourselves. The following guidelines offer suggestions for ways to begin this work.

## THE SPACE

### Creating a Studio

A studio can take many forms. In your program, you might have ample space, enough that you can dedicate an entire room to art, creating a full-fledged studio. Or you might have a corner in a classroom or in your family child care home that you can set apart from the hustle and bustle of the room's activity with several simple screens or shelves. The experiences you and the children share in the space are what matter, not the formality of the studio space.

An art studio needs a few basics:

- a tile floor, because many encounters with art are messy;

- a table with plenty of work space for four or five children and you;

- good light from both natural and artificial sources;

- storage shelves for art materials: these shelves can be at the children's level—materials don't need to be kept in a closed cupboard that is inaccessible to children;

- space for paintings to dry: this can be a drying rack, a clothesline from which paintings can be

7

hung, or a shelf system with lots of space for large paintings;

- space for three-dimensional sculptures to dry: shelves spaced so there's plenty of room between them work best for this.

Find a way to set the studio space apart from the rest of the classroom. Some programs use tall, open shelving to create a "wall" around the studio space. Other programs use simple free-standing screens made of wood frames and sheer white fabric. Hanging screens, like those designed for outdoor patios, are another option. Vines planted in a box on the floor can grow up a trellis to create a living wall. The intention in dividing the studio from the rest of the room is to invite focus and attention and to communicate to the children, "You can immerse yourselves in this work. You can linger here, uninterrupted. We honor your work here."

Make the studio space beautiful, a place that nourishes the spirit and senses. If you have the resources, store paint in clear jars to bring vibrant color into the room. Bring lush green plants into the space. Pour glitter into glass jars and set them on the window ledge to sparkle in the sun. Arrange shells, rocks, or branches on shelves, or hang them on the wall. Tuck unexpected treasures into the studio: a vase of feathers, a basket of sea glass, or an abandoned bird's nest. Store paintbrushes in pottery jars. Create a space that stirs the imagination and awakens the senses.

As you create your studio, remember that "studio" is as much about how we think about art practices as it is about a specific place. Barbara Burrington writes that "studio" is "a name that implies work, study, and art all in a breath" (2005, 56). A studio stands for a way of experiencing the possibilities of art materials in community with others.

### Setting Up the Space

As you prepare to invite children into the studio, arrange the work space in a way that creates focus and attention. The table ought to be cleared of all but the materials you'll need at the beginning of your exploration; these materials can be displayed with order and beauty in the center of the table: a few jars of paint, perhaps, or one lump of clay, unwrapped and waiting for the children. Each child's work space can be defined with an echoing simplicity: a piece of white paper with a brush laid across the top, or a piece of canvas awaiting clay. In the way that you arrange the space, you create an invitation for children to bring their full attention to the art medium they are about to encounter.

If you cover the table, use a simple plastic tablecloth or big pieces of butcher paper. Choose a neutral color—white, light tan, or black—and avoid patterns or designs that visually take over the work space. The table covering should emphasize the materials and the children's work, not distract from them.

Be thoughtful about the sound in the studio space—again, with the intention of creating an environment that fosters quiet concentration. You may strive to create silence in the studio space. Or, if your studio space is part of the larger classroom, you may use a CD player to play quiet, rhythmic instrumental music that brings focus to the space.

Have a plan for cleaning up before you begin! As children finish fingerpainting or working with clay, how will they wash their hands? How will they dry their hands? Where will the children's paintings go to dry? Where will you set the clay pieces? How will you label each child's wire sculpture when it's completed? Create a system for cleaning up and for tracking art pieces before you invite the children into the studio space, so that you're not scrambling to figure this out when the first child finishes her work! (More guidelines for cleaning up can be found on page 12 and in the chapters on specific art media.)

## MATERIALS

You'll use some materials in a number of art explorations, and a few materials that are specific to particular art media. Each chapter lists the materials needed for that specific exploration. You can use these lists to stock your studio.

Gather materials from places like hardware stores, restaurant supply stores, kitchenware shops, and yard sales, as well as from the more typical art supply stores and educational provisioners. A search on the Internet will lead you to companies from whom you can order many materials. Inexpensive art materials are available at Discount School Supply (www.discountschoolsupply.com), Creation Station (www.creationstationinc.com), and Dick Blick Art Materials (www.dickblick.com).

## THE PROCESS

### Gathering the Children

Certainly, we want all of the children in a classroom community to have lots of opportunities to explore each medium. We also want each child to receive the luxuries of time, space, and attentive support, which allow deep relationships with art media to grow. For this to happen, children ought not to be competing for resources and for a teacher's attention. Small groups of no more than six, and optimally four, children are best.

This may feel like a daunting task. Most classroom groups hold many more than six children. Here are some strategies teachers have used to bring a small group of children together for studio explorations:

- If your program has two adults, make a plan to invite a small group of children into the studio space with one adult while the other adult works with the other children. You might schedule this during a time in the day when children are typically doing "free choice" sorts of activities. Another option is to schedule studio work during a time in the day when children typically do small-group work.

- Ask each parent to spend an hour in the classroom every few months. With the support of even one parent a week, you can carve out weekly small-group experiences in the studio.

- Consider using "floater" positions as classroom support to allow the regular classroom teacher to work in the studio with a small group of children.

- In some half-day Head Start programs, teachers offer each other regular support by "trading time." A teacher responsible for an afternoon group has planning and preparation time in the morning; that teacher could step into the morning classroom once or twice a week so that the morning teacher could work in the studio with a small group of children. The morning teacher would then offer the same support to the afternoon classroom during his planning and preparation time.

- In some programs, administrators establish regular schedules to be in the classroom once or twice a week, adding an extra adult into the ratio for that hour.

When you gather children in the studio, you may decide that the group will stick together: you and the children will head to the studio at the same time and stay in the studio as a group until everyone's finished with the exploration and the studio is cleaned up. Or you might decide to create a more fluid coming-and-going between the small group in the studio and the rest of the children in the classroom. As each child finishes at her own pace, she neatens her work space, and then heads back to the classroom, allowing another child to join the studio group. Either way works fine—but it's best to have a clear plan at the outset.

Do keep track of which children have spent time in the studio exploring a particular art medium. Make sure that every child has a full turn with each art medium, then move through the list one or two more times, so that each child has several encounters with the medium.

### Introducing a New Art Medium or Material

What if we introduced children to a new art medium as if we were introducing them to a dear friend, someone we expected would become a treasured companion to them? What if that sense of hopeful anticipation infused our introductions between children and paint, or clay, or wire?

> *I'm glad you're in the studio today. I'm eager for you to know about paint—how it feels on your hands, how it moves on paper, how its colors come together to create new colors. Get comfortable so that I can show you the beginning of our work today.*

We want our introductions to be simple and direct, marking a beginning and focusing the work.

> *You are artists, and there are some tools you need to know about. Today, we'll experiment with an important tool for clay that artists use, so that you can use it in your work.*

It's helpful to use "technical" language with children, giving them the real names of the media and materials in the studio: "tempera paint," "a size 2 paintbrush," or "wedging clay to get the air bubbles out." We want to give children a full and accurate art vocabulary, which provides them access to the medium and allows them to talk with each other with detail and specificity.

## The Teacher's Role During Art Explorations

Several goals about children's studio work help us understand our roles as teachers:

- We want children to explore the sensuality and beauty of color, texture, movement, lines and curves, and space through encounters with a wide range of media and materials.

- We want children to strengthen the dispositions of artists and scientists, dispositions to look carefully, to pay attention to detail and nuance, and to work with intention and awareness. We want children to reflect on their experiences, to use their reflections to guide their explorations. And we want them to collaborate with each other in ways that honor each person's work.

- We want children to become knowledgeable about a range of media, developing skills that allow them to use each medium with ease.

- We want children to be in dialogue with each other, to take new perspectives, and to deepen their relationships with each other.

With these goals to guide our work, we have some specific roles to play during children's studio explorations.

Encourage children to slow down, to take plenty of time with their work.

*You can take a very long turn in the studio, so you really get to know about tempera paint.*

*I appreciate the way you're spending a long time with that clay; that's just what an artist does.*

Sometimes, a child rushes from one painting or clay sculpture to the next, getting caught in a fast-moving effort to produce many finished products. When you see this happening, or sense that a child is paying only superficial attention to her work, you can ask her to stop and refocus herself. Listed here are some examples of things you might say to her. Study these examples and the other examples throughout the book, paying attention to the underlying tone, intention, and values. These examples can help you get started in your conversations with children; over time, you'll find your own voice.

*I see you moving fast to make lots of paintings. I'd like you to try taking a longer time with one painting.*

*Before you decide you're finished with this painting, let's look at the work you've done and see if there's anything you want to add or change. I see that you've used mostly red and orange, but that you've also got purple on your palette. I wonder if you want to use the purple paint somewhere on your painting.*

Another way to encourage children to slow down and take time with their work is to invite them to draw on all their senses to explore the medium.

*What does the paint feel like as it moves on the paper?*

*Is the clay cold on your skin?*

*I wonder how you'd describe the smell of the clay.*

*Look at how the colors of the watercolor paint swirl together.*

*Listen to that squishy sound when you mush the clay between your hands!*

Or you might help children notice different elements of their work. Call attention to the details you see, and encourage the children to look at their work more closely.

*I notice that you've created spiky lines with your paintbrush by pressing it down on the paper.*

*Your clay is getting softer and softer; it's easier to move it into new shapes.*

*You've bent the wire nearly in half.*

You might ask questions that help the children reflect on their work.

*I wonder what your idea is for the clay, now that you've rolled it into a long, thin strip.*

*You've been adding so many dots to your painting. How are you doing that?*

*What are you discovering about watercolor paints?*

Call children's attention to each other's work. Help children see what their companions are discovering, and encourage them to serve as resources and teachers for each other.

*Pattiann has found a new way to use that tool. Let's take a break from our own work for a*

*minute so that she can teach us what she fig-ured out.*

*You want to attach that tube to the box to make a chimney. I see that Alex has a tube on his construction; I bet he can show you a way to make your tube stay on.*

Coach children about how to work with a medium or tool. Children need and deserve direct teaching about how to use the materials and media we give them. Stay alert for times when they get stuck or run out of ideas about how to use the medium, and offer them specific coaching.

*I see you're having a hard time with that tape. Let me show you a way to tear the tape off the tape holder.*

*I think you're ready to learn about a new tool to use with clay. This will help you with the sculpture you're trying to make.*

At times, a child will use art tools in unexpected ways—dipping the tip of a brush handle into the paint, for example, and using that to make lines on paper. When this happens, observe for a few minutes to understand what the child is trying to figure out. Is she discovering a new possibility in the tool? Is her use of the tool helping her discover an intriguing or important quality of the art medium? Once you have a sense of what she's working on, you can reflect with her about it.

*Look at the thin, thin line you made with the tip of the brush handle! It looks different than the thin line that the hair of the brush makes. Did you notice that?*

*It's interesting to paint with stiff tools, isn't it. Not like the soft hair of a paintbrush, but hard and strong. Let's try some other tools that are stiff like the brush handle. How about a twig? A piece of wire?*

Sometimes, the unusual way in which a child uses a tool can break the tool or mess up the art medium: sticking a delicate paintbrush into clay, for example. When this happens, gently coach a child about how to best use that tool.

*That thin paintbrush works best for making lines and adding color to paintings. When it gets*

*stuck into clay, the hair on the brush becomes tangled and gooped up with clay. And the clay gets hair in it. We'll save the paintbrushes for paint, and the clay tools for clay.*

Offer the child another, more appropriate tool to use.

*It looks to me like you're curious about how to make deep holes, like tunnels, in the clay. Let's find a tool that will help you do that.*

Sit with the children as they work, minimizing your movement around the room. You might paint or sculpt alongside the children. When we sit with the children, we communicate that the work of art is important—that it's worthy of slow, deliberate atten-tion, that it's worth sitting down for! When we move around the art space tending to little details, leaning over the children's work briefly to check in, we dis-courage quiet focus and disrupt children's work.

Keep the work space uncluttered and inviting. As the children work, keep an eye on the table. You may quietly neaten the space, so that the children are able to sink into their work without clutter or mess get-ting in their way. Or you may call children's attention to recurring issues so that they can learn how to best manage a particular medium.

*I notice that your canvas keeps slipping over the edge of the table, and when that happens, bits of clay roll onto the floor. Pay attention to the edge of your canvas. When you see it coming over the edge of the table, pull it back like this.*

Pay attention to time. You want to be sure children have plenty of time to bring their work to a close.

*This is a good time to start thinking about how you want to end your work with clay today.*

It's important that children don't start a new undertaking right before cleanup time. It's awfully frustrating to just get started with something and then be asked to stop.

*The painting that you're working on now will need to be your last one today. We're coming close to lunch, and there isn't time to start another painting now.*

Noticing how long a particular exploration takes will give you a sense of how much time to set aside

when you next take up this exploration with children, which will be helpful as you plan your work.

During an art exploration, consider what you would find helpful from a teacher if you were learning how to use a new art medium. Most likely, you'd look for some specific coaching about tools and techniques; you'd appreciate gentle feedback and correction when you struggled. You'd look to the teacher for clear guidance about this unfamiliar medium—and you'd expect the teacher to offer that guidance with deep respect for your ability to wrestle with something new and to stick with challenges. You'd want to leave with a sense of increased skill and expanded possibilities. You'd probably be frustrated if the teacher simply glanced at your work occasionally and made vague comments about "nice job" and "interesting colors." We can offer children the specific, generous, respectful coaching that we would hope to receive as learners.

### Cleaning Up

Before you begin, have a plan for how you'll clean up. Devise your cleanup system as you set up for the exploration, before children arrive in the studio. There are suggestions for cleanup systems in the chapters about specific art media that follow.

As you set up the studio, consider where children will put their paintings, sculptures, collages, or constructions as they finish. Think about what will best preserve the integrity of the work: if children are painting with tempera paint, for example, then you may want a drying system that allows the paintings to lie flat, since tempera paint tends to run. Will children be returning to work on their clay sculptures another day? If so, you'll need some plastic wrap ready to drape over their clay to keep it moist. Set up these systems for drying and storage as you set up the studio.

Consider how you'll keep track of the children's projects. Again, it's important to respect the integrity of a child's work. We often write a child's name on a painting or drawing; consider doing this on the back of the painting or drawing, in ballpoint ink rather than with a marker that bleeds through the paper. With a clay sculpture, you can carve a child's name on the bottom. With loose parts, collage, and wire, consider writing a child's name on masking tape and taping that loosely to the sculpture, so that it can be removed easily.

As you decide on a labeling system for each medium, keep in mind that we want people's eyes to go to the work itself, not to a child's name written in some overbearing place. Sometimes, children want to write their own name or symbol on their work; give children a ballpoint pen and have them write on the back of their painting or drawing, or invite them to write on a piece of tape that can be attached to their work. We want to honor children's eagerness to write their names on their work, claiming with pride the art that they've created, and, at the same time, we want the viewer's eye to fall on the work itself.

## EXTENSIONS AND FOLLOW-UP

### Inviting Children to Revisit Their Work

We want to encourage children to take time with their work in the studio—time that may extend over several days or weeks. When children revisit their work over time, they are able to view it through different lenses. Seeing it from new perspectives, they may decide to add to it or change it.

Create storage and labeling systems that allow children to save their work and come back to it later. Some programs use "saving cards," simple index cards with children's names that children can set on their work to indicate that they're planning to return to it and would like it to be left as it is. Other programs have art cubbies set up in the studio in which children can save their work in progress. The studio-saving system ought to be flexible enough to allow for work done in a range of media to be stored for later work: paintings, clay, wire, loose-parts construction, and even easel paintings. These systems communicate to children that we expect them to revisit their work over time.

Teachers can take the lead in urging children to continue with their work later. When a child declares she's done with a particular creation, we can encourage her to take a break for a few minutes, and then to look at it again to see what she might want to change or add:

> *How about getting a drink of water, and then coming back to this painting to see if there's any more work you'd like to do on it?*

When a child is engaged in her work as cleanup time rolls around, reassure her that she can save her

work and come back to it later, so she doesn't feel rushed to finish a piece.

We emphasize the importance of lingering with and revisiting work not to stop children from finishing their work, or from ever taking anything home, but to create a spacious sense of time in which children can immerse themselves in their studio work, allowing it to unfold through a relaxed and thoughtful dialogue with the art materials.

## Creating Opportunities for Many Different Encounters

It's important for children to have many different opportunities to explore a particular art medium or material. Just as it takes many encounters for a deep friendship to grow—many opportunities for conversation, for shared experiences, for storytelling—it takes many encounters for a child's relationship with an art medium to grow into easy familiarity.

Plan a range of ways for children to explore an art medium or material. Begin by inviting children to explore a medium through their senses, without a great deal of teacher instruction. Early encounters with clay, for example, may include opportunities to work it from stiff coldness to warm pliability by rolling, pounding, and stomping on it; investigation of what happens to clay when it meets water—a little bit of water, and then a little bit more, and then a lot more, until there's a puddle of gooey water and not much clay at all; exploration of how it feels to lay clay on our faces, or to wrap it around our arms, or to mold it around our feet.

From these first sensual encounters, we can build other explorations of a medium. What tools are useful with this medium? How do they work on the medium? How is this medium used for representation? These sorts of encounters involve teacher guidance, as children apprentice themselves to learn specific techniques for using tools.

Another way in which children become intimate with an art medium is by learning how to set up a work space to use that medium. What's needed for watercolor painting? For clay? For loose-parts construction? Where are those materials kept? How are they best arranged on the table? And how do we clean up these materials after studio work? Our aim is for children to develop familiarity with art media so that they can take a project from start to finish with a particular medium, gathering the materials they need,

setting up the work space, and carrying out their vision for their work.

## Representing and Re-representing an Idea or Experience

We can extend children's thinking by encouraging them to represent and re-represent their ideas and experiences in a range of art media. For example, you might invite a child to create a black and white sketch of her clay sculpture, or to translate her marker drawing into a watercolor painting. This practice of using multiple media to represent an idea or experience can take place over several days; it is another strategy for inviting children to take time with their work, embracing the process of thoughtful creation rather than a finished product.

When children move from one medium to another, or work on different scales, or move from two to three dimensions, they see their work in new ways. They take different perspectives. They notice new details. They develop new understandings of the relationships between elements of their work. They come to deeper awareness of the role of color or line or texture. The practice of representing and re-representing an idea or experience often sparks a transformation of thinking.

# DOCUMENTATION

## Creating Written Documentation about Children's Art Explorations

Art explorations are rich experiences for children. They inspire scientific investigation, as children seek to understand the qualities and uses of an art medium. They spark collaboration and strengthen relationships among children, as children share discoveries, coach each other about strategies to try with an art medium, and work together on a creation. They demand focused attention and physical finesse. They stir the senses and emotion, delighting eyes, hands, and heart.

Art explorations hold many stories worth telling: stories for children to hear about themselves, stories for families to hear about their children's art learning, and stories for program administrators and other adult visitors to your program that challenge them

to see the importance of art in children's education. Written documentation is a way to tell those stories.

There is an increasing emphasis in early childhood programs on written documentation of children's exploration and learning. Some programs use written documentation as part of formal developmental assessments of children. Some programs use written documentation for curriculum planning. And some programs use written documentation to bring the stories of children's work and play to their families, to visitors, and to children themselves.

If you work in a program that emphasizes checklists and other formal developmental assessments, you may find yourself frustrated by the sense that these tools are disconnected from the daily experiences you share with the children—experiences of curious investigation, belly laughter, triumphant achievement, heartfelt tears, satisfying discovery, and full-bodied engagement with the smells and textures and messes of the world. These stories need to be told—and you are the person to tell them. I invite you to step into the role of storyteller, taking up that work as a form of deep regard for children and for yourself, and as an act of advocacy for the rights of children. Children deserve to have their stories—not just checklists and assessments—anchor our programs. The suggestions and guidelines provided here and in each chapter following will help you experiment with how to give form to the stories of children's encounters with art media.

If you work in a program that hasn't yet experimented with written documentation, the suggestions and guidelines in this book will help launch you into this important practice. And if you work in a program that is already engaged in the process of creating and reflecting on written documentation, the thoughts offered here and in each chapter will help you deepen your practice.

There is a wide range of possibilities for collecting written documentation. You might collect written documentation in a binder that you keep in the studio or in the area where families sign in each day. You might create a journal for each child. You might add written documentation to children's portfolios. You might send written documentation home with families. You might create handmade books for the studio about particular art explorations. Each of these ways of collecting and organizing written documentation honors children's investigation and discovery.

At Hilltop, we've developed a structure for written documentation that helps us organize our thinking and shape our stories. In our written documentation, we tell the story of children's explorations and play, we reflect on their play, we share our plans about how we will extend their play and explorations, and we invite families to think with us about the children's play.

## Tell the Story

- Include many details to bring the story to life.
- Capture the children's dialogue; use their real words.
- Use lively, engaging language and conventional grammar.
- Emphasize description rather than interpretation.
- Consider including sketches, scanned copies, or photocopies of children's work.

Isaac and Ian arrived in the studio this morning eager to paint. They slipped on smocks and looked at each other and at the easel with its big sheet of white paper.

"We're gonna paint a picture at the easel together, right, Isaac?" said Ian in a hopeful invitation to his friend.

"Yeah, sure we are! Let's do it!" Isaac replied with a grin.

They took the lids off the jars of paint at the easel and gathered brushes, and then paused.

"How about a tornado?" Ian proposed.

"Yeah, a tornado! A really big one!" Isaac agreed.

And the two companions began to paint, filling the easel paper with swirls of color, their bodies moving together, their arms reaching up and over and around each other.

"We're artists together, right, Ian?" suggested Isaac.

"Right—artists together," Ian confirmed.

## Reflect on the Story

- Describe the meaning you make of the story.
- Share your questions about the story.

When Ian and Isaac arrived at the easel at the same time, both eager to paint, I anticipated conflict: Who would have the first turn at the easel? How long would the other person have to wait? But Ian sidestepped that conflict with his proposal to work together, surprising both me and Isaac. I shouldn't have been surprised, really. Ian and Isaac are good buddies; their play is often quite physical and always full-throttle, and they know how to figure out problems together.

I was curious about how they'd negotiate the space at the easel. Though the easel stands tall and the paper it holds is large, the space becomes tight with two children standing side by side, extending their bodies to the easel. As I watched Ian and Isaac, I wondered if this effort to share the space and the creation process was, in fact, the most important part of their easel work. It seemed to me that their work together at the easel was like a dance, a way to engage with each other physically and, together, to engage with the easel: the broad arm movements, the turn of a torso, the leaning close and stepping back, moving color across the paper.

The physical dance with each other and with the paint speaks volumes about Ian and Isaac's friendship. Their affirmation to each other that they are "artists together" moved me. It seemed to me to capture the strength and intimacy of their connection, deepened by their collaborative easel work. And it reflects an important value in our studio: that art is not necessarily a solitary endeavor, but one that is anchored in relationship.

## Describe Next Steps and Further Plans

- How will you follow up on the children's explorations, questions, and discoveries? Will you add materials to the classroom? Will you offer specific activities?

- How will you pursue the questions that this experience raised for you?

- How will you make the children's learning visible to them? How will you use this experience to invite them into further exploration and reflection?

I've been thinking about how I might grow Ian and Isaac's artistic collaboration, and how I can use their work to nudge other children into collaborative work. I hung the photos I took of Ian and Isaac next to the easel, with the story of their work together. I added another hook and a second smock to the wall next to the easel, to suggest the possibility of two children painting together at the easel.

I want to think more about how we can build collaboration into our work with each art medium we take up. Next week, we'll begin exploring clay in the studio. I want to give each child time to work on his own, to get to know the clay, but I also want to offer opportunities for children to explore and shape the clay together. When I was learning to be a teacher, I was taught to make sure that all the children have plenty of materials, so that they don't have to worry about taking turns or sharing. I've questioned that conventional notion, though, as I've worked with children. I see great value in collaboration, in focusing on shared effort and shared accomplishment. Ian and Isaac's work at the easel rekindled my commitment to keep questioning my practices, and to push myself to create more opportunities (and expectations) for collaboration.

## Begin a Dialogue with Families

Invite families to share their thinking with you. Include questions like these in your written documentation:

- Have you seen your child engage in this sort of play or exploration in other contexts?

- How does this play reflect or challenge your family's beliefs, values, or practices?

- What do you think is meaningful about this play for your child?

- What are you curious about in relation to this play or exploration? Does anything about this play surprise you?

- How would you like us to explore the ideas embedded in this play together as a community?

I'm curious about what you think of the balance between individual effort and collaboration. How does Ian and Isaac's work as "artists together" fit with what you hope for for your child? Does it leave you with a sense of what you want me to do as their teacher? I'd really like to hear your thoughts about this. I'm tucking a piece of blank paper into your children's journals, just after this story; it's for you to write on! You can also call during my planning time, from 1:30 till 2:00, or send me an e-mail.

Written documentation is not a final, stale product. It is a lively tool for communication, for new learning, and for advocacy. Written documentation has a range of uses:

- We share written documentation with children, reading the stories and looking at the photos together. When children revisit their experiences this way, they often decide to take up a project again from a new perspective or to invite other children into an extension of their earlier work. They reconsider their theories and explore new understandings.

- We share written documentation with families. Our stories create windows for families, letting them see into their children's experiences during their time apart. And our stories invite families to share their thoughts and questions with us, a way for them to help shape our programs.

- We use written documentation to meet program requirements for keeping records of children's

learning. Our observations and reflections create meaningful stories that capture details of children's thinking and their relationships with one another, specific elements of their physical and sensory development, and verbatim examples of their language development.

- We use written documentation as a tool for social change. The stories that we tell of children's investigations and play have the potential for changing how people understand and value childhood. We can share our stories with other early childhood professionals, with program reviewers, and with visitors from the community. Our stories call attention to the too-often unheard or disregarded voices of children.

- We use written documentation to record a shared history for ourselves and for the children and families in our programs. Participation in an unfolding story is a cornerstone for creating community. Our documentation tells the stories of these shared experiences, which, woven together, become the fabric of community.

Each chapter contains specific questions and suggestions to help you create written documentation. As you write the stories that make children's experiences visible, keep in mind the deep value of your work. Telling these stories is an act of respect for children, for yourself, and for the community in which you work.

## Displaying Children's Work

Display is different from written documentation. Written documentation refers to the process of collecting observation notes, still photographs, transcriptions of children's conversations, and samples of their work. These traces of children's work become written stories that bring the children's experiences to life for the reader. Display refers to the visual arrangement—usually on a large scale, like a bulletin board—of paintings, prints, sculptures, photographs, observations and reflections by children and teachers, and questions for viewers. The intention of display is to create a visually beautiful presentation that invites viewers to look closely at children's work and that awakens new understandings of the meaning of children's work.

There is an art to display—especially to displays of art! We can be creative in how to tell the story of art explorations, whether on a bulletin board, a classroom wall, or a long shelf. Display is a visual art: photos, prints, and samples of children's work are the primary components. Text is a secondary emphasis.

Display catches the attention of families, visitors, and children. It sparks conversation and exchange and inspires new insights into the meaning of children's work. It instills pride in children—and in their families. It invites children to revisit their work, and it can invite families to participate with them in that revisiting.

As you consider ways to display children's art, think about the story you will tell in your display: Was the children's studio work primarily about the sensory experience of color? About using color to represent experiences and observations? Or about mastering tools like paintbrushes? Let your display tell a specific story, choosing photos and samples of children's work that bring that story to life. In each of the following chapters, you'll find suggestions for organizing your display around a compelling story.

A few general guidelines to keep in mind as you create displays of children's art:

- Create a display against a neutral background. Consider covering bulletin boards with cream or ivory paper, or with a light-colored or undyed burlap. If you are creating display boards, choose black or white. A neutral background keeps a viewer's attention on the images and text.

- Include close-up photos of the children at work on their art. Print these photos as 5 x 7 or 8 x 10 images; the bigger the print, the more eye-catching it is.

- Keep text to a minimum. Provide a simple, brief overview that gives the viewer a context for the display. Emphasize children's observations and reflections, and include a few of your own observations and insights about the children's work.

- Use a large font (at least 18- or 20-point), if you're typing your text. If you write your text by hand, use large, bold, black print.

- Consider giving a title to the display: "Portraits of Sunflowers" or "Exploring Line and Shape." Headings give focus to a display.

- Consider "framing" children's two-dimensional art by placing black paper behind it. This creates a small, simple border around a painting or sketch that lets it step forward to catch a viewer's attention.

- Weave poetry or other writing into a display. Invite children to create a poem or story as a companion piece to a mural, for example. Or include the work of a writer that speaks to some element of the art. For example, the poems of Mary Oliver are natural companions to paintings, sketches, or sculptures of the natural world.

- Include questions that invite a viewer to reflect on the children's work. You might ask the viewer to make connections between his or her experiences and the children's art, or to study the children's art from a particular perspective. Consider making space in a display for viewers to write their comments and questions—and for you and the children to respond.

## Creating Portfolios

Artists keep a representative sample of their work in portfolios. This collection of work allows an artist to revisit earlier work, noticing themes that have held constant through her work, or different techniques that she's tried, or changes to themes or style over time. Consider creating portfolios for the children in your group: simple easel-sized cardboard folders in which representative samples of a child's work (paintings, drawings, photos of three-dimensional work) can be collected. You can think with each child about what to include in his portfolio; these conversations provide an opportunity for you to highlight important elements of a child's work, and to hear from him what he considers important about his work.

*I'd like to make a copy of this drawing for your portfolio. I've seen you working hard to learn how to draw people's faces from the side; you've tried and tried and tried, and I think you've got it figured out! This drawing shows what you've learned.*

*This is the first wire sculpture you've created! I want to take a photo of it for your portfolio, and I'd like to write down your ideas about this work to go with the photo. What do you want*

*people to know about your work with wire in making this sculpture?*

Be sure to set aside regular time to look through each child's portfolio with the child, perhaps every six weeks or so. Use this time to reflect together on themes you notice in a child's collection of work, specific media and techniques that he's explored, and ways that his work is changing. Invite the child to share what he remembers about his work and what he notices as he studies the collection in his portfolio. Take notes as you talk; the child's thoughts can become part of the portfolio!

It may be a new practice for you and for families to keep children's work in the studio or classroom rather than taking it home right away. Talk with families about your intention to have children revisit their work and build on their earlier thinking. And assure families that children's full portfolios will be theirs to keep at the end of the year or when children leave your program.

When you do invite children to take their work home, suggest ways that families might honor their children's work:

---

Dear families,

Your children are proud of their art. They've invested tremendous energy and effort in it and are excited to share the results with you. They talk about you as they create: "My mom is gonna love this beautiful canoe!" "My dad will be so surprised when he sees my painting!"

It's challenging, though, to honor your child's work when a lot of it begins flooding your home. Here are some ways you can support your children's important representational work when it comes home:

- Create a special display space at home, like a shelf with room for one or two sculptures and paintings and title cards: "A Truck, by Dylan." You and your child can choose the creations to display.

- When an art piece first comes home or when an art piece is replaced on the display shelf, take a photo or make a drawing of the creation. Keep these photos and sketches in an album: "Emma's Art Book."

---

- Invite your child to teach you how to make a sculpture, a drawing, or a painting like the one she brought home. Gather similar materials and follow your child's directions as you build, draw, or paint. Take notes as your child talks you through her process, or make a step-by-step sketch as your child describes the process she used.

We are always eager for conversation with you about what you see when you look closely at the children's representations. What ideas are they expressing? Which details surprise or delight you? What do you think we might pursue next together?

---

Consider inviting families to meet with you, either one-on-one or in small groups, to review children's portfolios. During these meetings, you can look at children's work through the same lens you use with the children when you study their portfolios.

*What themes do you see in the content and in the aesthetic captured in your child's work? What seems to particularly engage your child? What art media particularly draws her? What have been landmarks for her, in her work? What changes do you notice when you study her work as it unfolds over a period of months?*

## Reflecting on Your Work

Many of us are hesitant to call ourselves artists. It's often quite new for us to use real art media, like oil pastels or porcelain clay or sculpting wire. Most of us take our first uncertain forays into this new terrain in the studio alongside the children.

Don't wait until you feel that you've mastered an art medium before trying it with the children. Do some initial exploration yourself, certainly. But be bold: bold and intentional—not bold and unprepared. Set up the studio space using the suggestions in each chapter and invite children to join you in an exploration of an art medium. Stay curious and aware as you and the children work. You'll have small disasters and large triumphs, moments of uncertainty and moments of great joy and discovery. You'll come away

from your exploration with new understandings and new questions—and will feel more confident in your ability to journey into this new terrain. The only way to begin is to begin.

Reflection is an essential element of this bold work. After each art exploration, take time to reflect on what happened in the studio. On page 20, you'll find reflection questions that you can use after each exploration. These questions are intended to help you track what works well for you in your particular context and what doesn't work well, what you want to do differently next time and what you want to be sure to do in just the same way. When we reflect on our experiences in the studio, we begin to grow our own understandings and routines. Reflection helps us invent our way into studio practices.

## GETTING LAUNCHED

The studio explorations are divided into four chapters: "Exploring Textures and Movement," "Exploring Color," "Three-Dimensional Media," and "Representational Drawing and Painting." In each chapter, you'll find sections on specific art media, with guidelines for creating a studio exploration with each medium. Here's how each art exploration is organized:

**Materials:** a list of the materials that you'll need for the exploration and for cleanup. You'll likely invent your own systems and strategies over time; my suggestions are to get you started.

**Setting Up the Studio:** suggestions for how to arrange the materials and set the table for the exploration. I encourage you to set up the studio for children's first encounter with an art medium; then, during each following encounter with that medium, coach the children about how they can set up the work space for themselves. This invites the children to claim the studio and the art materials as their own.

When you set the table with work spaces for each child, include a work space for yourself. If space is tight around the table, group a set of materials on a tray that you can set on your lap, or tuck a set of materials on a nearby shelf to pull onto the corner of the table for your own use during the exploration. This lets you explore the materials alongside the children, and also gives you a set of materials to use for demonstration.

**Exploring and Creating:** steps to follow, questions to pose, and aspects of an art medium to emphasize as you introduce and explore an art medium. You'll find lots of detail and very specific suggestions about how to move through an exploration. My intention is to help you get launched into art exploration by giving you a clear starting place. I expect that you'll revise and reconfigure these suggestions over time as you invent your way into your own studio practices.

In this section, you'll also find many examples of things you might say to children during an art exploration. This isn't intended as a script to follow word for word, but as an example of how to talk with children about the art medium in a way that invites exploration, reflection, and collaboration. You'll find your own voice as you become at home in the studio and with the art media.

**Cleanup:** a few simple suggestions about how to coach children about the immediate cleanup of an art medium. Again, please adapt these to fit your specific context.

**Documentation and Display:** suggestions for how you might focus your written documentation and display about the art exploration. You'll find a sample piece of written documentation from my teaching experiences at Hilltop in this section of each chapter. I share these as examples of how we can communicate with families about the dispositions and skills that children acquire during studio experiences and how we can create a history for the children of their work in the studio.

**Ways to Build on This Exploration:** suggestions for how you might use this art medium to expand children's learning and to strengthen their relationships with each other.

# REFLECTION QUESTIONS
## Inventing Your Own Studio Practices

How did children use this medium? Was their focus primarily sensory? Did they venture into representational work?

What seemed to impede the children or to detract from this experience?

- Skills that children needed but didn't have?
- The set-up or the materials?
- The cleanup process?

What worked well for you as you guided the exploration?

- The language you used to describe the materials?
- Suggestions and guidance you offered?
- Questions you asked?
- Notes and photographs you collected?

What didn't work well for you during the exploration process? What adjustments did you make?

What might the children want to do next with this medium?

What do you want to remember the next time you work with this medium?

What questions do you want to ask another teacher about this medium?

# EXPLORING TEXTURES AND MOVEMENT

2

Cornstarch and Water

Fingerpaint

Easel Painting

In our work with these materials, we strive to:

- honor the ways in which children live in their bodies, growing relationships with materials through their physical encounters with them;

- revel, alongside the children, in messy, physical exploration that celebrates all our senses;

- provide opportunities for children to explore texture and movement through a range of physical encounters, building a foundation for further art exploration.

This chapter offers explorations that are often seen as standard-issue "sensory activities" for young children. They're rich with sensual pleasure and with the playful delights of mucking about with gooey, wet, drippy, sticky, slippery, squishy concoctions. They are not, however, only about "getting messy" or "exploring with our bodies." The emphasis instead is on the ways in which these sensory-based explorations open doorways into the nuances of texture, density, viscosity, fluidity, and pliability.

This learning is anchored by intellectual and physical curiosity, and is enhanced by reflective observation. Children engage with sensory materials with their bodies *and* their minds, noticing and comparing textures, for example, or making connections to other sensory encounters they've had. The physicality of these explorations encourages them to investigate possibilities, to uncover subtle aspects of the materials with which they are working. Their understandings become embodied, and their embodied understandings become part of their intellectual awareness.

In this chapter, threads of "sensory play," "science," and "art" are woven into a single strand, the strand of a nuanced understanding of texture and movement.

# CORNSTARCH AND WATER

In this exploration, children experience the ways in which cornstarch is transformed from soft, silky powder to slippery, crunchy liquid. In the process, they also observe and reflect on the startling, magical creation of color. Working with two primary colors, children can explore the range of shades those two colors can create.

## MATERIALS FOR THE EXPLORATION

- a tub (optimally with a big tray underneath) for each child

- a tray for mixing colors (such as a mini-muffin tray) for each child

- pitchers of colored water, each a different primary color: red, yellow, or blue (use liquid watercolor paint or food coloring to color the water)

- two small, clear cups or short, wide-mouthed jars for each child

- two eyedroppers for each child

- a bowl of cornstarch powder for each child

- a spoon for each bowl

- a smock for each child

- an empty bucket or a sink into which children can pour their colored water when they finish experimenting with it

- a pitcher of clear water or a sink for rinsing off the mixing trays during the exploration

## MATERIALS FOR THE CLEANUP

- a bucket or tub with shallow water for soaking the cups, bowls, and mixing trays as children finish

- a substantial tub of water or a sink in which children will rinse their hands

- paper towels

- a trash can

## SETTING UP THE STUDIO

Set a tub on a tray for each child. Put a mixing tray and two cups (or jars) of the colored water, with an eyedropper in each, in the tub. Each cup (or jar) should contain a different primary color. For each child, have a bowl of cornstarch and a spoon ready to go; set the bowls and spoons aside on a nearby table or shelf, as the children won't use them right away.

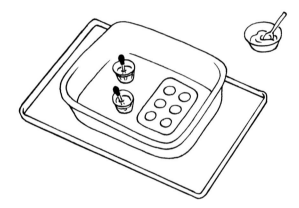

If you don't have a sink in the room, put an empty bucket near the table; children will empty their trays of colored water into this when they're ready to refresh their work spaces. Keep a pitcher of clear water handy; you'll use the clear water to rinse the mixing trays as children finish a round of exploration.

Set the pitchers of colored water on a nearby shelf or table: you'll use these to refill the children's cups or jars during the exploration.

Keep a pile of paper towels close to the table, easily within your reach, to hand to a child when she finishes; she'll use a paper towel to minimize drips as she makes her way to the sink or rinsing station.

If you don't have a sink in the room, set up a rinsing station for children's hands near the table where the children will be working: a tub or bucket of shallow water, an ample supply of paper towels, and a trash can.

## EXPLORING AND CREATING

### Exploring Color

Welcome children to the studio with an invitation into exploration.

> *We're going to do the work of scientists and artists, and see what we can discover about color.*

Introduce the children to the materials. Eyedroppers may be a new tool for some children; demonstrate how to use them.

> *Put the eyedropper in the water. Squeeze—and let go. The water goes in! Then lift it out of the cup and squeeze again—the water comes out.*

The children can practice as you coach them through the process several times.
Explain that the mixing tray is for mixing.

> *We'll use the mixing tray for experiments. That way, we can keep the jars of water clear and clean.*

Coach the children about moving water from the cups or jars into the mixing tray. Demonstrate as you describe the process.

> *We can put water in the mixing tray with an eyedropper. We'll carry water from the jars to the trays with the eyedroppers, and do experiments in the mixing tray.*

> *Put the dropper in the water, squeeze, and let go. Then lift it out of the cup, move it to the mixing tray, squeeze—and the water comes out into the tray! You can put more of that color in the mixing tray—or you can add some drops of the other color, and see what happens.*

After this simple orientation to the materials, invite the children to dive into their research, exploring the possibilities that the colored water holds.

> *See what you can discover about color. You can do the work of scientists, learning about colored water and eyedroppers.*

As the children experiment, point out what you see and invite the children to reflect.

> *What happens when the red water meets the yellow water?*

> *I'm curious about how you made purple. Will you teach us what you've discovered about that?*

When a child's mixing tray is full, help him empty the water into the sink or empty bucket, and give the tray a quick rinse, so that it's ready to use as a palette again. (If you don't have a sink in the room, you can use a pitcher of clean water to rinse the mixing tray.) Invite the child to revisit and deepen his experimentation.

> *Do you remember how you made that green? Your mixing tray was full of green water before you rinsed it out! I wonder if you can make more green—light green and dark green.*

During their exploration, children's cups or jars of colored water may become muddy—or empty! Use the pitchers of colored water to refill or refresh children's individual cups, so that they've got a good supply of color for their work.

### Adding Cornstarch

After a stretch of time exploring the colored water, children will be ready for a new challenge, a next step in their investigation of color. Offer each child a bowl of cornstarch and a spoon.

> *This is cornstarch, a kind of powder made from corn that people sometimes use in cooking. See what you can discover about what happens when cornstarch meets colored water in the mixing tray.*

Children can spoon cornstarch into the mixing tray and add drops of colored water to it. Or they can put water in their mixing tray and sprinkle cornstarch into it. You can encourage children's exploration with a few questions.

> *What does dry cornstarch feel like on your skin?*

> *What happens when water meets cornstarch?*

> *Why do you think that's happening?*

> *Which do you think is more powerful: cornstarch or water?*

Cornstarch tends to "pull apart" the mixed color into its primary components: for example, green is "divided" back into yellow and blue. This is likely because each solution has a unique solubility: blue may be more soluble than yellow, for example, so the blue dye stays mixed in the water while the yellow dye separates from the water. The science of this is not particularly important—especially for the children to hear about—but it's fascinating to observe! Watch for this, and when you see it, point it out to the children.

*Where you put your green water on the cornstarch, I see some yellow and blue. What do you suppose is happening?*

During this exploration, your questions should be aimed at helping the children notice and reflect. They shouldn't become a drill, or take over the children's encounter with the materials. Be sure to leave lots of space and silence for the children's exploration. Take notes about the children's comments, questions, and discoveries: write down their words, and describe their gestures and actions in writing.

Eventually, the children will have a big, goopy glob of cornstarch! The children will probably scoop it out of the mixing tray into their larger tubs. Take away the cups, eyedroppers, mixing trays, bowls, and spoons to make room for the children to dive into the satisfying goo in their tubs. However, they may want to use those tools in their play, so keep them handy.

## CLEANUP

Expect some blobs and drizzles of colored cornstarch on the table and floor. One way to minimize the number of drips as a child moves from her work space to the sink or rinsing tub is to hand her a paper towel. This catches a good portion of drips as she walks to the sink or rinsing tub. It's also a good idea to have a child keep her smock on while she's washing up.

While a child is cleaning up her goopy hands, you can slip her tools into a bucket for later cleanup. Cornstarch is simple to wash away: run warm water over the tools and the cornstarch will simply dissolve. A few wipes with a damp sponge will clear the table. Let the cornstarch on the floor dry, and you'll be able to easily sweep it up.

## DOCUMENTATION AND DISPLAY

Children maneuver their eyedroppers with deep concentration, they bury their hands in thick, silken, cornstarch. Capture children's immersion in their exploration with photos: close-up images of their hands, their faces.

Children exclaim about transformations in color, about the silky, crunchy, gooey, slippery textures. They describe their discoveries, they pose questions, they teach each other what they've figured out about color and cornstarch. Capture children's physical and intellectual engagement by writing down exactly what they say and what they do.

Your photos and notes will create documentation that tells the story of this encounter with color and texture. Choose a particular focus for your story. You might frame your writing around the sensory experience of the encounter: the delight and pleasure that come with visual and tactile stimulation. You might focus your written documentation on the ways in which children began to build an understanding of color. You might choose to organize your written documentation around the ways in which the children were researchers, exploring the qualities of colored water and cornstarch, making discoveries that shaped new questions. When you've decided on the story you'll tell, you can choose photos and include comments by the children that bring that story to life, adding your own reflections and questions.

As you prepare your documentation—whether it's a simple one-page narrative or a bulletin board display—consider how you might invite adult readers into the experience that the children shared. If your story is framed around the sensuality of the children's encounter, you might invite adult readers to recall experiences that they've had of being engulfed by their senses.

*This experience with cornstarch and water deeply engaged the children's senses. When have you experienced being swept up by color or by the feel of something lush and soft on your skin?*

If your focus is the children's deepened relationship with color, you might ask adult readers to think of a primary color, and consider ways to describe that color.

*Consider red. It comes in many shades! What name would you give to the red of strawberries? Ketchup? Blood? Cherries? The sun at sunset?*

If your focus is the children's research, you might pose a question for readers that asks them to be researchers about the children's learning.

*How do you see the children teaching each other about the cornstarch and water?*

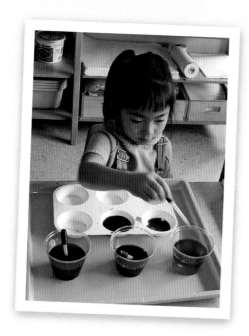

October 2

"This is an experiment about colors. What can you discover about red, blue, and yellow?" I said to a small group of children in the studio. I'd set up four workstations, each with a cup of red, blue, and yellow water; eyedroppers; and an empty mixing tray. I sought to create a "provocation," an invitation to explore, ask questions, pose hypotheses, and make discoveries. As you read about their experimentation, notice the children's research process. How are they collaborating to deepen their observations and form hypotheses?

"I'm making orange!" exclaimed Olivia. "First you get yellow or red, then you get the other one. It's orange!"

Logan was engrossed in his experiment: "I maked purple with red and blue—I just squirted it out and got purple."

Halley: "This is like an art museum, a special kind of art museum where we do stuff."

Logan: "It's a mixing museum."

Halley: "I discovered that I could make black."

Arianna: "How did you do that?"

Halley: "I mixed yellow, red, and blue all together."

Olivia: "That's what I did too. I mixed all the colors in the world and made black."

Logan: "I'm filling mine as full as the sea."

The children became captivated with making "black," mixing all three primary colors together over and over until their mixing trays were full of dark liquid. As I watched and listened, I considered how I might open new ways for the children to see that dark liquid, helping them notice the nuances of color that the rich liquid held. I decided to offer the children cornstarch, knowing that the white powder would absorb the liquid, creating a sort of spectrum in the process. The cornstarch would also expand the children's sensual experience of color, inviting tactile play to complement their visual encounter with color. I offered each of the children a bowl of cornstarch, suggesting that they could add spoonfuls of this to their mixing trays, along with the colored water: "I'm curious about what you'll discover when you do this next part of your research here in the mixing museum," I said.

The children stirred heaping spoonfuls of cornstarch into the colored water in their mixing trays.

Arianna: "Why does it get all sticky?"

Olivia: "Because cornstarch is a little bit hard and the color is a little bit like water, so that's how it makes it sticky."

Arianna: "You pour cornstarch in the water and it makes it a little bit harder."

Olivia: "It feels like rubber bands."

Logan: "It looks like lace on you."

Olivia: "You should feel this—it's very gooey. It feels good on your hands, like rubber and soft."

Logan: "Can I play with that gooey ball that you made?"

Arianna: "We could make snowballs with this."

Olivia: "After you get it wet."

Arianna: "Right. If you want to make a snowball, get it wet."

Olivia: "Now it feels like clay. I squeezed it so much that it's like clay."

Logan: "Look at my magic! I made it snow inside!" He rubbed his hands together and sprinkled cornstarch like snowflakes.

Halley: "Pretend you're coming to the art museum to see the artists."

Olivia: "And we are the artists, because we're painting so much. First I didn't know that all these colors make different colors. Now I know that if you mix the colors and you didn't do it before and then you try it, then you know what colors they make."

As they explored colored water and cornstarch, the children took action and observed the results, generating hypotheses about what was happening. They shared their thinking with each other, posing questions and reflecting on them together, offering suggestions and insights to their companions. This is the work of artists and the work of scientists, creating a "museum" of discovery and beauty from the simple elements of colored water and cornstarch.

## WAYS TO BUILD ON THIS EXPLORATION

You might use cornstarch and water:

- when children are investigating physical transformation—how a substance or person changes identity;

- when children are investigating the power of water: water drizzled and dripped onto dry cornstarch creates pools, rivers, and enclosed bubbles of water lightly dusted with cornstarch;

- to foster an awareness of scientific method: making predictions, and charting observations about how new colors are created or about how a dry powder becomes dense liquid.

With cornstarch and water, children can take a range of perspectives. They can:

- describe the encounter with water from the perspective of the cornstarch;

- write directions for children who have never seen cornstarch, teaching them how to turn cornstarch from powder to liquid;

- write a story about the meeting between two primary colors, from the perspective of one of the colors: "This is the story of the day that red met blue . . ."

You might use the colored water to create a reference display about color. Add water to jars or bottles with lids, then have children color the water by adding drops of red, yellow, and blue liquid watercolor paint or food color. Put a sticker on each lid where children can record the colors that they used to make the color in the jar. (For example, on the lid of the jar with deep orange water, they might write "three drops of red, one drop of yellow.") Arrange the sealed jars in a rainbow spectrum along a window, where light can shine through them: red, orange, yellow, green, blue, indigo, violet. Children can refer to this display throughout the year, to remember how to create particular shades as they work with watercolor and tempera paint, oil pastels, and chalk pastels.

# FINGERPAINT

Fingerpaint invites attention to color, to texture, and to movement, as children run their fingers, the palms and backs of their hands, their arms and elbows across paper slick with colored paint.

### MATERIALS FOR THE EXPLORATION

- a plentiful supply of slick fingerpaint paper
- fingerpaint in clear cups or jars
- a spoon for each jar or cup of paint
- a smock for each child
- a covering for the table: preferably a plastic cloth without much design or color
- a drying rack or shelves for finished paintings

### MATERIALS FOR THE CLEANUP

- a tub of water or a sink for washing hands
- paper towels
- a trash can

## SETTING UP THE STUDIO

Make sure there's plenty of room around each child's work space for big arm movements. You might cover the table with a plastic cloth or big pieces of plain white butcher paper; the intention is not only to make cleanup easy, but to provide a simple background for the children's work, something that emphasizes the children's exploration of color, rather than something that visually "takes over" the work space.

For each child, set out a piece of fingerpaint paper, with lots of space around it. In the center of the table, put clear cups or jars of fingerpaint, each with a spoon. Consider the invitation that you are creating for children. Putting fingerpaint in clear

jars is an extra effort: it already comes in perfectly good bottles! This effort, though, allows the children to see the color through the glass or clear plastic, to engage with it visually from the moment they see the table. It's like putting a beverage in a nice pitcher for a dinner party, rather than keeping it in its commercial packaging: a way to honor the people gathered, and the relationships that will grow around the table, nourished by the shared feast.

Have an ample supply of fingerpaint paper nearby. The children will use lots of paper when they fingerpaint.

Prepare for the cleanup that will follow this deliciously messy experience by anticipating where children will wash their hands (and arms and elbows!). If you have a sink in your studio, how will you and the children manage the faucets? The faucets will soon become covered in paint if the children turn them on with hands covered in fingerpaint. You might have paper towels near the art table so that children can do an initial wipe-down before heading for the sink. Or you might have them use paper towels to turn on the faucet, in which case you'll need paper towels right at the sink.

If you don't have a sink in your art space, set a tub of water on the floor (you might put a towel under this to catch splashes and drips). Have an ample supply of paper towels near the tub, with a trash can nearby.

## EXPLORING AND CREATING

Invite children to choose one or two colors of fingerpaint to start their exploration. Using just one or two colors allows the most satisfying exploration of color: it highlights nuances of shading as well as the transformation of colors. A bunch of colors at the same time quickly becomes a muddy brown. (To explore brown as a color, use several shades of actual brown fingerpaint or skin-tone paint, to allow brown

to maintain its integrity. We don't want brown to be seen as the disappointing end result of mixing a bunch of bright colors, which children often expect to make a rainbow.)

Two generous spoonfuls of paint is a good amount to start with. If children are scooping their own paint, coach them about how much they'll need to get launched.

> *Two scoops to start. You can always add more later if you need it.*

If you're "serving" the paint, ask each child where she would like you to put the initial scoops of color on her paper. This respects children's right to make decisions about their work.

> *Where would you like me to put the paint? You can point to show me.*

Children will likely dive right into the paint! Questions and thoughts to offer the children, as they begin to explore the fingerpaint, include the following:

> *What happens if you use just the tips of your fingers? What happens if you use your knuckles? Your thumbs?*

> *You can draw in the paint! And "erase" it, then draw again.*

> *Notice the color . . . In some places, the red is very light, almost pink. The color is dark and full here, where the paint is thick.*

> *Would you like to add a color? You began with one color; I wonder what would happen if that color met another color.*

> *What happens if yellow tiptoes through blue? Let's put yellow on the tips of our fingers and tiptoe them across the blue paint.*

> *What if your red hand shakes hands with your friend's blue hand?*

> *Would you like a scoop of paint right in your hand, instead of on the paper?*

> *Look at all that green you made! What is the story of green? What should we know about green, to know it like a friend? What is the sound of green? If green were a person, what would green like to do? What would green's favorite smell be? Where would green like to visit?*

> *Notice how the paint moves across the paper. What happens when there's a big blob of paint? What happens when there's not much paint on your hands?*

As a child fills his paper with color, the paper will become more and more fragile, with holes opening and tears fraying the edges. To avoid a sudden dissolution, have the child stop for a moment while you slip the paper off the table and onto the drying rack or shelves. Offer the child a new piece of paper, and check with him about whether he'd like to rinse his hands and start with new scoops of color, or continue with his hands as they are.

During the exploration, we can emphasize the unfolding discoveries and the sensory experiences with color and texture, rather than emphasizing paintings as finished products. Occasionally, a child will etch a design into his fingerpaint that he wants to preserve, but most of the time, a child's focus will be on the movement and shading of the paint. And that ought to be our focus, as well.

In fact, an option with fingerpainting is to skip the paper and paint directly on a white length of butcher paper, a white plastic cloth, or white or clear plastic placemats. This clearly communicates that the focus is about investigating the color and movement of the paint rather than about "making a painting." When the plastic is full of paint, you can wipe it down and rinse it off, then begin again, or call it a day, letting the paint dry on the plastic. If you try this option with clear plastic, you can hold the plastic in front of a window or a lamp so that light illuminates the color.

## CLEANUP

If you have a sink in your art space, hand children paper towels for an initial wipe-down of their hands and arms before they head to the sink. Have them toss those towels into the trash, and use new ones to turn on the faucet, so that the sink handles don't become goopy with paint. Children typically need some adult help rinsing the paint from their arms and elbows, so be ready to offer assistance.

If you don't have a sink in your art space, coach children about how to rinse their hands in the bucket or tub of water. This can be an initial rinse, aimed at getting the bulk of the paint off a child's arms and hands. From here, a child can move to the sink and wash off the rest of the paint.

## DOCUMENTATION AND DISPLAY

The story of fingerpainting is not about the actual completed paintings. The *process* is the story. Think of the finished "paintings" as snapshots of action and as records of hues and shades, documents that reflect the children's research process and discoveries.

As you collect documentation about fingerpainting, highlight the encounter between children and color, the adventures in movement and texture. Photos can capture the children's hands up-close, covered in paint. Aim for a photo of each child early in her encounter with fingerpaint, when her hands first meet the paint, and a photo later in her exploration, when her hands are full of color. Take notes as the children work:

- What do the children say as they move the paint on paper? Do they tell stories as they paint? Do they make connections between their experience with fingerpaint and other experiences?

- How do the children move their bodies as they paint?

- What discoveries are the children making about color, movement, or texture?

- How do the children share their observations with each other? How do they test their discoveries with each other?

To create a display about fingerpainting, choose a few paintings that capture visible movement and that contain a range of color shades and hues. If the children were working on plastic, you might use this plastic in your display, or you might take a few photos of sections of the plastic cloth in which movement and nuances of color stand out. Also, choose a few photos of children's hands that tell the story of movement, of research, of sensual delight. Your text for the display can include children's words and your reflections about the children's experience of movement and color, and their collaborations with each other while they fingerpainted.

October 24

Fingerpaint in the studio . . . slippery, slick, cool, sticky, vibrant, and bold.

Eddie: "This feels like I'm on rubber."

Raven: "I'm sticking to the paint! My hands are full of paint!"

Eddie: "It feels like flubber."

Raven experimented with scratching lines into the paint: "Does this remind you of pipes, or roller coasters?"

Raven's and Eddie's exploration of the fingerpaint was sensual and quiet; they didn't talk much, except for occasional exclamations of discovery or delight. They immersed themselves in the color, the texture, the movement of the paint on the paper, alive in their senses.

Look at the delicate dance of Eddie's hands. One hand in yellow, one hand in red, Eddie gradually, gently brought his two hands closer and closer until they met at the center of his paper, where they transformed each other.

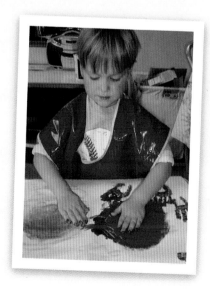

Raven created purple first on her hands, by rubbing her red and blue hands together, laughing delightedly at the cool, wet, slippery feel and the wild new colors she created.

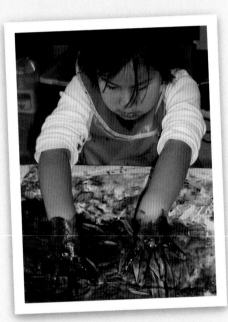

Eddie and Raven are strengthening their understandings of texture and movement while they fingerpaint. The paint holds the record of their hands' motion, and their hands hold the memory of the paint's slick consistency.

## WAYS TO BUILD ON THIS EXPLORATION

You might use fingerpaint:

* to invite children to express and record emotion: How would scared hands move across the paper? angry hands? curious hands? excited hands?

* to record the story of a wild physical game: re-create a chase game, or wrestling, or hide-and-seek.

* to strengthen children's relationships or to explore collaboration: invite a small group of children to work together on one big piece of paper, perhaps each with a unique color of fingerpaint. The children will be physically close, arms overlapping, bodies touching as they work, and they'll likely do some negotiating about how to move the color on the paper.

# EASEL PAINTING

A floor or tabletop easel allows children to interact with color on a big scale. Easels emphasize movement: the movement of an arm with a brush, the movement of paint across the big paper. Children paint with bold brushstrokes at an easel, they stand eye to eye with the paper, they shift their weight from leg to leg, they turn at an angle to the paper, they lean back away from the paper and lean forward toward the paper. Easel painting is a dance, a physical encounter with paint.

## MATERIALS FOR THE EXPLORATION

- easels: one floor easel generally allows two children to paint at a time, one on each side; you can also use tabletop easels or large pieces of paper hung on the wall to add work spaces

- clips to hold the paper on the easel

- paint in a range of colors, in clear glass or plastic jars or cups

- thick-handled, thick-bristled paintbrushes: one for each jar or cup of paint

- covering for the containers of paint: lids or plastic wrap

- a shelf or cart within easy reach of the easel for the containers of paint

- an ample supply of full-sized easel paper

- a drying rack or shelves for finished paintings

## MATERIALS FOR THE CLEANUP

- a bucket of shallow water for brushes

- a drop cloth under the easel to catch drips

## SETTING UP THE STUDIO

Place the easel in an area where there's plenty of space for movement: children's arms need to move boldly and broadly, and they need room to step close to and away from the easel. Consider placing the easel next to a window where the colors, sounds, textures, and movement of the outside environment are the children's companions at the easel.

Most easels have a built-in shelf for holding the cups or jars of paints. If your easel doesn't have this, situate the easel so that it's next to a table or shelf on which you can set the containers of paint. For instructions on how to create a color palette of paint for the easel, see pages 41–43.

If you have the resources to do so, put the paint in clear containers so that children can receive the full impact of the color. Color has a strong presence, and that presence invokes sense memories and connections: seen from the side and the top in all its boldness, a glass jar of red paint calls to mind a bowl of salsa on a hot summer day, a juicy strawberry, a fire truck, blood, chilies—each with its own emotional tone and expressive voice. Imagine this jar of red paint—and one of yellow, blue, green, brown—calling you to an easel, stirring your senses.

Now imagine an opaque plastic jar with a red plastic lid over the top, and a brush handle sticking out of it. It is voiceless, emotionally neutral.

Prepare the paint for the easel so that it beckons to children. Put a brush in each jar, or stand a bouquet of brushes in an empty jar next to the paints. It's helpful to have a stock of extra clean brushes handy to replace brushes that become muddy or that fall on the floor.

Clip a sheet of full-sized easel paper to the easel. Stack a good supply of easel paper on a flat surface near the easel, so that children can replace the paper on the easel.

Make sure the drying rack or shelves are accessible to the children. If you use a drying rack, make sure there are plenty of clips available for hanging the wet paintings.

A bucket of shallow water near the easel is a good place for used brushes. Soaking them awhile makes washing them easy.

## EXPLORING AND CREATING

Children's easel work tends to be more about the physicality of interaction with paint and paper than about representational art. An easel is a setup for physicality: the paper is as big as the child's torso and he stands face-to-face with it, moving his whole arm to spread paint. This is the beauty of easel painting!

Coach children about committing one brush to each color, rather than moving a brush from jar to jar.

*Each color gets its own brush. To put red on your paper, use the red brush. To put blue on the paper, use the blue brush.*

Colors do eventually blur on the brushes; when a brush becomes muddy, simply have a child plop it into the bucket of water and choose a fresh brush. This will keep the paint in the jars relatively "pure."

Help children manage drips.

*When you lift the brush out of the paint, give it a little swipe against the edge of the jar. That makes the brush less drippy.*

*When paint starts dripping on your paper in a place you don't want a drip, use your brush to catch it!*

Call attention to the physical experience of easel painting.

*You can move your arm in big gestures at the easel. Try moving your arm in big circles—and smaller and smaller circles.*

*See how far away you can stand from the easel and still touch the brush to the paper.*

*Try to put paint from the top of the paper all the way to the bottom . . . How about moving the paint from one side of the paper all the way to the other side?*

*When I look at the paint on the paper, I see the lines of your brush's hairs.*

*Look at the paint slowly moving down the paper, like a drop of rain runs down the window.*

*You started with red and now you're adding blue. The paint on your paper is changing color!*

*Look at the tree outside. Its branches are moving in the wind. Can you paint like that tree is moving? Imagine that your arm is a tree branch and the wind is blowing gently.*

Consider leaving a painting on the easel for several days, inviting a child to revisit it over time to add to it and change it. A child can look at her painting from different vantage points—from across the room, for example, or casually while passing through the room. The light changes through the day, and from one day to the next; this shift in light affects how a painting looks. As a child sees her painting from different perspectives, she may decide to add to or change what she's painted.

When a child is finished with an easel painting, coach her about how to take it off the easel and move it to the drying rack or shelf. This is a challenging job for one child alone. I usually ask children to work in teams.

*One person will hold the paper and one person will work the clips. Let's decide who will do each of those jobs.*

To the person managing the paper: *Hold on to the paper right next to the clips. When the clips let go, your hands will hold the paper.*

To the person managing the clips: *A clip is like a mouth. Squeeze the clips like you're opening their mouths wide. Hold the clip open while your friend takes the paper out of the clips.*

To the person managing the paper: *Take the paper out of the clips. Carry the paper over to the drying rack.*

To the person managing the clips: *Let the clips close.*

If you use a string-and-clothespin-style drying rack:

To the person managing the paper: *Hold the paper close to the string, so that the clips can hold on to the paper and the string at the same time.*

To the person managing the clips: *Open the clips like a mouth, and let them take a big bite of the paper and the string. One clip goes on each corner of the paper.*

After several rounds of practice, children become quite adept at this and don't need much coaching or help from an adult.

An extension of the physicality of easel painting: Cover a wall in your classroom with plastic (like a painter's plastic drop cloth), then add big sheets of butcher paper over the plastic. Invite children to paint on the wall! This is a strong, bold experience of big brushstrokes, full-body involvement with paint and paper and movement.

Another extension: Bring buckets of water and your clean easel brushes outdoors. Invite children to "paint" with plain water on the walls outside. This is an exuberant experience of movement and texture.

## CLEANUP

As brushes become muddied, have children slip them into the bucket of water where they can soak until it's time to wash them. When that time arrives, children can take charge of cleaning the brushes in a sink. Coach them as follows:

*Hold the brush under the running water. Rub the hair of the brush between your fingers and squeeze it a few times while the water is running on the hair. Keep doing that until you don't see any more color coming out in the water or on your fingers.*

*Lay the brush on a paper towel. Do you see any color coming onto the towel? If there's no color, then that brush is clean. If there is color, then that brush needs a little more washing.*

When the brushes are washed, wrap them in a couple of paper towels, give them a squeeze to get the extra water out, then let the brushes air-dry. Restock the paint jars as needed, so that they're ready for another round of easel painting. Cover the jars tightly with lids or plastic wrap.

## DOCUMENTATION AND DISPLAY

Your written documentation and display can call attention to the encounters with texture, movement, and color that easel painting involves. Take photos that capture the physicality of children's interaction with the easel: stand behind a child while he works at the easel and focus on his arm in motion, or on how his body leans and turns. Get up close behind him and take a photo that shows both the paint's strong presence on the paper and his brush's contact with the paper.

For display, create a "field guide" to easel painting, using photos of the children at work and a few of the most eloquent paintings. Write text that emphasizes the children's arm movements and brushstrokes and the ways that they position themselves at the easel. Include your reflections about the meaning and value of the children's bold physical movement. Label elements of the paintings with brief text, and link these descriptions to the elements on the painting with string.

*This drip began near the top, but was quickly captured by Beth with her brush. You can see the movement of the brush reflected in this swirl of bristle marks.*

*This is an example of how the brush gives texture to the paint on the paper. Look for bristle marks and lines in the paint, and at the concentration of color in this area.*

*The line leaves the paper at this point along the edge. Eduardo's arm moved so broadly that his arm's circle was bigger than the paper.*

*The red and the yellow begin to blend here. Stella held a red brush in one hand and a yellow brush in the other, and brought them closer and closer to each other on the paper. When they met here, she exclaimed, "Orange!"*

Anchor this sort of analysis with broader reflections about the ways in which easel painting invites children to understand texture, movement, and color.

September 21

Children's bodies are eloquent when they stand at an easel to paint. The gestures of their arms, the tilt of their bodies, their eyes' steady gaze tell the story of children's engagement with color, with movement, with creative offerings. Look closely at these images of children painting at the easel: they hold captivating stories . . .

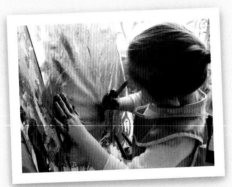

Theresa leans into the paper, reaching out to the deep, full blue. One hand moves the paint with a brush; the other hand, eager for involvement, takes hold of the blue and follows the brush across the paper. Both arms move fully, up and down, side to side.

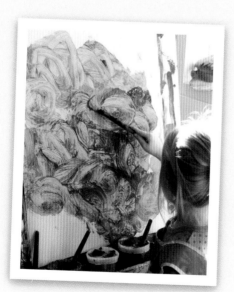

Ariana honors the integrity of the colors as she offers them to the paper separately. Blue, then yellow. Suddenly—green! The point of contact is the point of creation, where a new color emerges. The paper holds the record of the swirling brushstrokes, telling the story of how Ariana brought the yellow and blue together.

## WAYS TO BUILD ON THIS EXPLORATION

You might use easel painting:

- to invite children to reflect on big physical play: revisit a chase game by looking at photos or a video clip, then invite children to paint the game at the easel;

- to offer possibilities for children to change scale: invite children to take a small sketch or watercolor painting they've done and re-create the image on the much larger easel paper;

- to create an experience of collaboration: invite two children to work together on one painting, standing side by side at the easel;

- to create an experience of listening and negotiating: ask children to work as partners, one child on each side of the easel, with each giving the other directions about what sort of lines to paint and what colors to use.

3

# EXPLORING COLOR

Black and White Paints

Tempera Paints

Watercolor Paints

Oil Pastels and Chalk Pastels

In our work with these art media, we strive to:

● honor children's aesthetic awareness and their attention to beauty;

● introduce children to color: primary and secondary colors, shades, and tones;

● mentor children as they learn to create specific colors;

● teach children how to use tools that give them mastery with color media: pastels and paintbrushes in a range of sizes.

Color anchors us to our world. It calls on our sense of sight as well as our other senses. A rich green can invoke the feel of grass on bare feet, or the taste and texture of juicy grapes. Deep orangey-gold reminds us of the sun's warm caress. Color holds story, metaphor, emotion for both children and adults. Color is a cornerstone in classroom culture in which art is a tool for reflection, communication, feeling, and thinking.

As we offer children many encounters with color and color mixing, our emphasis is on creating opportunities for them to learn about color through personal experience rather than through our directed teaching or quizzing. We want to avoid geography lessons; instead, we want to invite travel to the landscape of color. We can provide maps and supplies for the journey, we can serve as companions along the way—but it is the children's journey to make. They will follow the trail of their curiosity, instinct, and senses, anticipating what they might encounter along the way and being wildly surprised by the unexpected, as well. As they travel the landscape of color, they will grow complex understandings and new questions, and learn to speak the language of that land like a native tongue. They will learn the ways in which colors come together to create new colors. They will learn the many shades that a single hue can generate. They will learn the ways in which colors complement each other and contrast with each other. The knowledge that they gain allows them to use color to express emotion, to represent the world, and to tell stories.

# BLACK AND WHITE PAINTS

Before launching into the full spectrum of color, stand at its edge with white and black, the beginning and end of color. Black and white provide a frame through which we more clearly see and understand color. Side by side on paper, the contrast between black and white calls each more fully to life.

## MATERIALS FOR THE EXPLORATION

- black tempera paint in a clear glass or plastic jar for each child
- white tempera paint in a clear glass or plastic jar for each child
- a mixing tray for paint for each child
- paintbrushes, in a range of sizes: in a jar, pot, or basket
- craft sticks for mixing paint: in a jar, pot, or basket
- a spoon for each paint jar
- paper towels
- an ample supply of large black paper
- an ample supply of large white paper
- a drying rack or shelves for finished paintings

## MATERIALS FOR THE CLEANUP

- a bucket or tub of shallow water to soak brushes and mixing trays
- a trash can for mixing sticks
- plastic wrap or a sheet of acrylic to cover the paints (optional)

## SETTING UP THE STUDIO

Arrange the table so that each child has a spacious work area. Set a piece of black or white paper at each child's work space. You might alternate the paper, so that some children begin their work with white paper, while others begin with black paper. This way, children can compare discoveries and exchange questions as they work.

Children can experiment with paper in both colors during the exploration. If there is room at the table, you might set a piece of black paper alongside or above a piece of white paper at each child's work space so that a child can move from one to the other as she paints, observing the different impact that black paint has on white and on black paper, for example. The simple decision about how to offer paper to the children communicates your intention for the exploration: "I'm eager for you to collaborate in your learning"; "I expect you'll want to do some research as you explore these colors."

At each child's work space, set a jar of black paint and a jar of white paint, each with its own paintbrush. Lay a dry brush across each child's paper; you'll use these during an initial introduction to paintbrushes. In the center of the table, position the stack of mixing trays, a jar or pot of mixing sticks, a jar or pot of spoons, and a jar or pot of paintbrushes for children to use as they blend colors. Set the paper towels on the table where children can easily reach them. Keep a stash of extra paper handy, perhaps in the center of the table or on a nearby table or shelf.

Set your drying rack close to the table, in a place where children can easily access it. Be sure there are plenty of clips for hanging the paintings.

Have a bucket or tub with shallow water handy for cleanup. When they finish painting, children can put their brushes and mixing trays in the bucket.

# EXPLORING AND CREATING

## Exploring Paintbrushes

Before diving into the paint, introduce children to the dry paintbrushes.

*Painters use a tool called a paintbrush to spread paint on paper. Check out your dry paintbrush. What do you notice about it? Feel its soft hair on your hand, your cheek.*

*Do you notice that the hair on the brush stands up straight? That's the best way for the paintbrush's hair to be—standing up straight. If you push your brush down hard, the hair gets squished flat. When the hair is squished, the paintbrush can't spread paint very well.*

*We touch the brush to the paper with a light touch so that the hair stands up when we paint.*

Demonstrate for the children, and invite them to experiment with their still-dry brushes.

*Experiment to find out how gently you need to touch the brush to the paper so that the hair stays standing up.*

*If the hair stands up, then you are the boss of the brush. The paint will go just where you want it to go. If the hair is squished flat, then the brush scratches your paper and puts its own marks on it—the brush becomes the boss of your painting. Remember, when the hair stands up, then you are the boss of the brush.*

Next, demonstrate how to use a brush with paint.

*Dip the brush into the paint. Wipe it on the edge of the jar to catch the drips. Paint on the paper. Dip—wipe—paint. That's how we move paint from the jar to the paper.*

## Exploring Black and White Paints

After these initial introductions, welcome the children into the exploration with an invitation.

*Black paper and white paper. Black paint and white paint. Two colors that are opposites! I'm curious to see what we discover about these colors that are so different from each other.*

Black paint on white paper makes a strong declaration. White paint on black paper calls attention, draws the eye. Invite the children to move slowly, noticing the impact of the color on the paper and the interaction between the colors.

*Black is a strong color. Look at that line of black on the white paper! What story is that black line telling? Where does the line begin? Where is it going? What happens to it along the way?*

*White paint on white paper . . . Can you see the difference between the paint and the paper? How can you tell where the paint is on the paper?*

*Step back for a minute and look at the black and white paint on your paper. It looks like they're dancing/chasing each other/taking turns in a game. What do you notice about how the colors are moving with each other?*

*Black is a deep, powerful color. Black makes me think of the night sky, a mug of coffee, a cool shadow on a hot day. What does it make you think of?*

As they paint, coach the children about how to use the brush.

*Remember to let the hair stand up. That way, you're the boss of the brush! Touch the brush lightly to the paper.*

*Dip—wipe—paint. When you wipe the brush on the edge of the jar, it puts the drips into the jar, so that they don't fall onto your paper.*

Encourage children to try a range of brush sizes. Large brushes work well for spreading paint, and small brushes work well for making intentional or representational lines.

*You've been using a big brush, and you've filled the bottom edge of your paper with black. I'm*

*curious to see what sorts of marks a smaller brush would make on your paper.*

*You've made such delicate white lines with that small brush. When you get a new piece of paper, you might also try a bigger brush to see what sorts of lines that brush can make.*

Encourage children to experiment with both black paper and white paper as they paint.

## Mixing Black Paint and White Paint

After the children have had time to explore the simplicity of black and white, introduce the mixing trays and the process of formally mixing paint (certainly, the children will have done some mixing on their paper in the process of painting!). Demonstrate as you describe the process.

*These are mixing trays—trays for mixing colors to make new colors. We use them so that our original colors stay clear and strong.*

*Here's how mixing works: When we mix paint, we always start with the lightest color. The light colors are weak colors; it's hard for them to change a darker color. Dark colors are strong colors; just a few drops of a strong color makes a light color change. White is lighter than black, and that makes it weaker than black, so we start with white.*

*Use a spoon to scoop some white paint from your jar into the mixing tray. Put the spoon back in the white paint; you can keep it there until you need more white paint. Then use a new spoon to scoop some black paint from your jar into your mixing tray. Put that spoon back in the jar of black paint.*

Use a mixing stick to stir the white and black together. Call the children's attention to the ways that the black swirls into the white, slowly blending. It's not an instant transformation of color, but a slow, gradual process that we can witness. Take time to watch the black and white knit together.

*When we're done mixing, we can put the mixing stick on a paper towel. What name should we give this new color? It's a soft, pale gray. What does it remind you of?*

*When you're ready to paint with your new color, choose a brush from the jar on the table. Every color gets its own brush. That keeps each color strong and clear.*

After this first demonstration, do another round. This second time, invite the children to work along with you, each child creating color in his tray. Move slowly, step-by-step. There will likely be quite a bit of variation in the colors that children make, as they mix varying amounts of white and black. Encourage the children to compare their experiences and to observe the new colors being created.

*Henry started with a big scoop of white and added just a tiny drop of black. Henry, what happened to the white when you started stirring?*

*Look at Jacqui's deep, deep gray. Will you teach us how you made that, Jacqui?*

After this round of mixing together, invite the children to continue mixing and painting, following their own paces and rhythms.

*I expect you'll create other intriguing shades of gray as you work. I'll be interested to see what colors you create, and how you use the gray, black, and white on your paper.*

*Notice when you're ready for a new sheet of paper. If you've been working with white paper, you might want to try using black paper. It'll be interesting to see how your gray colors look against a different background.*

As children paint, some will immerse themselves in the visual aspects of the black, white, and gray paint on black and white paper. Help them notice the contrasts between paper and paint, the sharp edges and the invisible distinctions between paint and paper.

*The white paint makes a path to follow into the dark black of your paper.*

*The black line on the white paper is like a shadow on the paper . . . It's like a door opening into a dark room.*

*The gray swirls on your paper remind me of rain blowing in the wind.*

Some children may explore the representational possibilities that the paint holds. Look with these children at the evocative lines and shapes, study their paintings with them, and offer technical support for their efforts.

> *The black background is such a contrast to the paint. Using white lines to create your painting helps it stand out in a powerful way.*

> *Small brushes work best for thin lines. Try a smaller brush for those details in your painting—it'll give you more distinct lines.*

When a child feels finished with a painting, coach her about how to work with a partner to lay the paper on the drying shelf or hang the paper on the drying rack. For suggestions on how to do this, see pages 32–33.

## CLEANUP

When children finish a painting session, they can slip their brushes and mixing trays into the bucket of water to soak until you or the children wash them. Mixing sticks can be tossed in the trash. Jars of black and white paint can be covered with lids, plastic wrap, or a sheet of clear acrylic, to be used again later.

## DOCUMENTATION AND DISPLAY

The story of black and white is easily overlooked, dismissed as unimportant, not as immediately engaging as color. Shades of gray evoke vagueness, a dusty irrelevance in the landscape of creativity.

But children's encounters with these colors and shades are rich, nuanced, and full of textural depth. The story of these encounters is a story worth telling.

As children work, take photos that capture the bold lines of color set against a contrasting background. Capture the first swirl of black into white as children mix the two colors. Photograph children's hands navigating the brush over the paper, their faces full of focused, curious attention.

Take notes about how the children describe the relationship between paint and paper. Aim to capture the poetry of the language that children use as they give voice to the striking beauty of these simple colors:

- How do the children describe the contrast between black and white? The mystery of white on white or black on black?

- What names do they give to the shades of gray that they create?

- What stories do the children tell as they work?

- How do the children collaborate, sharing observations and discoveries with each other?

- If children step into representational work, what is the focus of their painting? What images do these colors inspire?

As you gather images and prepare text for display, consider how you will call attention to the subtleties and to the striking boldness of black and white. You might use red paper to frame your text; the red contrasts sharply with the black and white, allowing those colors to step forward with strong voices. You might frame the children's paintings to call attention to the layers of color: black paper behind the white paper, white paper behind the black.

There is a long lineage of art made from black and white. Twentieth-century artist Piet Mondrian, for example, emphasized the interplay of black lines with white in his paintings. And shodo, the art of Japanese calligraphy, makes striking use of black ink on white scrolls. As you create a display of the children's black-and-white paintings, consider including a few prints that locate the children's work in the larger context of art concerned with black and white (you can find images of these artists' work on the Internet, as well as at museum gift shops).

January 24

Sinclair moved her brush with careful deliberation. She extended a black line from one side of the paper to the other. Then she painted a parallel white line alongside the black, following the black line's subtle curves, dips, and peaks. Her hands moved with precision, grace, and quiet concentration.

## WAYS TO BUILD ON THIS EXPLORATION

You might use black and white paint and paper:

- when children are exploring lines, using a variety of tools for making lines on paper: twigs, feathers with their shafts cut at an angle, toothpicks, string;

- when children are exploring the idea of negative images;

- when children are investigating shape and silhouette.

What did Sinclair see as she laid first the black and then the white line on the paper? What meaning did the work hold for her? The lines divided the paper. The black line broke open the white expanse, while the white line both underscored and softened the black line. Sinclair moved her brush with slow steadiness; her attention and grace reminded me of a Zen monk, inscribing calligraphy prayers on a scroll.

The bold contrasting lines invite meditation, stillness, awareness. Black and white are potent colors. They call attention to line, to the edges of shapes. Their starkness helps us see deeply.

# TEMPERA PAINTS

Red blends into yellow and a new color is born. No magic, no machinery with hidden parts, no unpronounceable chemicals. Red blends into yellow and, simply and astonishingly, there is orange. When children work with tempera paint to mix and create color, they step into the arena of mystery and discovery.

### MATERIALS FOR THE EXPLORATION

- clear glass or plastic jars with lids or with a sheet of clear acrylic that covers the whole set of jars: 25 or 30 jars should be plenty for four or five children

- red, yellow, blue, and white tempera paint (consider putting it in squirt bottles like the ones used in restaurants for ketchup and mustard)

- craft sticks for mixing paint

- paintbrushes in a range of sizes—enough for each child to use six or eight brushes

- heavy white paper for painting

- notepaper for each child, perhaps on a clipboard

- a set of colored markers for each child: red, yellow, blue, white, orange, green, purple, brown

- a drying rack or shelves for finished paintings

### MATERIALS FOR THE CLEANUP

- a bucket of water to soak brushes

- a trash can for craft sticks

- butcher paper or a clear or neutral-colored plastic tablecloth

## SETTING UP THE STUDIO

Each child's work space around the table can be empty at the outset. Consider covering the table with butcher paper or a plastic tablecloth, as there will likely be drips and splashes of paint.

Gather the materials in the center of the table: the squirt bottles of paint, empty jars, craft sticks, and paintbrushes (you can stand the sticks and brushes into jars or clay pots). If space is tight, place the materials on a shelf or small table set within easy reach of the worktable.

Keep the notepaper, colored markers, and paper for painting handy, but out of the way at first; you won't need them right away.

Make sure the drying rack or drying shelves are easily accessible.

Set a bucket of water near the table for soaking brushes, as well as a trash can for the mixing sticks.

## EXPLORING AND CREATING

### Mixing Colors

Welcome the children by giving them the big picture of this exploration.

*We're going to use tempera paint to make colors that we can use for painting. We've got the primary colors: red, yellow, and blue. And we've got white. We'll mix the colors in jars, and keep the jars of new colors in the studio to use for painting.*

If the children have been developing a repertoire of knowledge about how to create secondary colors, revisit their collective understandings.

*You've been figuring out how colors are made. You've experimented with fingerpaint, with*

*paint at the easel, and with cornstarch and colored water. What do you remember about how red, yellow, and blue make new colors when they mix together?*

If the work with tempera paint falls early in the children's investigation of color, suggest that the children approach their work as research.

*We can experiment with red, yellow, blue, and white today. We'll be scientists and artists, making important discoveries about these colors.*

*Let's make notes today about what we figure out about these colors. I've got paper and markers for us to use to write down and draw our discoveries.*

For children who are veteran color mixers as well as for children who are new to this undertaking, tempera paint holds its own challenges and satisfactions. Do a few rounds of experimentation with mixing the tempera paints as a group before launching children into their own investigations.

*Let's try mixing two colors. Which colors shall we try? Choosing two colors is the first step in mixing tempera paint.*

With the children, choose two colors from the four squirt bottles.

*We mix tempera paint in jars to make new colors. So we need an empty jar and a stick for stirring.*

Gather those tools as you explain this.

*There are strong, dark colors and light, weak colors. Blue is the darkest and strongest of the primary colors. Red is next-strongest. Yellow is next. White is the lightest, weakest color of all. Blue—red—yellow—white. That's the order, strong to weak.*

Together with the children, create a simple sketch to illustrate this. Using the markers and notepaper, you might draw a long, thick, heavy line of blue, a smaller, shorter, thinner line of red, a small, short, thin line of yellow, and a tiny line (or outline) of white. The children may have other suggestions for ways to record this information. Keep this illustration handy

so that you and the children can refer to it during your work with tempera.

*Let's start mixing the two colors we chose. We'll start with the weaker one.*

Refer to the notes you made together to determine which one of the two colors is the weaker one.

*I'll squeeze some of the weaker color into the jar. Now I'll add just one drop of the stronger color. Do you have predictions about what will happen when the stronger color meets the weaker color?*

Leave some space for the children to contemplate the possibilities. Invite their reflections.

*Why do you suppose that will happen? Have you seen that happen before?*

*Now we stir the colors together and notice what happens.*

Use a stick to stir the colors together.

*What do you notice? How is the weak color changing? What happened to the strong color? This is just what we predicted. / This is different than we predicted.*

*We can stop now, and let the paint be just this color, or we can add another drop of the strong color. What shall we do?*

Together, make a decision. Some of the children may want to stop, preserving the new color, while others, curious and eager to move deeper into the magic of creation and change, may press for adding more color. You can certainly leave this first color as it is, and start a new jar, replicating the process: about the same amount of the weak color, one drop of the strong color, mix and stir—then onward from there, adding more of the strong color to this second jar, creating a deeper, darker color to contrast with the first jar's shade.

*When the color is as dark as we want it to be, we stop adding the strong color. We made our new color!*

Do a couple of rounds of paint mixing as a group, narrating the process, demonstrating techniques,

facilitating observation, and inviting reflection and collaborative decision making. During this process, make notes with the children about the colors you're creating, tracking the colors you've mixed and the new colors you've created. You might use the colored markers and notepaper to chart a list of mathematical equations: a line of red + a line of yellow = orange. Or you might use the paint itself: a swirl of red paint meets a swirl of yellow paint, and in their intersection, orange.

This collaboration certainly provides a foundation in the technique and process of mixing tempera paint. But it also holds the joy of a shared adventure, the held-breath excitement of discovery, the intellectual engagement of venturing a hypothesis and testing a prediction. And it reverberates with the mysteries of color. Red, yellow, blue, and white come together, holding their own identities intact for a moment, then melting together into a new, shared identity.

After two or three rounds of collaborative mixing, invite the children to create their own palettes. Suggest that each child create four or five colors to make a simple palette; invite them to choose four or five jars, and four or five mixing sticks. Remind the children of the process.

> *Choose two colors. Start with the weaker color. Add one drop of the stronger color. Stir it together, and study the new color: Is it as dark as you want it to be? If you want it to be darker, add another drop of the stronger color.*

As the children dive into their color mixing, they'll be asking each other to pass the squirt bottles, jars will be bonked and some will spill, drippy mixing sticks will be dropped onto the floor. Welcome this swirl of energy as the sound and motion of researchers and artists, engaged in the joy and effort of creation and discovery.

You might offer each child some notepaper and a set of markers, suggesting that he make notes about what he discovers as he mixes the paint.

> *You can make marks on your notepaper to help you remember what you discover. We can use your notes the next time we mix tempera paint.*

Or, you might move from child to child with a clipboard and a set of markers, recording each child's discoveries on a collective data sheet.

## Painting

Eventually, the jars will hold an array of colors, shades, and hues. It's time to paint! With the children, clear the squirt bottles, notepaper, and markers off the table. Toss the used mixing sticks into the trash, and clear the unused ones off the table. Have the children choose a paintbrush for each jar. Set the stack of painting paper in the center of the table, and offer a sheet to each child. There'll be some arranging to do as each child creates a work space around her paper; help her situate her jars of paint to the upper left of her paper if she's left-handed, and to the upper right of her paper if she's right-handed. Then give the children a couple of simple reminders about painting with tempera.

> *Dip the brush in the paint. Wipe the drips on the edge of the jar. Paint on the paper. Dip— wipe—paint.*

Demonstrate as you describe these steps.

> *Let the hair of the brush stand up. That way, you're the boss of the brush.* (For more description of this idea, see page 37.)

> *Keep the paints strong and clean. Every color has its own brush. If you notice that one of your brushes gets other colors on it, you can get a new brush.* (It doesn't work very well for children to rinse tempera paint off brushes and keep using them, as the water that inevitably remains in the brushes after a rinse tends to dilute the paint. It's easier just to get a fresh brush.)

Then, onward into painting!

As children work with their paints, invite their reflection about the colors they've created.

> *Look at that pale, lemony yellow! Is that how you imagined it would look when you made it? Does it look different on paper than in the jar?*

> *That's a luscious deep red. What does that color remind you of? What name would you give that color?*

> *What would that color sound like, if it had a sound? What would it smell like? What would it taste like?* (Make sure the children don't actually taste it!)

Some children will immerse themselves in the movement, form, and complexion of color on paper, while other children will use the colors they created to represent an object, an experience, a place. When a child moves toward representational painting, offer him a bit of coaching about brushes.

*Small brushes are good for painting thin lines and making shapes. Big brushes are good for thick lines and spreading color. I'm thinking that a thin brush would work best for you right now, because you're trying to paint lots of details on your house.*

*Hold your brush just like you hold a pencil or marker for drawing. A paintbrush is another tool for making lines that tell stories.*

When a child finishes a painting, invite him to work with a partner to hang it on the drying rack. For suggestions on how to do this, see pages 32–33.

## CLEANUP

At the end of the painting session, ask children to put the brushes into the bucket of water, where they can soak until you or the children wash them. Cover the jars of paint as tightly as possible: seal them with their lids, or set them close together on a shelf and cover the whole group with a sheet of clear acrylic. These paints will become part of your studio, a palette to which children can return again and again for their painting.

As you consider where you'll keep the jars of paint in the studio, think about how they can continue to nurture children's relationship with color. Where will children best be able to see the jars of paint? How will you group the jars? You might arrange the jars as a color wheel, on a carousel spice rack on the shelf, spinning red to yellow to orange, green to blue to lavender and indigo. You might arrange the jars in a simple straight line tracing the color spectrum, with a finger's space between each one. You might create a flowing, curving wave of jars, evocative of the movement of paint on paper. You might group the jars into a dense pool of color, in a tightly woven dance from one color to the next. The simple decision about storage holds many possibilities for delight, for beauty, for invitation.

## DOCUMENTATION AND DISPLAY

Creating color is an act of wizardry. Children join the lineage of alchemists as they drop one color into another, staring into the jar, alert to the smallest shift in identity. In their conjuring of color, children turn toward mystery.

This mixture of magic and science is the story of mixing tempera paints. To tell this story, take photos that capture children's faces as they lean close to the colors they're mixing. Capture that first swirl of one color inside another. Create images that speak of anticipation, delight, surprise. Make notes about children's exclamations of discovery; their spoken observations, questions, and stories about the colors they create.

In your documentation and display, complement your photos, observations, and reflections about the children's experience with questions and invitations for the readers.

*This was an encounter with mystery and magic for the children. Where in our adult lives do we encounter mystery like this, things we observe that we don't really understand? How can that help us understand the children's experience with these paints?*

*How might these children see the world differently after creating color?*

For your display, create posters with bold, solid blocks of the colors that the children created, leaving empty space around the color blocks. You might include some of the words that the children used to describe the colors they created. Invite viewers to write in the empty spaces.

*What does this color remind you of?*

*What might you name this color?*

*What stories does this color tell?*

When viewers add their thoughts to the display, share those ideas with the children. Your display can launch a dialogue about color and its meanings among the children and adults who see the display.

December 3

melia entered the studio eager to paint, but hesitated once she'd put on her smock and set out a large piece of paper. "I'm thinking about what to paint," she told me, as she studied the empty white paper.

After a few silent minutes, melia nodded, then got a jar of rosy pink-red and a jar of mossy green paint from the shelf. We'd made the colors last week, blending primary colors and white to create a broad palette of color and hue. melia set the jars near her paper, chose a small-sized paintbrush for each jar, and began to paint with quiet intensity.

She moved the brush slowly across the paper, sketching the outline of a design then filling it in with color. She worked in silence, glancing away from her painting only to locate the jar of paint to replenish her brush. After a few minutes, she added two more jars of paint to her work space: deep orange-yellow and soft, pale blue.

melia created a detailed painting, full of spirals, tiny blades of grass, a vibrant sun set in a sparkling sky unmarred by clouds,

and tiny pink flowers blooming everywhere. In time, the tiny pink flowers became "pink dog footprints." melia's attention shifted to an exploration of color and movement as her painting became a study of pink!

## WAYS TO BUILD ON THIS EXPLORATION

You might use tempera paints:

- when children are investigating transformation;

- when children are exploring emotion and mood: mix colors to capture a particular emotion, or to reflect the change from one emotion to another;

- when children are playing with metaphor and poetry: explore image and experience by associating colors with sense experiences:

  brown looks like . . .

  green smells like . . .

  red sounds like . . .

  pink tastes like . . .

  white feels like . . .

# WATERCOLOR PAINTS

Watercolor paint flows onto paper in a splash of vibrant color. It lays silky, dense color on heavy paper, awakening the eyes. It is both intensely sensual and quite specific in the skills it requires.

## MATERIALS FOR THE EXPLORATION

- one clear plastic or glass cup or jar containing water for each child

- water (if you don't have a sink in your room, use a pitcher of water)

- paper towels

- thin paintbrushes (try sizes 2 and 4)

- watercolor paper: you might cut each sheet in half, as a full-sized sheet of paper can feel like a daunting amount of space

- liquid watercolor paint (liquid paint is much bolder and stronger than traditional dry blocks of watercolor paint) in clear plastic or glass baby food jars, small paint trays, or similar sorts of containers for the paint

- a drying rack or shelves for finished paintings

## MATERIALS FOR THE CLEANUP

- a bucket or tub with shallow water to clean brushes, cups or jars, and paint containers

- an empty bucket, tub, or sink to collect dirty water

- a trash can

## SETTING UP THE STUDIO

Arrange the table with "place settings," just as you would for a lovely dinner party for dear friends. Each place setting should include:

- a piece of watercolor paper;

- a paper towel, folded over to increase its thickness, set like a napkin next to the watercolor paper; if a child is right-handed, this goes on the right side of the paper, and if a child is left-handed, this goes on the left side of the paper (if you're not sure which hand a child uses, offer him a brush and watch which hand reaches out to take it);

- a cup or jar of clear water, set at the top of the paper towel;

- a brush laid on the paper towel;

- a spectrum of liquid watercolor paints in small, baby-food sized jars or in a small paint tray on the outer edge of the paper towel.

Set each place in the same way to create a feel of simplicity, quiet, and harmony among the elements: each brush laid at the same angle on the paper towel, the cup of water at the same spot on the towel's upper edge, the paint colors arranged in the same sequence. This care with details communicates that you honor the people who will gather around the table and the work that the table will hold.

Keep a stack of watercolor paper nearby. If the table has room, you might set this in the center of the table.

Children will need to refresh the rinse water in their jars periodically. If your room doesn't have a

sink, set an empty bucket or tub near the table for the children to pour out their dirty water. Place a pitcher of water in the center of the table to refill the jars.

Children will also need fresh paper towels every so often. Make sure you've got a stash handy.

Set your drying rack close to the table, in a place where children can easily access it. Be sure there are plenty of clips.

Have a separate bucket or tub with shallow water handy for cleanup. Children can put their brushes, paint trays, and water cups in this bucket as they finish their painting.

# EXPLORING AND CREATING

## Exploring Watercolor Brushes

Before children begin to paint, introduce the tools and the process.

Introduce the tools by inviting children to investigate their dry paintbrushes. For instructions on how to do this, see page 37.

## Establishing a System for Painting

Next, introduce the other materials.

> *You've got a cup of water to keep your brush clean, and a towel for drying your brush. You've got paints that are clear and strong. You've got special thick paper that's made especially for watercolor paint, called watercolor paper.*

Then, introduce the process. You may want to create a little chart illustrating each step in the process to use as a visual guide.

> *There's a special way to use watercolor paint. This will let you be the boss of the paint. Here's how it works: Water—towel—color or clear?— dip in paint—wipe the drips—paint on paper.*

This—or a shorthand version—will become a little refrain to repeat again and again; the children will learn it and make it their own, using it as a song line to carry them into watercolor painting.

Demonstrate each element of the refrain as you say it.

> *Water.* (Dip your brush in the jar of water and swirl it gently.)

> *Towel.* (Wipe your brush lightly on the paper towel.)

> *Color or clear?* (Examine the paper towel.) *Did the brush leave any color on the towel? If there's color, dip it back into the water because it needs more washing. When it doesn't leave any color on the towel, the brush is ready for paint.*

> *Dip in paint.* (Dip your brush into a jar of paint.)

> *Wipe the drips.* (Touch your brush gently to the edge of the jar of paint to snag any drips.)

> *Paint on paper.* (Move your brush across the paper.) *Remember to let the hair of the brush stand up!*

Demonstrate this process a couple times, then invite the children to do it with you. Move through each step slowly at first, pausing to offer details about each step and reminders about letting the hair of the brush stand up, and to leave space for children's observations and comments. Each time you move through the sequence, repeat the refrain: "Water— towel—color or clear?—dip in paint—wipe the drips—paint on paper." If you repeat this refrain out loud, using the same words every time, the children begin to internalize it. When we learn a language, we focus our early attention on mastering the sounds, the inflections, the accents; eventually, these disappear from our conscious awareness as they become integrated into speech. When children learn the language of watercolor paint, they first pay careful attention to each step in the process: dipping the brush in paint, catching the drips, moving the brush across the paper, cleaning the brush. Eventually, they master the process, and their attention shifts from the mechanics to the expressive possibilities.

Coach children to keep their brushes clean so the paint stays strong and clear. The delight of watching watercolor paint bring paper to life can carry the children into fast movement and shortcuts. Gently remind them to clean the brush between each color.

> *Remember: water—towel—color or clear? We do that every time we change colors.*

*When you keep your brush clean, the paint in the jars stays strong and bright and clear. When your brush gets dirty, the paint in the jars gets muddy and dull.*

## Painting

After this initial emphasis on the tools and the sequence of steps, invite children to paint. Stay close, partnering with children individually to whisper the refrain with them, to coach them about touching the brush gently to the paper, and to notice and enjoy with them the colors' impact on the thick paper.

*Do you notice what's happening at the place where the blue meets the red? What are these two colors saying to each other, there where they meet?*

*The edges of the lines sometimes get blurry on the paper. Do you see that happening with your paint?*

*I notice that when I touch my brush to the paper really lightly, the lines I make are really thin. And when I touch my brush to the paper more firmly, the lines are thicker.*

*You might experiment with moving one color across another color. What happens if you fly a yellow bird across a sky of blue? A blue butterfly over a green park? A brown sparrow over tall buildings? A black raven past a red-rock canyon?*

Children's paper towels will become soggy after a while. Coach children to notice when they need a new paper towel.

*Your towel is full of water and color. Looks like you don't have much clean, dry space left for wiping your paintbrush. Time for a new towel!*

Children can toss their wet towels into the trash and fold a new one to take its place. Coach children about how to fold and arrange their towel.

*If you fold your towel in half, then it can hold more water. Set your new towel between your paper and your paint, and close to your rinse water. Then you can move your brush from water to towel to paint to paper.*

Similarly, children's rinse water will become muddied, thick with color, and not very useful for cleaning brushes. When you see that happening, coach children about refreshing their water.

*Your water is full of color! Each time you dip your brush in the water, the paint slips off and stays in the water. It's harder to clean a brush when the water is full of color. Let's get fresh water for your rinse jar.*

*Pour your rinse water into the sink/bucket. It's a good idea to clean your jar by rinsing it before you fill it up again: put a tiny bit of water into the jar and swish it around, then dump that water out into the sink/bucket. Then fill your jar with fresh, clear water.* (If you don't have a sink, children can fill their jars from a pitcher of water.)

As children paint, notice the quality and focus of each child's interactions with the watercolors. This will help you facilitate her work. A child may be captivated by the way the paint changes from liquid in the jar to a solid line on paper, or by the way the color soaks into the paper, or by the change in color when it is lifted from the jar to the paper. She may be fascinated by the blending and blurring of color on the paper.

A child immersed in the sensuousness of color, texture, and movement may fill her paper with paint until it threatens to dissolve or tear. Offer her fresh paper so that she can continue her investigation of the identity of watercolor paint.

The small watercolor brushes lend themselves to representational lines. A child may be taken with the possibilities for creating images that hold a story, capture an experience, or reflect a relationship. He may experiment with how to create form and shape, or with how much space to leave around a line so that the lines don't blur into each other. He may need coaching about strategies for using the brush. Or he may welcome an invitation to step back from the painting and study it from a new perspective. Offer guidance with a gentle hand that honors both his desire to master this new medium and his vision for his painting.

When a child finishes a painting, help her evaluate whether it's ready to be moved off the table. Often, there will be a small puddle of paint on the paper.

This will run and drip when the paper's lifted, which can be awfully discouraging. Offer children strategies for managing these puddles.

*I see a tiny pool of watercolor paint on your paper. When you lift up your paper, that pool will turn into a river and wash over your painting. There are a couple of things you can do. You can use your brush to spread the paint across the paper until it's not a pool anymore. Or you can dip the edge of a paper towel into the pool and let the paper drink up the paint.*

On pages 32–33 there are suggestions for ways in which children can partner with each other to hang a painting on a drying rack. You can use these strategies with children to help them navigate their watercolor paintings onto the drying rack.

## CLEANUP

Children can pour the water from their rinse jars into the sink or bucket. If you won't be reusing the paint in the jars or trays, children can empty the paint into the sink or bucket, which makes a gorgeous swirl of color. Brushes, rinse jars, and paint jars or trays go into the bucket or tub with shallow water, where they can soak until you or the children wash them.

## DOCUMENTATION AND DISPLAY

Your written documentation and display can tell the story of how the children learned to speak the language of watercolor paint. This story includes the practicalities of tools and the step-by-step process of using watercolor paint, the sensuousness of color as both liquid and solid line, and the images formed by line and color as children represent their experiences and relationships.

Take photos that tell this story: photos of children's hands as they touch the brush to the paper, of children's faces in expressions of concentration, of the color filling the paper. A close-up photo of the first bold brushstroke of paint on paper can be stunning, as can a photo of paper full of overlapping colors. Photos of children's completed paintings tell the story that there are many ways to use watercolor paint: some children's paintings will be wild swirls of color laid on top of each other, some will emphasize lines surrounded by space, some will be concrete and representational, and some will organize the color into patterns and mosaic-like designs.

Take notes about what you see as the children paint:

- How does each child approach the initial learning about the tools and the process?

- Do the children tell any stories as they paint? Stories sparked by the color, texture, or movement of the paint? Stories related to representational images they're creating?

- How are children moving their hands and arms? Bold, decisive motions? Careful, delicate gestures? Tentative or curious brushstrokes?

- How do the children collaborate, sharing observations and suggestions with each other?

When you display the children's paintings, create a neutral background for each painting. Put a piece of black paper behind each painting to frame it, sized an inch or so bigger than the painting itself. Include photos of the children at work in your display; print these as large as possible, and consider framing them with black paper, as well. The text for the display can include your observations, children's words, and comments that invite reflection by the viewer.

*Look at the children's hands in these photos. They are the hands of apprentices gaining mastery and confidence.*

*There are many ways to use watercolors. When you look at the range of paintings, what do you notice about how the children use the watercolors?*

*The first stroke of color on white paper is a strong commitment. What feelings are stirred in you as you look at these images of children's first brushstrokes?*

October 23

Watercolor paints in the studio ... Drew immersed himself in the flow of color across the paper, watching it seep into the paper and encounter other colors.

I'd welcomed children into the studio with an invitation: "This studio work is about becoming artists with watercolor paints and paintbrushes. The first part of this work is learning about the tools. The second part is painting, and finding what you especially enjoy about how color moves on paper."

Drew accepted this invitation with a grin and a nod, settling into a work space with a cup of water, a paper towel, a fine-haired paintbrush, and a paint tray of watercolor paints. Together with the other children in the studio, we practiced how to "be the boss of the brush" by holding the brush gently and touching it to the paper lightly so that "the hair of the brush stands up." We also learned a simple refrain for working with watercolor paint: "Water—towel—color or clear?—dip in paint—wipe the drips—paint on paper." This rhythmic process opens up watercolor painting for the children, allowing them to create stunning designs with clear, bold colors; control of the paintbrush; and a pace that invites awareness and reflection.

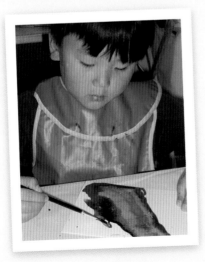

Drew initially concentrated with methodical attention to the process of painting, figuring out how to carry paint from jar to paper without drips, how to negotiate the brush's movement across the paper, and how to clean the brush. Once he'd developed an ease with these skills, Drew turned his attention to the paint's colorful flow on the paper. Brushstroke by brushstroke, Drew layered color on the thick watercolor paper: bold red flowing into yellow, yellow to turquoise, then soft green, rich magenta, deepest blue. His face was intent and full of wonder.

## WAYS TO BUILD ON THIS EXPLORATION

You might use watercolor paints:

- when children are involved in representational work, such as still-life portraits or field sketches;

- when children are investigating an element of the natural world, such as leaves in autumn, flowers in spring, or the sky at sunset in winter.

# OIL PASTELS AND CHALK PASTELS

Oil pastels and chalk pastels offer an intensity and a variety of color not found with typical wax-based crayons and standard-issue sidewalk chalk. Oil pastels are made of a mixture of pigment and oil, while chalk pastels are pigment held together with a dry binding agent. Both oil and chalk pastels hold rich possibilities for layering and blending colors. And they are both texturally engaging.

The process of exploration is very similar for oil pastels and chalk pastels, so I've grouped them together here. However, I suggest that you introduce them one at a time, rather than offering them at the same time, as they have unique textures and they move in very particular ways. After children are comfortable working with each of these media, you might offer them at the same time—perhaps while working on a mural or on still-life portraits.

### MATERIALS FOR THE EXPLORATION

- oil pastels/chalk pastels in a full range of colors
- white, heavyweight, textured paper, such as watercolor paper or card stock
- liquid watercolor paints in jars or small paint trays
- substantially sized paintbrushes—not the fine-tip brushes that are used for detail, but brushes that spread a solid, thick swatch of color
- one clear glass or plastic cup or jar containing water for each child
- water (if you don't have a sink in your room, use a pitcher of water)
- paper towels
- pencil erasers (optional)
- a covering for the table, such as white butcher paper
- a drying rack or shelves for finished paintings
- **for chalk pastels only:** empty trays to catch chalk dust (two children can share one tray)

### MATERIALS FOR THE CLEANUP

- paper towels
- a trash can
- a bucket or tub with shallow water to clean brushes, cups or jars, and paint containers
- an empty bucket, tub, or sink to collect dirty water
- a tub or bucket full of water or sink for rinsing/washing hands

## SETTING UP THE STUDIO

Consider covering the table with white butcher paper, as both oil pastels and chalk pastels can leave behind shavings and residue that can be a nuisance to clean off a table.

At each child's work space, set a piece of thick, textured paper. Set a paper towel or two next to each child's paper.

Oil and chalk pastels are typically packaged in trays, carefully arranged in a spectrum to highlight the relationships among colors. Set the tray, uncovered, in the center of the table, to call attention to the vivid colors.

**For chalk pastels only:** Put an empty tray between children's work spaces; two children can share one tray. These trays are to catch chalk dust as the children shake it off their papers.

Prepare the watercolor paints and the materials that go with them: brushes, cups of water, paper towels. Set these to the side, perhaps on a nearby shelf or table, so that they're ready to go but out of the way initially.

Set up the supplies that you and the children will need to clean up the watercolor paints; for details, see the "Watercolor Paints" section on pages 46–50.

Make sure the drying rack or drying shelves are easily accessible to the children.

If you don't have a sink in your room for hand washing, set a bucket of water near the table, as well as a stack of paper towels and a trash can.

## EXPLORING AND CREATING

Welcome the children by calling attention to the beauty and order of the oil pastels/chalk pastels.

> *Look at these drawing tools, lying side-by-side in the tray. One color leads to the next color. Red leads to orange, orange leads to yellow . . . The colors are like a rainbow, waiting for us in the tray.*

> *These beautiful drawing tools are called oil pastels. They're like cousins to crayons. / These beautiful drawing tools are called chalk pastels. They're like cousins to sidewalk chalk.*

Invite the children to notice the texture and density of the paper.

> *We use oil pastels/chalk pastels on paper that's especially thick. Check out the paper at your work space. What do you notice about how it moves? How does it feel? How is this paper different from our regular drawing paper?*

After the children have explored the feel and weight of the paper, invite them to take up the oil pastels/chalk pastels.

> *I'm curious about what we can discover about the oil pastels/chalk pastels.*

> *Let's pass the tray of pastels around the table. When it comes to you, choose two or three colors that you'd like to start exploring.*

> *We'll keep the tray of oil pastels/chalk pastels in the center of the table so that when you're ready to try another color, you can take a pastel from the tray. Let's keep the pastels in the tray, so that everyone can take turns with them.*

Each child ought to have at least two or three pastels with which to get started; encourage children to choose colors that are somewhat different from each other so that they'll be able to track the colors and the changes in the colors as they use them on paper

(red, pink, and green, for example, are better choices than pale pink, bright pink, and rosy pink).

When each child has a small handful of pastels, set the tray in the center of the table; every so often during the exploration, you'll probably need to help children scoop up extra pastels that are accumulating at their work spaces and tuck them back onto the tray so that a wide range of colors is accessible to everyone (when you do this, don't worry about maintaining a particular order or arrangement on the tray).

## Exploring Line and Texture

One of the delights of both oil pastels and chalk pastels is their textural relationships with paper. The thick, rough paper catches at the pastels and creates a drag, or pull, on them. Chalk pastels initially highlight the weave of the paper, as the chalk settles into the tiny "troughs" on the paper; as more layers are added, and the chalk becomes thicker, the weave is filled in and the texture of the paper changes. Oil pastels have a silkier, slicker feel as they move across the paper, which is a striking contrast to the paper's texture; the layers of oil pastels become increasingly soft and fluid, with a tangible density to them. As children begin to work with the oil pastels/chalk pastels, invite them to notice the textural qualities of the pastels' movement on the paper.

> *How does color move on this thick paper?*

> *Notice how the color looks on the paper. Is it smooth? Bumpy? Rough? Silky? Can you see the lines of the paper inside the color?*

> *Try closing your eyes and drawing on your paper. That'll help you feel how the pastels move on the paper. What do you notice?*

Invite the children to experiment with ways to use the pastels to make lines.

> *What happens if you use the flat end of the pastel?*

> *Try using the skinny edge of the pastel. What kind of line does that make?*

> *What sort of line can you make with the long side of the pastel?*

> *You might experiment with holding two pastels at one time. What sorts of lines does that make?*

## Blending, Erasing, and Etching

The color of oil pastels and chalk pastels is rich and dense. Both blend easily, giving birth to brilliant, striking colors. Encourage the children to explore the blending of colors.

*What happens when you put one color over another color?*

*Look where two colors are next to each other. What happens if you rub them together, so the lines get blurry where they meet?*

Invite the children to blend the color with their fingers (some children will want their paper towels handy to wipe off their hands as they work).

*Try blending the pastels with your fingers. What does that feel like on your fingertips?*

The children will likely find their way into the many possibilities held by pastels, but you can suggest a few techniques.

Encourage children to erase the color by rubbing it away or by using a pencil eraser (erasing works more easily with chalk pastels, but is also possible with oil pastels). Or invite children to etch into the color.

*You can use your fingernails to make lines in the color. You can draw with your fingernails!*

*Try putting one color on top of another color. Then make a scratch in the top color. What do you see inside?*

You can offer other materials for etching; possibilities include paper clips bent into straight lines, handles of thin paintbrushes, twigs, or the shafts of feathers.

**With chalk pastels only:** As the children work with chalk pastels, they'll generate a fair amount of chalk dust. This can quickly become a frustration as it fills their paper and makes it challenging to add new color or design to the paper. Coach children about how to pour off the chalk dust onto the empty trays on the table (there ought to be a tray between two children, so that every child can reach a tray without getting up). Demonstrate as you describe the process.

*Lift your paper up—keep it flat while you lift it! If you tilt it before you get to the tray, the dust will slide off onto your work space.*

*Hold your paper over the tray. When the paper is over the tray, tip it to make a slide. The chalk dust can slide down the paper onto the tray.*

*Give your paper a gentle shake to get the last bits of chalk dust off.*

Chalk dust can spark sneezing and itchiness, so it's best to aim for a fairly short opening exploration of chalk pastels.

## Using Watercolor Paint with Pastels

After this initial investigation of the qualities of pastels, offer children watercolor paints to use with the pastels. Suggest that the children gather up the pastels and put them in the tray at the center of the table to make room for the watercolor paints. If children's hands are particularly full of color, invite them to rinse their hands at the sink or in the bucket of water so that they're ready to dive into the work with watercolor paints.

**For chalk pastels:** Wipe chalk dust off the table with a damp sponge or damp paper towels and stack the trays of chalk dust off to the side to clean at the end of the exploration. Clean up the chalk dust yourself, rather than asking the children to help, to minimize their exposure to the chalk dust.

With the children's help, arrange the watercolor paints at each child's work space; for details on how to do this, see pages 46–47 in the "Watercolor Paints" section. The child's paper, on which he's been experimenting with pastels, anchors his work space. Leave the pastels in the center of the table so the children can continue to use them.

Once the table has been rearranged, invite the children to investigate the dynamics of watercolor paints and pastels.

*Artists sometimes use two sorts of media together. Let's try using watercolor paints with pastels and see what we discover.*

*You can paint right over the drawing that you did. What happens when the paint meets the pastels?*

Coach the children about how to brush the paint across the paper, moving over the surface of the pastels. Encourage children to move between watercolor paint and pastels.

*Now there's paint on the paper, on the part of the paper that used to be empty. What happens if you draw with pastels on that part of the paper?*

*How do pastels move on the wet paper? Is their color different on the paint than on the plain paper?*

Keep an eye on the children's paper. It'll likely reach a place of full saturation—and beyond that, it'll tear and disintegrate if children continue to add paint and rub pastels onto it. When you see a child's paper nearing saturation, suggest that the child finish her work on that sheet.

*Your paper is full of color from pastels and the watercolor paint. It'll likely start tearing soon. What would you like to do to finish your work on that paper? We'll get a fresh piece of paper when you're done.*

## CLEANUP

As children finish their exploration with pastels, invite their help in gathering the pastels onto the tray at the center of the table. **With chalk pastels only:** An adult should clean up the chalk dust on the trays; slide the dust into a trash can, and rinse the trays in a sink.

Children can clean up the watercolor materials; for details on how to do this, see page 49 in the "Watercolor Paints" section.

Children's hands will be a jumble of color, with chalk dust or the greasy imprint of oil pastels. If you don't have a sink in the room, ask children to rinse their hands in the bucket of water before making their way to the sink that they'll use for a more thorough washing.

## DOCUMENTATION AND DISPLAY

With oil pastels and chalk pastels, children explore color with their fingertips as well as their eyes, feeling its slick smoothness or its grainy dryness. Pastels add intriguing texture to color, offering a new way to experience color.

Oil pastels and chalk pastels demand awareness of texture as well—the surface of the paper on which they are layered. Children explore the rough density of the paper, which contrasts with the smooth surface of more typical drawing paper and the paper in books.

In your written documentation and display, tell the story of children's visual and tactile immersion in color. Take photos that capture the textures and movement of color: a child's first line of oil or chalk pastel on her paper; a close-up photo of a child's fingertips blending color on the paper; a brushstroke of watercolor paint across a page marked with oil or chalk pastels. Track a child's exploration with a sequence of photos that capture the unfolding extravaganza of color: the first stroke of a pastel, colors layered and blended, watercolor paint transforming the images. Photograph a child's paper before and just after the paint has been washed over it.

Make notes about children's reflections and discoveries:

- What words do children use to describe the texture of the paper? The texture of the pastels?
- What do the children notice about the colors? How do they create new colors with the pastels?
- How do the children use their fingers with the pastels?
- What captures the children's attention when they add watercolor paints to their drawings?
- How do the children share their discoveries with each other?

In your display, create a sequence of full-sized photos that tells the story of one sheet of paper, beginning with the plain white paper and evolving into a colorful montage of lines, shapes, and textures. Call attention to the knowledge held in children's fingertips by using photos of their hands blending color and etching lines in the color. Invite viewers to notice the knowledge in their own hands by hanging a piece of the textured watercolor paper on the board and making a simple suggestion.

*The children used their fingertips to understand the paper and the pastels. What can you discover about this paper by touching it with your eyes closed?*

July 28

Sam, Maria, Brooke, and Liliana gathered in the studio this morning to explore the possibilities of oil pastels. We worked on thick watercolor paper ("roughish paper," Maria called it), which provides a strong base for the dense, silky color. The bold color of oil pastels is complemented by their smooth, thick texture. During this first encounter with these new materials, the children investigated the relationship between the pastels' color and texture, exploring the ways in which pastels can be layered, blended, and scraped away to reveal what's below the surface.

Sam, Maria, Brooke, and Liliana began by spreading color across the paper—decisive strokes, quick back-and-forth swoops, careful laying-down of lines.

Maria: "I started with pink and now I'm putting blue over it. The blue changes on the pink!"

Sam: "It's going to get even cooler! Look at the color I made!"

Brooke: "I'm inventing colors—see, just hold two at the same time"

Sam: "You can smear it with your finger—watch this."

Liliana: "Hey! Scratch it! You can make a design with your finger, like lines."

Maria: "When I do that, pink shows through. It's under the blue, hiding. But when I scratched the blue, there was the pink."

After a long stretch of experimentation with the oil pastels, I offered the children watercolor paints. I wanted to call the children's attention to the way in which oil pastels resist water. Watercolor paint soaks into the paper, but pools on the oil pastels.

Sam plunged in with the paint, sweeping his brush across his vivid blue page: "Hey! It's making lakes on the drawing!"

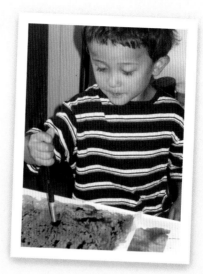

Maria watched Sam's work, then dipped her brush into the paint and ran it across her paper, from white paper across her oil pastel drawing back to empty paper: "You're right, Sam! The paint doesn't stick. It only stays on the paper where there's no color."

Liliana and Brooke began to paint.

Liliana: "It looks like a flickering light."

Brooke: "I put lots and lots of paint over it and it's still showing."

Maria: "When I paint on the paint, all the paint washed away. It goes into the paper and can't come out. But when I paint on the drawing, the paint just stays there."

The children experimented with using the pastels on top of the watercolors. Layer by layer, their designs grew increasingly dense with color and texture: thickly woven paper covered with soft watercolor wash and then layered with swirls of oily color.

Their work today was an introduction to this new art medium, one which we'll use often throughout the year to add color and texture to portraits and murals.

## WAYS TO BUILD ON THIS EXPLORATION

You might use oil pastels or chalk pastels:

- when children are exploring pattern, texture, and line: lay a sheet of paper over a shell, a leaf, textured paper, bubble wrap, or a woven mat, and rub with oil pastels or chalk pastels to uncover the texture of the object underneath the paper;

- to promote collaboration and negotiation: on a large sheet of paper, such as a length of butcher paper, invite children to draw images and then, together, to add a watercolor wash over their images;

- when children are working to illustrate a story or to represent objects or experiences.

# THREE-DIMENSIONAL MEDIA

Clay

Found Materials and Loose Parts

Wire

In our work with these art media, we strive to:

- honor the ways in which children take up lots of room in the world by inviting them to build and sculpt in three dimensions;

- affirm children's sense of power and efficacy by offering them physically demanding materials and by cultivating the skills needed to create in three dimensions;

- create opportunities for children who are drawn to construction and physical play to take up studio work, and challenge children whose primary focus is two-dimensional art (drawing, painting) to explore new perspectives in their art.

Clay, loose parts, and wire engage children's bodies as well as their senses. These are strongly physical media. Children's interactions with them are muscular: they press, bend, squeeze, twist, and tear. Their hands' sensitive understanding of texture, density, and malleability informs their interactions with these media.

Visually, these art media call attention to shape, line, and form. They require children to consider composition from multiple perspectives as they think about how the elements of a sculptural piece fit together.

Wire, clay, and loose parts invite a new way of understanding "art." Children tend to associate art with drawing and painting, and think of themselves as artists in relation to their enjoyment and skill with drawing tools. When we offer children three-dimensional media, we invite them into an expanded definition of art. Sculptural art media call out to children who spend lots of time building with blocks, tying knots in rope, wrestling, and shaping mud into castles. Their strong bodies and finely tuned tactile knowledge create an instant rapport with clay, wire, and found materials. When the children encounter these art media, it is like old friends meeting for the first time.

Three-dimensional art media also expand the possibilities for children who are already skillful with drawing and painting. These art media challenge children to add depth to their usual two-dimensional work, moving up and out and down. They ask children to consider the ways that lines and shapes take up space, observing how they fit together or collide, how they balance or collapse.

This work also expands children's vocabulary as they learn the names of new tools, techniques, and materials. This expanded vocabulary, in turn, allows them to speak with increased nuance and insight.

# CLAY

Clay comes from the earth: ancient, organic, substantial. It smells cool and dark. It is grainy inside its smooth moistness. Clay requires muscle. We engage clay with our hands and feel it on our skin. There is an intuitive aspect to working with clay; through many encounters, we develop a sense of its fluidity and substance.

In this chapter, "First Steps into Clay: Stage One" contains an exploration that introduces children to clay with exuberant physical play and "First Steps into Clay: Stage Two" contains an exploration of how clay behaves. We build on these first steps by taking "Further Steps into Clay," where the children are invited to use the knowledge they've gained to shape the clay into sculptural form. The children begin to use the clay to articulate their ideas, experiences, and observations.

These encounters with clay take place over a stretch of time, not in a day or a week. The steps described here are intended to be sequential, first building a physical, experiential knowledge of clay, then using it for representation.

A note about clay: There are many sorts of clay, ranging from earthen clay to manufactured modeling clays like Plasticine, Sculpey, and Crayola's Model Magic modeling compound. The clay I've used with young children is porcelain clay, a fine-grog white clay, smooth and soft, yet also quite dense. Fired in a kiln, porcelain clay hardens to a lasting durability.

Modeling materials like Plasticine are designed to be air-dried. They are very lightweight and don't mix with water, so their texture cannot be changed. They tend to be brittle. Animators typically use these modeling materials (think *Wallace and Gromit* and other claymation films).

If you have the resources, I encourage you to invest in a natural clay such as porcelain. It's responsive, softening when touched with water and drying when exposed to air, and is the type of clay potters and ceramic artists use. Offering this clay to children communicates our deep regard for their rights as learners and for their competence as artists. It is an invitation into the centuries-old tradition of working with the earth.

# FIRST STEPS INTO CLAY: STAGE ONE

Before working with clay as an art medium, children need to understand its identity. "First Steps into Clay: Stage One" emphasizes full-body exploration, inviting children to climb on a big block of clay, dig into it with their toes and fingers, and press into it with elbows and knees. As children bring their whole bodies to their relationship with the clay, they experience the responsiveness of the clay. This first encounter, body to body, begins the dialogue between children and clay.

### MATERIALS FOR THE EXPLORATION

- a clean plastic tarp for the floor
- one big block of porcelain clay, roughly 20 inches long by 10 inches deep: most clay comes in blocks about this size; the children will work together using one block of clay

### MATERIALS FOR THE CLEANUP

- a bucket or tub of water (even if you have a sink in the room) to wash arms, hands, legs, and feet
- paper towels
- an airtight container for the clay: a tightly sealed plastic bag or a container with a lid

## SETTING UP THE STUDIO

Clear a big stretch of floor, as big as the tarp. Cover the floor with the tarp and set the block of clay in the center.

Set the bucket or tub of water at the edge of the tarp, with a stack of paper towels next to it.

## EXPLORING AND CREATING

Invite children into this playful, full-bodied encounter with clay.

*Kids, meet clay. Clay, meet kids! We're going to play with clay with our whole bodies!*

*We'll need bare feet and rolled-up pants. Short sleeves are helpful too; if you have long sleeves, we can roll them up so your arms are bare.*

Once you and the children are stripped down to bare arms, legs, and feet, invite the children onto the tarp.

*Let's get to know the clay. You can use your arms, feet, legs, and hands to get to know the clay.*

The children might be tentative at first, unsure how to begin. Encourage them to explore with their whole bodies, climbing onto the block of clay, jumping from it, digging into it with toes and fingers.

*The clay is strong. It can hold you up! Try standing on the block of clay. You can climb up and jump off the clay.*

*What happens if you press your elbows into the clay?*

*You can lean all the way onto the clay with your hands. Press down on the clay and feel it pressing against your hands.*

*Can you lift this heavy clay? Roll it? Turn it upside down?*

Ask the children to stay on the tarp, even when they take a break from the clay. This keeps their feet clean and, in turn, keeps the clay clean, so that it can be used again.

As the children clamber over and around the clay block, it will slowly change shape, becoming flat and wide. As it changes shape and becomes more malleable, encourage the children to experiment with curling it at the edges, with tearing off pieces of the clay, with scratching it into shreds. Eventually, the block of clay will be transformed, perhaps into one large, flat pancake, perhaps into many small pieces. The children may be done playing with the clay—but if they're not, simply work with the children to roll it back into a big lump and dive back in.

## CLEANUP

When children are done with the clay, help them rinse off their feet, legs, arms, and hands in the bucket or tub of water. They probably won't have much clay on their skin, as the clay is fairly dry; they'll likely have a soft coating of powdery dust to rinse off. It's important to rinse clay and dust off in a bucket or tub rather than in a sink, as clay quickly clogs drains.

The clay can be shaped back into one big lump and used again. Pack it as tightly as you can into a plastic bag; the more densely it's packed, the more moist it'll stay. If the clay feels quite dry or is crumbly, add a sprinkle of water as you pack it into the bag. Seal the bag tightly.

You can wipe down the tarp with a sponge, take it outside and hose it off, or simply let it dry and sweep it clean.

## DOCUMENTATION AND DISPLAY

The story of this first encounter between children and clay is a playful, exuberant story to tell. During the exploration, take close-up photos of the children's physical engagement with the clay: toes pressed into the clay, fingers digging into the giant lump of clay, arms circling the block, feet in mid-leap off the clay.

Take notes that capture details of the children's encounter:

- How do the children use their bodies with the clay? Are they tentative and careful? Wildly joyful? Forceful? How do they use their toes, fingertips, elbows, heels, palms, knees?

- Do the children's interactions with the clay remind you of their physical play in other contexts? In what way?

- What comments do the children make as they play with the clay? What connections are they drawing between this experience and other experiences they've had?

To communicate the physicality of the experience in your documentation and display, emphasize images more than words. Keep your text simple, using it to call attention to the relationship that is just beginning between the children and clay.

march 24

How does a child become friends with clay? Easy, familiar friends—the kind of friends who fling themselves into each other's arms when they meet, who sit close to each other, who speak without words.

Rachel, Anna, and Jessa began building that sort of friendship with clay this morning. The studio floor was empty, except for a big white tarp and, in its center, a block of light-gray porcelain clay. "Kids, meet clay. Clay, meet kids," I said. "This morning, we get to play with the clay with our whole bodies."

The children touched the clay first with tentative fingers, introducing themselves to the clay and listening for the clay's response. Gradually, the children became more sure in their gestures of friendship. I encouraged them to be bold, to see the clay as an invitation to play big, physical games: "You might experiment with standing on the clay. It's strong and can hold you. See how it feels under your feet. Can you use your toes to explore the clay?"

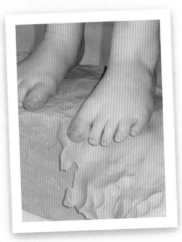

Anna took the first cautious step up onto the block of clay. The other children watched closely—then, when Anna grinned at the clay's cool strength, they hurried to climb up onto the clay with her. "Jump!" shouted

Rachel, launching a game with the clay. The girls climbed up onto the clay and jumped off, they dug their toes into the clay, they stomped and hopped all over the clay. Slowly, the clay changed shape, offering a response to the children's play.

Rachel leaned into the clay with her whole body, pressing her hands into it. "I wonder if you can roll this clay over," I said. Rachel and Anna began to heave and push at the clay, until, with a big flop, it turned onto its side.

Friendship (n): the mutual feelings of trust and affection and the behavior that typifies relationships between friends.

Jessa, Anna, and Rachel began a friendship with clay this morning, offering themselves to the clay with generosity and great affection, learning how it moves and changes shape and receives their offerings. Their friendship, born in exuberant physical play, will deepen over the months ahead as the children and clay continue to encounter one another.

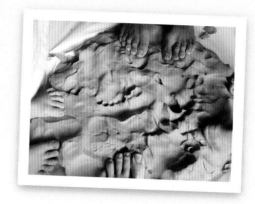

# FIRST STEPS INTO CLAY: STAGE TWO

"First Steps into Clay: Stage Two" builds on the relationship that children began with clay during their full-body play. Now the clay moves to the table. Children work with it in individual chunks, changing its texture by adding water to it. This stage invites children to continue building their physical knowledge of clay, noticing its movement and texture, as they move toward eventual sculpting work. This is a decidedly messier exploration than the first stage, because this stage adds water to the children's relationship with clay!

### MATERIALS FOR THE EXPLORATION

- a canvas-covered wood board for each child: approximately one-foot square. Cut pieces of wood into one-foot squares. Cut sturdy, undyed canvas cloth into squares bigger than the boards (canvas drop cloth, available at construction supply stores, works well for this). Stretch the canvas over the boards, and use an industrial stapler to attach the canvas to the back of the boards. These boards will be used again and again during clay work, so it's worth the investment of time and effort.

- a clean sponge for each child (these sponges should be used only with clay, not with other media like paint and not for general cleaning)

- porcelain clay

- a tool for cutting clay (you can buy a wire clay cutter from art supply stores)

- a smock for each child

- a bucket or tub of shallow water or a sink in which children can moisten their sponges

- a plastic tarp or drop cloth for the floor

### MATERIALS FOR THE CLEANUP

- a bucket or tub of water (even if you have a sink in your room) to wash hands

- paper towels

- an airtight container for the clay; a tightly sealed plastic bag or a container with a lid

## SETTING UP THE STUDIO

Cover the floor under and around the table with a plastic tarp or drop cloth; this is a particularly messy exploration!

Create a work space at the table for each child: set a canvas-covered wooden board at each child's place. Place a dry sponge at the corner of each child's board.

If you don't have a sink in your room, set a bucket or tub of shallow water near the table in which the children can moisten their sponges.

Prepare for the end of the clay session by setting a separate bucket or tub of shallow water near the table, with paper towels nearby. Even if there's a sink in the room, children should rinse the clay from their hands in this bucket because clay quickly clogs sink drains.

## EXPLORING AND CREATING

Welcome children by reminding them of their first encounter with clay.

*Here's the clay again! Do you remember when you first met the clay? We took off our shoes and*

*socks and rolled up our sleeves. Then we played with the clay with our whole bodies! What do you remember about the clay?*

Introduce them to the clay in this new arrangement.

*We'll work with the clay on the table today, using our hands.*

*The canvas board is your work space. The canvas holds the clay better than the table. Clay sticks to a table, but not to canvas.*

*The sponge is going to hold water for your clay work. Sometimes the clay gets dry; you can use water from your sponge to moisten the clay.*

Help the children get their sponges wet in the bucket or at the sink.

*Dip your sponge into the water, then turn it over and dip it again. That gets both sides wet. Now give it a squeeze to get most of the water out—but not all of it! You'll get the feel of how much water you need in your sponge as you practice with clay.*

Once the children are settled at the table with moist sponges, cut the clay into good-sized chunks—not so big that it's unwieldy, but not so small that it's uninviting. This is a dramatic moment to share with the children.

## Softening the Clay

The clay will be stiff at first. Coach the children about how to soften the clay. Demonstrate this as you describe the process. As you do so, move slowly so that the children can follow along with their own clay.

*The first part of clay work is muscle work. We've got to soften this stiff clay so that we can shape it.*

*First, use your sponge to moisten your clay. Hold your sponge above the clay and give it a soft, quick squeeze—just enough to make a few drips come out.*

*Now comes the muscle work of mixing the water into the clay. To mix water into clay, squeeze the clay . . . rub it . . . push it . . . knead it . . . roll it.*

Demonstrate each of these actions as you talk—and any other mixing and kneading sorts of motions.

*Every so often, add a few drops of water to the clay, and keep mixing!*

Notice if children need coaching or encouragement, but steer clear of giving lots of direction about how much water to use or how to avoid a mess. At this stage, the children are researching, exploring the properties of clay when it's dry, saturated with water, and just moist enough.

As the children work, invite observation and reflection.

*What are you discovering about what happens when clay meets water?*

*All that water is softening your clay. Your clay looks like it's melting into a mud puddle. I bet it feels slippery!*

*Your clay has lots of cracks in it. Does it feel dry? Crumbly?*

## Exploring Shape and Texture

The clay will eventually become soft and pliable. Call attention to possibilities for shaping the clay and to the ways that water affects the shape of the clay.

*What can you discover about how to change the shape of clay? Try folding the clay. Bending it . . . stretching it . . . flattening it . . . rolling it.*

*When you make a shape with your clay, does it keep that shape? Why do you think it keeps (or loses) its shape?*

*See if you can discover which kind of clay works best for making shapes: really wet clay or really dry clay or clay that's a little bit wet and a little bit dry.*

Some children will immerse themselves in a full-on sensory exploration of clay's qualities. These children are likely to dissolve the clay into a gooey, grainy mud. They are researchers, investigating the impact of water on the clay, and their research is an important step in their journey toward representational work with clay. Avoid the temptation to interrupt their research to give direction about how much water to

use. You can certainly aim to contain the mess a bit, helping a child sponge her watery clay into the bucket and offering her a new batch for experimentation, but mostly, offer support for children's research.

> *What's happening to your clay? Where the clay used to be, I see a big muddy puddle. How did the clay change?*

> *Your hands are full of clay, and your face looks so happy.*

Some children will move toward representational work, naming the shapes they see in their clay as they manipulate it: "It looks like a volcano." "It's a snake." "It's a pancake." "It's a baseball." These children are reading the clay. Honor their awareness of shape and of design elements by describing the evocative shapes.

> *It's like a volcano with that thick, round base that gets thinner as it gets taller. It's a cone shape.*

> *It's long and thin and curvy like a snake.*

> *It's round and flat on the table, just like a pancake.*

> *It's round and thick, and fits right in your hand like a ball.*

Some children will be determined to make something. Talk with them about the value of "messing around" as artists.

> *Often, sculptors spend time experimenting with their clay, trying out different ideas, seeing what works and what doesn't work. You might try that part of the work of an artist: just mess around with the clay for a while and see if it gives you some ideas about what you could make.*

> *You have an idea about making a flower. Experiment with how you could shape the clay like a stem and petals. How many ways can you find to use clay to sculpt a flower?*

At this early stage, encourage children to see any sculptural work they do as temporary, not something to save or take home. This strengthens the disposition to "mess around" and to focus on process more than product. As children grow this disposition, they

become more relaxed with an art medium. This leaves space for an idea to take form, and children become comfortable with revisiting and revising earlier work.

These children may work the clay so much that it begins to dry and crack. Encourage them to keep the clay moist by adding drops of water from their sponges. Suggest that they keep their hands moist as well by rubbing the palms of their hands on their sponges.

During their explorations, their sponges may run dry. Remind the children how to wet their sponges.

As they work, children's hands and arms will accumulate a layer of clay. For some children, this will be a thin, powdery coating, while for others it'll be big chunks of actual clay. When the clay dries on children's skin, it can get itchy. Show children how to rub the sponge over their hands and arms to remove the bulk of the clay and powder. Children may want to rinse their hands in the bucket or tub of water every so often as well. (Remember not to use the sink!)

## CLEANUP

As children finish their clay work, coach them about rinsing the sponges in the bucket or tub.

> *Dip and squeeze, dip and squeeze. Five times should rinse your sponge clean.*

> *The last time that you dip the sponge into the water, give it a big squeeze so that all the water comes out.*

Keep the sponges in an open basket where they can dry in the air. Tuck them away with the other clay materials so that they're not used with other art materials or for cleaning.

There will likely be quite a gooey, sloppy mess on some of the canvas boards. You might decide to deal with this yourself, or you might invite children to help. Move the bucket close to the edge of the table and use one of the clay sponges to scoop the mud into the bucket. After scraping the clay off the canvas boards, set them on a shelf to dry.

If there's a blob of clay that is still identifiably clay but very soft and runny, scrape it into a plastic container with a tightly sealed lid. This soft clay will make great slip, or clay glue, later, when the children venture into sculptural work.

Some of the clay will be fine to reuse just as it is. Put this clay into a plastic bag that can be tightly sealed.

Have children rinse their hands in the bucket to get the bulk of the clay off their hands, before washing more thoroughly in a sink.

The bucket that's full of clay-water? Pour the water down the toilet, rinse the bucket, and store it with the other art materials.

## DOCUMENTATION AND DISPLAY

Children's relationship with clay deepens with each encounter. The written documentation and display tells the story of this unfolding relationship.

Take photos that capture children's growing familiarity with clay: hands pressed into the clay, cheeks smeared with clay, arms dusted with dried clay. Photograph children's hands at work: fingertips pressed into the clay, a fist tightly squeezing the clay so that it oozes between fingers, flat palms pressing the child's full weight into the clay, hands stretching and rolling and pounding the clay. If children begin to read the shapes of the clay ("a volcano," "a snake," "a pancake"), take close-up photos of these shapes.

Take notes that help you remember details of the children's encounter with clay:

- What words and sounds do the children use to describe the changing texture of the clay as they add water to it?

- What stories do the children tell as they work with the clay and water?

- How do the children position and move their bodies as they work? Do they stand? Sit? Lean forward into the clay? Maintain some distance from the clay? Lift their feet from the ground with the effort of pressing into the clay?

- What connections do the children make between their earlier, full-body encounter with clay and this work with the clay?

- What discoveries do the children make about the interplay of water and clay? How do they make those discoveries?

- How do the children collaborate, sharing observations and understandings with each other?

The display you create can include your reflections and observations about the children's growing knowledge of clay, quotes of the children's words and sounds, and large photos of the children at work. You might also include invitations for viewers to reflect on their experiences of learning with their hands.

*What knowledge do your hands hold?*

*Think about how you learned to bake bread, knit, fix a car engine, or type on a keyboard. Your hands became skillful, confident. What do the hands of a person who is just learning these arts need to know?*

Your display can create a window into a new way of understanding children's clay work, shifting the focus and value from product to process, from what children make with clay to the knowledge their hands are gaining.

November 6

Olivia, Melia, Arianna, Liam, and Logan sunk into clay in the studio this morning, reveling in its changing textures and densities, its firmness and its pliability. We used only our hands and sponges of water with the clay. We'll wait to use tools with the clay, allowing the children time at this early stage in our clay work to develop a relationship with clay, learning its qualities and temperament, its dynamic personality.

As the children explored the characteristics of clay, they talked together, sharing their observations.

Olivia: "Mine is as stiff as ice!"

Melia: "It's hard as a rock."

Arianna: "Mine is getting easier to pull apart because I wetted my hands. I squeezed it and it got softer. You try, Melia. Get your hands wet, then squeeze your clay."

Olivia: "My clay is getting soft as a bunny. I squeezed lots of water and it got softer. Now it's like glue: the clay was just standing on the cloth and then when I squeezed the water on it, some of the clay got very mushy. It's like I have soap on my hands!"

Liam got his clay quite wet with a dramatic squeeze of his sponge. After several minutes of blending the clay and the water, he commented, "The water mushes it and gooshes it. It makes the clay squishy. It's smoothing onto the fabric."

Olivia: "When I squish it and squeeze it, it makes a clicking sound. The water is making it. The water is mixing into the clay."

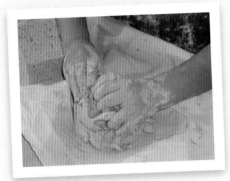

Liam: "Clay turns into mud. I might need new clay because this clay is so wet that it's just smooth on the fabric and falls apart and I can't make anything."

Arianna: "My clay, of course, is getting harder to squish because I didn't put enough water in it."

Ann: "Your clay is stiff enough to hold the shape you give it."

Olivia: "My clay looks like cream cheese on a bagel."

Logan: "My clay is getting hard and dry again."

Ann: "Why do you suppose it's getting dry and hard?"

Logan: "Because I'm patting it so much."

Ann: "Why does patting it make it dry and hard?"

Logan: "Because the patting is hard and fast."

Ann: "Why does hard and fast patting make your clay dry and hard?"

Logan: "Because the air makes it dry."

Arianna: "Mine's getting flat from patting it."

Logan: "Clay is interesting. I'm doing an experiment. I'm gonna take a piece, then take another piece, then squeeze them together."

Ann: "What do you think will happen?"

Logan: "They'll get stuck together."

After lots of exploration of the sensory experience of clay, the children began to explore its representational potential. This seemed an extension of the sensory exploration, as they moved from a focus on the tactile experience of clay to its visual possibilities. As they worked the clay, they began to notice that the forms the clay took reminded them of particular objects. They moved from shape to shape, squeezing and folding and scooping out their lumps of clay, calling out descriptions:

It's a cave!

A person!

A volcano!

A ball to play with!

A little nest!

We'll spend lots more time with clay in the coming weeks, building a solid understanding of clay's qualities and possibilities so that it becomes a tool for communication and representation.

# FURTHER STEPS INTO CLAY

With their physical exploration of clay, children develop knowledge and instincts that lay the foundation for sculptural work. As children take further steps into their relationship with clay, they begin to intentionally shape the clay into pieces that you might fire in a kiln and glaze.

### MATERIALS FOR THE EXPLORATION

- a canvas-covered wood board for each child
- a clean sponge for each child (these sponges should be used only with clay, not other media like paint and not for general cleaning)
- porcelain clay
- a tool for cutting clay (you can buy a wire clay cutter from art supply stores)
- a plastic container with a tight lid or the container of slip from the earlier exploration (see page 64)
- plastic wrap
- drying shelves for finished clay pieces
- a smock for each child
- a bucket or tub of shallow water or a sink in which children can moisten their sponges

### MATERIALS FOR THE CLEANUP

- a bucket or tub of water (even if you have a sink in your room) to wash hands
- paper towels
- an airtight container for the clay; a tightly sealed plastic bag or container with a lid

## SETTING UP THE STUDIO

Set the canvas boards and sponges on a shelf or table so that they're easily accessible to the children. If you don't have a sink, set a bucket or tub of water near the worktable for moistening sponges.

Put a second bucket or tub of water by the table, even if there is a sink in the room. Children will use this bucket or tub to rinse their hands of clay bits, which can clog a sink. Set a stack of paper towels near the bucket.

## EXPLORING AND CREATING

Welcome children with an invitation to set up their own work spaces.

*You are becoming clay artists! You can get a space ready for your work, just like artists do when they prepare for a day in the studio. Do you remember how the work spaces were set when we worked with clay last time?*

*First, put a canvas board at your place. That'll be your work space for the clay.*

*Get a sponge moist in the sink/bucket. Dip your sponge into the water, then turn it over and dip it again. That gets both sides wet. Now give it a squeeze to get most of the water out—but not all of it! You can keep your sponge at the top of your canvas so it's handy but not in your way.*

When the children are settled with their canvas boards and sponges, cut each child a good-sized piece of clay. Invite them to renew their relationship with the clay.

*Do your hands remember the clay?*

*How might your hands say hello to the clay?*

Remind the children about softening the clay.

*The clay is stiff from its time in the plastic bag. You can soften it and get it ready to take new shapes. Roll it, squeeze it, pound it . . .*

*You may need to add a bit of water to the clay to help it soften. Use your sponge to add a few drops of water.*

*If you moisten your hands with the sponge, that will help to soften the clay.*

## Wedging the Clay

After the children spend a few minutes of working the clay, it will be malleable and ready to be shaped. Coach the children about wedging their clay, which prepares it for sculptural work and, if you choose to do so, kiln firing.

*Sometimes when you work with clay, you'll want to mess around and experiment with it. And sometimes you'll have an idea about something you'd like to make with clay—something to keep. When we want to make something to keep, we need to wedge the clay. Wedging the clay gets the air bubbles out so the sculpture is strong.*

*Make your clay into a big lump. Then roll, roll, roll your clay. Tap it on one end, then the other end. Roll, roll, roll. Tap-tap, tap-tap.*

Demonstrate as you do this. Roll the clay back and forth a couple of times and tap each end on the table, like you're making a cylinder unit block. It should be about the thickness of a block, but a bit more squat.

*We'll do five rounds of rolls and taps. Roll, roll, roll, then tap-tap on one end and tap-tap on the other end. That's one round.*

Doing this can feel clumsy at first, and the clay can sometimes end up in an odd shape—long and thin or very stubby. But after a couple of rounds, children's hands (and yours!) will get the feel of the process, finding how much pressure to bring to the rolling and how forcefully to tap. After about five cycles of rolling and tapping, the clay will be a dense cylinder; it's ready for sculpting.

## Sculpting the Clay

A great first sculpture for children to make is a little bowl, cup, or pot. Coach the children about this simple process, demonstrating as you describe the steps. The children can work with their clay as you work with yours.

*Stand the wedged clay—the cylinder—up tall on the board.*

*Press into the top of the cylinder with your thumbs and squeeze the outside walls with your fingers.*

*Turn the pot around a little bit at a time, so that you press all the sides of the clay.*

Demonstrate how to move around the perimeter of the cylinder, keeping an even thickness to the walls so that the pot isn't too lopsided.

As children work, invite them to notice details about the clay and their press pot.

*When you see cracks in your clay, that means the clay is getting dry. You can moisten it with a few drops of water from your sponge. You can also keep your fingers damp by touching them to your sponge.*

*Look how tall the wall of your pot is on this side! Do you want your pot to have one side that's especially tall, or do you want it to be even all the way around? If you want it to be even, you can move your fingers to the short side and work on that for a few minutes.*

*When you press hard, the clay becomes very thin. When you press lightly, the clay is thick. Can you tell where you pressed hard on your pot? Where you pressed lightly?*

*Do you see that tiny split in the wall of your pot? The clay is starting to break apart right there. Moisten the clay and your fingertips. Then smooth the clay back together to heal the split.*

*The top edge of your pot is so thin that it's starting to curve open like a flower. Is that the shape you want for your pot? If it is, you can shape it so that it curves more. If it's not, you can fold it down and make the wall a bit shorter and thicker right there.*

A child's press pot may take a shape that he regrets or it may collapse in on itself—the walls may be too thin or too tall, or they may crack and split open, or the bottom may become a gaping hole. No worries! Coach the child to collapse the clay into a ball, wedge it (five rounds of roll, roll, roll, then tap-tap, tap-tap), then start again, working the cylinder into shape.

When a child is satisfied with his press pot, step back with him and study it together.

*What about this pot do you especially like?*

*Was there a part of making this that was hard for you? How did you figure out that hard part?*

*What did you learn about making sculptures with clay that you want to remember the next time you work with clay?*

The press pot will need time to dry before going home or, if you have the resources, to the kiln. You can carve a child's name into the bottom of the sculpture with a clay carving tool, a knife, or a straightened paper clip. Then set the pot back onto the canvas board and loosely drape it with a piece of plastic wrap; this allows a slow drying process, which prevents the clay from cracking and shattering. The child can set his canvas board (with his pot on it) on a shelf or table where it can sit undisturbed for a few days while it dries.

If a child is still working on her press pot when it's time to end the clay session, help her wrap her sculpture with plastic wrap, tucking the plastic in tight around the sculpture. The plastic wrap keeps the clay moist so it can be reshaped later.

Creating these little press pots allows children to get the feel of how to shape the clay with intention and vision. As they work on their pots, children learn about maintaining an even density to a sculpture, creating a measured balance among elements. Children's work on press pots allows them to experiment with the balance between force and delicacy, between giving direction to the clay and listening to the clay.

## Adding Skills for Sculpting

There are a few other skills and understandings to offer children as they move beyond press pots into their own representational work.

Children (and adults!) can feel overwhelmed about how to begin shaping clay into an animal or object. They may imagine a fully formed cat, for example, but actually figuring out how to shape a cat from the lump of clay in front of them can be a daunting task. Coach children to break an image into its parts, to see the shapes "inside" an animal or object.

*Are you imagining a cat standing up? Sitting down? Curled up, asleep?*

*Let's think about the shapes that make up a cat. A cat sitting down has an oval-shaped body, a roundish head, triangular ears, long rectangular legs, and a thin, curving tail.*

Children sometimes use the clay to make a "drawing" rather than a sculpture, using clay pieces to form a flat composition on the canvas. Encourage children to shape their clay in three dimensions, starting with the upright cylinder after wedging the clay.

Coach children about molding the clay—pressing and pulling shapes from the clay rather than making lots of small pieces and sticking them together. Molding the clay makes a clay sculpture sturdy and durable.

*We've got a cylinder after wedging the clay. There's a whole cat inside that cylinder of clay! Let's shape the top of the cylinder in a head shape. We can pull ears out of that head shape, just tiny bits of clay reaching out of the round head. The clay stays connected—it's one piece of clay made into ears and a head and a body . . .*

If a child does need to attach two pieces of clay together—adding a tail to the cat, for example—demonstrate how to use slip. Slip is a very soft clay that acts like glue, adhering pieces of clay together. You may have scooped some of the goopy clay from the "First Steps into Clay: Stage Two" clay-and-water exploration into a container; that makes great slip. If you need to make slip, simply mash a lump of clay with water until it's a thick goo, the consistency of soft cookie dough. Keep slip in a tightly sealed container. You may need to add water every so often to keep it gooey.

*Slip is like glue for clay. Before you put the slip on the clay, make a few scratches in the clay where you want to stick it together. That's called scoring the clay.*

Demonstrate how to score the clay. The score marks don't need to be deep; they simply make the surface of the clay more textured so that there's something for the slip to stick to. You can use a clay tool that's specially made for scoring, or you can improvise with small plastic forks, bits of rough-edged wood, or paper clips that have been straightened. Score both pieces of clay where you will be sticking them together.

*After you score the clay, rub a little slip on it. Now press the clay pieces together. Press hard enough so that the clay holds on tight, but not too hard! It's a delicate balance—you'll figure it out as you practice.*

Children will experiment with weight and heft and stability as they work. Help them explore how thick the clay needs to be to make legs on an elephant, for example, or how dense the clay needs to be to form the neck of a horse. Balance also comes into play: at what angle, for example, can the neck of a horse extend from its body and not topple over? Working with clay inspires a spirit of patient curiosity, a willingness to experiment, take risks, laugh, and start over.

The sturdiest clay pieces have a consistent thickness. This is particularly important if the clay will be kiln-fired; in a piece with uneven thickness, the thinner bits will dry quickly while the thicker parts are still moist, creating cracks and shattering the sculpture. When a child's work is uneven in its density, help him compress the walls/sides/bottom of his clay piece so that it's not fat or lumpy in some places and thin in others. Also, if a child's clay piece includes a big, thick element, like the base of a volcano, help him hollow it out. This will prevent the piece from breaking in the kiln.

In all our interventions in children's work with clay (and other media, as well), our intention is to offer children the knowledge and skill that allows them to use clay with ease. When we teach children a new language, we coach them about vocabulary, grammar, and syntax; we don't offer them a few words and let them fumble their way through their efforts to communicate, standing back in hopeful expectation that they'll figure out what they need to know. Similarly, when we teach children the language of clay, we offer as many tools as we can. Our intention is to help children develop the skills and knowledge that will allow them to use clay with confidence to express their ideas, experiences, and passions. It is a sign of deep respect to offer suggestions about technique and to invite children to revise their work so that it more fully expresses their intention.

## Firing and Painting the Clay

After the clay dries, it will be fairly hard but prone to crumbling and shattering. Firing the clay in a kiln strengthens the clay, transforming it into pottery and solid sculpture. If you don't have a kiln at your school, check with the community center in your neighborhood, with your local high school or community college art department, with pottery supply shops, or with paint-your-own-pottery businesses. These places often have kilns that people in the community can use, usually at little or no cost.

After a clay piece has been fired, it can be painted with tempera or acrylic paint. When this paint dries, the piece is done. (Of course, a sculpture doesn't need to be painted to be complete and lovely).

You can also add color to the fired sculptures by glazing them with pottery glazes. Pottery glazes require a second round of firing; the high heat of the kiln brings the color to life, creating a glowing, vibrant sculpture. Glazes can be purchased at pottery supply stores, at art shops, and at paint-your-own-pottery businesses. There are liquid glazes, like paints, and powdered glazes that need to be mixed with water before using. Typically, glaze changes color quite dramatically when it's fired; it's helpful for children to see samples of the finished color as they figure out which colors of glaze to use on their sculptures. There are also clear glazes that you can use to add a shine to clay; the one we've used at Hilltop is bright pink when we paint it onto clay, but becomes a lovely, bright shine after firing.

Children can paint the glaze onto their clay pieces with paintbrushes. Glaze goes on any surface *except* the bottom—the place where the sculpture sits flat, touching the table surface. If some glaze gets on the bottom, simply wipe it off while it's still wet.

After the glaze air-dries, it must be fired in a kiln. When the sculpture comes out of the kiln after this second firing, it's done!

## CLEANUP

As children finish their clay work, they can rinse their sponges in the bucket or tub. Keep the sponges in an open basket where they can dry in the air. Tuck them away with the other clay materials so that they're not used with other art materials or for cleaning.

Children can do an initial rinse of their hands in the bucket or tub, then wash more thoroughly in a sink.

Unused clay can be clumped together and sealed up in the plastic bag. Scrape off any chunks of clay left on the canvas boards, then set the boards onto a shelf to dry.

Dump the clay-water from the bucket down the toilet.

## DOCUMENTATION AND DISPLAY

The ongoing story of children and clay expands with each encounter. Your documentation and display tell this unfolding story, adding details that reflect children's increasingly sophisticated knowledge of clay, their mastery of technical skills, and their use of clay to communicate their experiences and observations.

As children craft press pots and other representational sculptures, take photos that capture the skill and focus of their work: fingertips smoothing, folding, pressing the clay; heads bent over the clay, eyes focused, brows furrowed in concentration. Photograph a sculpture in process, beginning with the just-wedged cylinder and following a child's work step-by-step as she shapes the clay so that you've got a series of photos that trace the creation of a sculpture.

Take notes of the children's comments as they work:

- What words do children use to describe the technical aspects of their work?

- How do children talk about the clay's texture, color, movement?

- What stories do the children tell as they work with the clay?

Make notes about the technical skills that children practice as they work:

- What are their struggles and their triumphs as they figure out how to wedge the clay? Pull a shape out of the clay? Build a clay piece in three dimensions, rather than flat on the table? Keep the clay moist so it doesn't crack? Use slip to attach clay? Balance the thickness and height of a piece?

- How do the children use the knowledge they formed during their earlier encounters with clay?

- How do the children share understandings with each other and offer each other suggestions and critiques?

In a bulletin board or wall display about children's clay work, consider using large photos and simple text to create a guide to working with clay. For example, you might include a close-up photo of a child's hands wedging the clay, with a short description of the steps involved in wedging clay. Or you might display a photo of a child squeezing the side of a press pot between thumb and finger, with a few sentences describing the effort to create a sustainable balance between height and thickness. Include photos and text about pulling shapes out of the clay, building in three dimensions, using slip, and keeping the clay moist. Children can help write the text, dictating the directions that accompany the photos. The photos and text you create for this display can also go into a notebook, binder, or handmade book to become an artist's guide about how to work with clay, honoring the children's knowledge about clay.

To display children's finished clay sculptures, consider setting them on a shelf with mirrors behind and under them. This allows a viewer to see the sculptures from a range of angles. Create museum-like identification cards: black lettering on white index cards, folded so that they stand next to each sculpture, with the name of the sculpture and the name of the artist: "Cat, by Eliza."

February 6

"Sinclair, how did you make that cool dinosaur?" Drew asked, eyeing with admiration the brontosaurus that Sinclair created several weeks ago. It was back from

the kiln and was sitting on a shelf near the clay table. That dinosaur became the focus of the children's work with clay this morning.

Drew, Mackenzie, Lukas, Halley, and Sinclair were gathered in the studio, ready to transform their lumps of clay into sculptures. They'd already wedged their clay, rolling and pounding it to squeeze the invisible air bubbles out of the clay so it could be safely fired in the kiln.

We brought the brontosaurus to the worktable so the kids could look at it as they shaped their clay. I asked Sinclair to serve as a teacher to her companions, helping them learn how to make a dinosaur. "What comes first?" I asked Sinclair. "How should these kids start their work?"

"First, make the tummy round," Sinclair directed. "Not round like a ball, but round like a tummy. I'll show you." And she demonstrated how to roll a wedge of clay into an oval shape.

"Next, make the legs. Then make the tail. Last, make the neck and head."

Drew, Mackenzie, Halley, and Lukas listened closely to Sinclair's instructions. I wrote them down as a sequence of four steps, adding brief illustrations of each step, and put those written notes on the table as a visual reminder of the four steps. Each of the learners rolled their clay into round shapes, holding them up to Sinclair for her to inspect. She offered feedback and coaching: "Not so round as that." "More flatter on the bottom." "Make it kind of smooth on the top."

When each of the children had a satisfactory tummy, they rolled their clay into small legs, long tails, and even longer necks. Once the various body parts were crafted, I called the children together for a lesson on slip, "glue for clay." I demonstrated a technique for using a special fork-like tool to roughen the surfaces to be attached, then showed the children how to spread the slip and attach the clay pieces. The tool and the slip were captivating. Halley jettisoned her dinosaur so she could just mess around with the slip and with the tool, making lumps of clay, scoring it with the tool, slathering on the slip, and sticking the lumps together. Drew, Mackenzie, and Lukas pressed on with their dinosaurs, but used a lot of slip in the process!

Eventually, Mackenzie and Lukas each had a dinosaur that they really liked. We etched their names on the bottom of their sculptures and set them out to air-dry. Drew's dinosaur, though, covered in slip, collapsed into a mushy pile. He was awfully frustrated, and cried disappointed tears. Lukas stood by him, a gentle companion in Drew's disappointment, and encouraged Drew to start over. And, after a few minutes, Drew did. He wedged the clay again, then took Halley's route with the tool and slip, letting go of the idea of creating a representational sculpture and just enjoying the clay's slippery smoothness.

Sinclair, meanwhile, turned her attention to creating a spiny-backed dinosaur, a companion piece to her brontosaurus. As she began to wedge the clay, she commented, "I'm tired of talking so much. I am just going to make a dinosaur, not teach about it!"

I appreciated the collaborative process that these children undertook. Sinclair shared her expertise, and Halley, Drew, Mackenzie, and Lukas embraced the role of learner, asking questions, offering ideas, and passing the tool and slip around the table. I was struck by their trust and ease with one another, and their comfortable companionship as they investigated the possibilities in a lump of clay.

# WAYS TO BUILD ON THIS EXPLORATION

You might use clay:

- when children are exploring physical strength and effort: work with a stiff lump of clay until it's soft and flat;

- when children's investigation involves structure and form or ideas that need to be tested in three dimensions;

- when children are working to bring a story or experience to life: sculpt key elements or characters from the story or experience;

- when children are learning about collaboration: ask several children to work with one piece of clay, creating a single sculpture together;

- when children are studying texture or lines: make impressions in clay, like fossils.

# FOUND MATERIALS AND LOOSE PARTS

Cereal boxes, toilet paper tubes, corks, juice concentrate cans, telephone wire . . . These sorts of "disposable" materials are sculptural treasures in an early childhood art studio. Found materials like these offer intriguing provocation. In a child's hands, a cereal box is no longer a container for cereal: it becomes a tiny home for a paper doll, with a door cut into the base, tissue-paper curtains fluttering in windows, wire smoke curling from a cork chimney.

## MATERIALS FOR THE EXPLORATION

- found materials and loose parts: materials such as cereal boxes and boxes from other typical grocery purchases (toothpaste, frozen meals, aspirin, for example), toilet paper and paper towel tubes, lids from individual yogurt containers, lids from juice concentrate cans, lids from bottled soda and water, film canisters, corks, handles from paper grocery bags, and Popsicle sticks. Put the word out to the children's families several weeks in advance of this exploration that you're collecting these types of materials—you'll soon have an ample collection.
- masking tape, in a dispenser
- clear tape, in a dispenser
- scissors
- a stapler
- glue sticks, or paste and spreading sticks (thick paste or glue works better than school glue for this exploration)
- a hole punch
- string or yarn
- drawing paper
- black drawing pens
- clear plastic stands for paper, like a cookbook holder or a display frame for full-sized sheets of paper (optional), one for each child; use these to hold the sketches that children make to use as "blueprints" for their sculpting work
- a tray for each child (optional)
- shelf or table space where sculptures can dry

## MATERIALS FOR THE CLEANUP

- a trash can
- sponges or paper towels for wiping up glue spills
- a bucket of shallow water, a spray bottle of water, or a sink

## SETTING UP THE STUDIO

On a shelf, table, or open space on the floor, arrange the found materials to call attention to their possibilities. Group boxes of similar sizes together. Stand the tall tubes behind the short tubes in an interesting half circle or at an eye-catching angle. Put small objects in baskets—film canisters in one basket, for example, and bottled-beverage lids in another. Set Popsicle sticks in a pottery jar. Pile the paper bag handles in a playful mound of curving lines. (Sorting and displaying the materials in this way creates a visual feast: the shape, texture, size, and color of each material leap forward, offering themselves to the imagination.) (If your studio has space, consider creating a permanent "loose parts" area, with found materials arranged on shelves, always available to the children.)

In the center of the worktable, set the tools for attaching things: tape, stapler, glue, hole punch, scissors, and string or yarn. You might consider using a turntable tray, like a "lazy Susan," for the tools, to make them most easily accessible to the children gathered around the table.

Make sure there are shelves or table space cleared where children can set their sculptures to dry.

Keep a trash can handy; there will be lots of small scraps to throw away!

## EXPLORING AND CREATING

Welcome the children into the studio by calling attention to the feast you've arranged.

*So many materials! What sorts of materials do you see? Can you tell what they are? How they've been used before today?*

*Let's look at each material, one at a time. What are you noticing about this one? What does it remind you of? What else does it remind you of?*

*Listen to the sounds these materials make . . .*

Invite the children to gather a selection of materials (you might offer each child a tray to hold their materials). Encourage children to consider foundational pieces as well as pieces that build up and out.

*Are some of these materials especially interesting to you? Are there some that you are curious about and would like to work with? Choose five or six things that you want to build with.*

*Think about what you could use as a sturdy foundation for a sculpture. You might choose a box or tube to use for a base.*

*You've got a couple of sturdy boxes that'll work as foundations. What other sorts of materials might you use with those boxes?*

Some children will gather materials with a specific intention in mind—a plan to create a spaceship or an ice cream truck or a bed for a doll. Help them think about what materials will lend themselves to their work.

*You're going to make an ice cream truck! Let's think about the parts of an ice cream truck. You've gathered a box; will that be the truck's body? What might you use for wheels? Ice cream trucks play music; is there something here that you could use to make your truck play music?*

Some children will simply gather materials that intrigue them and that catch their imagination.

After the children gather materials, help them arrange their loose parts at their work spaces at the table. Once children are settled at the table, call their attention to the tools for connecting materials.

*There are lots of ways to attach loose parts together. Here are some tools that you might need for creating your sculpture: tape, scissors, glue, a hole punch, and string. As you work on your sculpture, you can experiment with these tools to find what works best for each part of your sculpture.*

Invite the children to begin their sculptural work.

*Some of you have a plan about what you'll make with your loose parts. Think about what part you'll make first, and dive in!*

*Some of you chose loose parts that are interesting and curious to you. You might experiment with your loose parts awhile, seeing what you discover about them.*

As the children work, stay close to invite reflection, to offer coaching, and to be a sounding board for their ideas.

For children who are exploring the possibilities of the loose parts, suggest ways of seeing into the materials.

*How does this material move? Is it stiff or floppy?*

*What kind of lines and shapes do you see in this?*

*What does this remind you of?*

*What are some ways that this could be used?*

Help them explore possibilities for how to combine loose parts.

*How might these fit together?*

*Does one of these parts seem like a foundation?*

*How might the other parts fit on the foundation?*

Call attention to possibilities for symmetry and balance, and for building up and out into three dimensions.

For children who are focused on creating representational sculptures, offer coaching about how to realize particular elements of their ideas.

*Let's make a list about all the parts of an ice cream truck. There's the body of the truck, where the ice cream is! And there are wheels, and a speaker for music, and a sign that tells kids what kind of ice cream is for sale. And there's a cab for the driver.*

*Let's look at all the wheel-shaped loose parts and see which sort will work best for your ice cream truck. We've got corks, film canisters, toilet paper tubes, yogurt lids, soda bottle lids, juice can lids—so many different sizes and textures! Which do you think would work well for ice cream truck wheels?*

As children dive into the construction process, they'll encounter challenges about how to attach loose parts to each other. Act as a mentor to the children, using your experience to teach specific skills, point out technical problems and offer remedies, and provide feedback.

*I know a way to attach a tube to a box. Can I show you? I think it'll help you get that tube to stay in place where you want it. Make a bunch of little cuts along one end of the tube, like you're making fringe. Then bend that fringe so that it's flat; that makes a base at the bottom of the tube. That base gives you a place to put glue or tape or staples, to attach the tube to the box.*

*I notice that the yogurt lid keeps slipping off the side of the box. Glue might be too slippery to hold it steady. What are some other ways we could attach that lid?*

Invite children to share strategies and observations with each other as they work.

*Rowan figured out how to make seats in her canoe. I bet she could help you find a way to make seats in your ballpark.*

*Kobe, you are so skillful at tearing pieces of masking tape. Will you show us how you do it?*

As children complete their sculptures, they can set them on a shelf or table to dry (if glue was involved) and to keep them out of harm's way until they are arranged in a display.

## Drawing Before Building

A variation on this exploration invites the children to create "blueprints" for their sculptures before they begin to work. This approach encourages children to be more intentional with their work with loose parts.

In this variation, invite children into the studio in the same way, allowing them to take in the materials and consider the possibilities they hold. But ask the children to pause before they choose materials, gathering first at the table to plan their work. Offer drawing paper and black drawing pens, and invite them to set a course for their sculptural work.

*I expect that the loose parts gave you some ideas about what you could create. What ideas do you have?*

*Close your eyes for a minute and think about what you want to make. Can you see a picture of it in your mind? Notice all its parts . . . Once you have a picture in your mind of what you want to build, you can draw your plan. Your drawing will be your directions for how to build.*

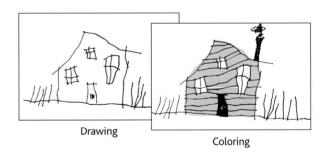

Drawing

Coloring

Coach children about the difference between drawing and coloring.

*When you draw an idea, you make the lines that show its shape. When you color, you put color and decorations inside and on top of the lines.*

*When we draw a plan for making a sculpture, we want to see the lines clearly. We don't color our drawings, because that can make it hard to read the drawing. The drawing is like a set of directions. It tells you about the shapes of your idea and how the shapes fit together. It's important to be able to read it clearly.*

As children sketch their plans for their sculptural work, invite them to consider details and include those in their drawings.

*You sketched a tall, tall skyscraper! Are there any windows in that building? I see the door, here at the bottom, but I don't see any windows, so I didn't know if you planned on putting windows in your skyscraper.*

When children have created their line drawings, invite them to take their sketches to the collection of loose parts and choose what they'll need to bring their drawings to life.

*Look at your plans for what you'll make. What sorts of shapes do you notice? You can look for materials with those shapes in the loose parts.*

*In your drawing, I notice a long, thin, rectangular shape. Let's look for a box like that.*

Children can, of course, come back to the loose parts as they work; this is just the first supply of materials to launch their work.

When children have gathered a collection of loose parts, help them set up their work space. Leave an open space for work, and arrange the loose parts and the drawing around it. The drawing ought to be somewhere close at hand so that children can refer to it as they work; clear plastic stands, like cookbook holders or display frames, work well for this.

Once they're settled into their work spaces, children can begin to shape and assemble their loose parts to fit their plans. This is challenging work, moving from two dimensions to three! Stay close, ready to offer coaching, technical assistance, and generous encouragement.

*Your plan tells you how to build. You can look and build, look and build. One bit at a time, and you'll create your sculpture!*

*I see lots of seats in your plan for a canoe. Let's count how many seats there are in your directions. That'll tell us how many Popsicle sticks you need.*

*I notice that you're starting to add film canisters to the wings of your airplane, like jet engines. But I don't see any engines on the wings of your airplane in the directions. You've*

*noticed something that was missing in your first plan! How about changing your drawing to show this new idea?*

The process of drawing and then building demands attention to detail. It requires that a child capture an idea on paper, moving between the two dimensions of a sketch and the three dimensions of "real life." This is a stimulating intellectual endeavor and deserves our respectful, unwavering support.

## CLEANUP

By the time children have crafted sculptures with loose parts, there will be bits of cardboard boxes, tubes, cork, wood, and paper scattered on the table and floor. There will also be tape and glue stuck to these surfaces. With the children, scoop the leftovers into the trash and wipe up the glue.

## DOCUMENTATION AND DISPLAY

Both approaches to loose parts—open exploration that allows the materials to lead the children and intentional, formally planned representational sculpture in which children draw directions for their work—invite children into relationships with found materials.

Graziella Brighenti, an educator in Reggio Emilia, has said that materials have a right to be listened to and understood, that they have the power to invoke in us our own experiences. "They can also suggest to us a memory of what the particular object could be," writes fellow educator Elena Giacopini. "No two people have the same idea of a piece of wood or plastic." Alba Ferrari concludes, "Materials . . . seem to have their own inner life and their own story to tell. Yet they can only be transformed through the encounter with people . . ." (Gandini and Kaminsky 2005, 6). The story of loose parts is the story of the encounter between materials and children in which both are the protagonists. In the interplay between them, sculpture is born.

Take photos that capture the interaction between materials and children: children's hands molding a piece of cardboard, a box being shaped into an ice

cream truck. If children are working from sketches, take photos that include the sketches as well as the work in progress, creating a visual link between these two expressions of a child's idea. Photograph each step in the sculpting process to create a visual narrative. Be sure to take photos of each child's completed sculpture.

Make notes during the children's work:

- What qualities draw the children to particular materials?

- What images, memories, and sounds do the materials evoke in the children?

- How do children describe their intentions about how they'll use the materials?

- What stories do the children tell as they work?

- What technical challenges do the children face? How do they solve them?

- How do the children teach each other building strategies and ways to use tools?

Create a bulletin board, wall, or shelf display that invites viewers to consider the identities of the materials. Attach a range of loose parts to the board or set them on the shelf, with questions similar to those you posed to the children:

*What qualities of this material stand out to you? Its color? Texture? Shape? Size?*

*What kinds of lines and shapes catch your attention?*

*What does this material remind you of?*

*How can you imagine using this material?*

In your display, emphasize the technical skills needed for sculptural work with loose parts. Use large photos of children at work to illustrate these skills, captioned by children's explanations of the strategies they were using in the photo. For example, underneath a photo of a child threading yarn through a hole in a yogurt lid, include a statement by the child about why she chose yarn to attach the lid to the box.

To display children's finished loose-parts sculptures, set them on a shelf with mirrors or reflective paper behind and under them. This allows a viewer to see the sculptures from a range of perspectives. Create museum-like identification cards: black lettering on white cards, folded so that they stand alongside each sculpture, with the name of the sculpture and the name of the artist: "Canoe, by Rowan."

march 18

Grifinn's plan for her box construction was detailed and complex: "I'm gonna make a merry-go-round," she decided, and she began to draw a festive, carnival sort of picture, with a merry-go-round (Grifinn ended up designing a Ferris wheel, but I maintained her original language), a big sign announcing the ride, and a woman pushing a cart full of cotton candy and other circus treats.

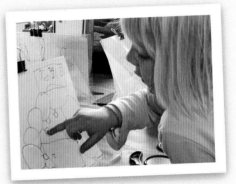

Once her drawing was complete, Grifinn gathered the materials she needed to make her merry-go-round: a small box, sticks, and juice can lids. In choosing her materials, Grifinn referred several times to her sketched plan. "I need round things like in my picture, for people to sit in." "I need to make the part that holds the seats; sticks will work for that." Grifinn's first step in the construction process was building the frame and attaching it to the foundational box—challenging enough work. But the deeper challenge came as she took up the second step in her construction: attaching the round seats to the frame. Grifinn had chosen metal juice can lids— eight of them to reflect the eight seats in her drawing. But the lids were heavy and threatened to pull down the frame.

We explored other options for the round seats, finally settling on muffin papers. "These are not heavy at all!" said Grifinn. "And they're easier to make stay up."

As Grifinn worked on this element of her merry-go-round, Josephine, watching closely, commented, "It's harder than you think when you draw something to make." Indeed!

Grifinn copied the sign from her plan, taping it into a frame and attaching it to the top of her merry-go-round. The final touch was crafting a woman to stand at the base of the merry-go-round, just as a woman stood near the merry-go-round in Grifinn's directions.

This was intricate, difficult work, and Grifinn was unwavering in her focus and her commitment to realizing her plan. When she finished, her pride was tangible. Satisfying work, translating an idea onto paper and then into three dimensions.

## WAYS TO BUILD ON THIS EXPLORATION

You might use loose parts:

- to explore balance, symmetry, weight, height, and stability;

- to re-create, on a smaller scale, the setting of a drama game or favorite story;

- when children are working with ideas that need to be tested in three dimensions.

# WIRE

Wire is elemental, formed of metal dug from the earth. It smells evocatively of the earth, and is cold and sharp. It is hard, resistant, and strong willed. To forge a relationship with wire, we must be strong willed ourselves, determined and persistent.

Working with wire is a study of line and form. It challenges us to attend to shape, angle, and curve, undistracted by color, texture, or fluid movement.

## MATERIALS FOR THE EXPLORATION

- wire in several gauges—18, 20, and 22 work well—and several types of metal—copper, stainless steel, aluminum, brass (offer each color in a number of gauges). **Note:** Never use wire that has begun to rust because children are quite sensitive to iron poisoning.

- a pair of wire cutters

- several pairs of needle-nose pliers to help with bending and crimping the wire

- masking tape or packing tape to cover the sharp ends of the wire

- unsharpened pencils and dowels in a range of diameters

- beads, feathers, twigs, washers, nuts, and other materials to combine with the wire

## MATERIALS FOR THE CLEANUP

- a trash can

## SETTING UP THE STUDIO

What tone do you intend for the first encounter between children and wire? You might lay white paper or a simple white cloth in the center of the table and set the coiled wire on it so that each coil stands stark against the white background, with wire cutters and pliers at the edge; this announces wire's bold presence. Or you might set the wire in a shallow, natural-fiber basket, and put the tools in another basket or upright in a clay pot in the center of the table; this creates a more soft-spoken introduction between children and wire.

Keep a roll of tape handy. You'll use the tape to wrap the ends of the wire so that they don't scratch the children as they work.

## EXPLORING AND CREATING

Introduce the children to the wire.

> *Wire is made of metal—it comes from deep inside the earth. When we work with wire to make sculptures, we're shaping a part of the earth.*

> *Wire is made from different sorts of metals, which give it different colors.*

Introduce the children to the specific wires.

> *This wire is made from copper—it's a lovely red-gold color . . . This shiny gold wire is made from brass.*

> *Wire comes in different thicknesses, called gauges. We've got 18-, 20-, and 22-gauge wire. The higher the gauge, the thinner the wire.*

After this simple introduction, invite each of the children to choose a type of wire to begin exploring. Help each child cut a length of wire (10 to 12 inches is a good length for initial exploration). You can hold the wire taut while the child uses the wire cutters, or you and the child can squeeze the wire cutters together.

> *Wire cutters are like scissors for wire. Open the wire cutters and put the wire in the cutters where you want it to be cut. Then squeeze the handle tight! That cuts the wire.*

Tape a small piece of masking tape or packing tape to each end of the wire to minimize the pokiness of the wire. Children can help with this.

Once children each have a length of wire, invite them to investigate its properties.

*I wonder what you'll discover about how wire moves and bends and straightens!*

As children fold and twist the wire, work alongside them, calling attention to the movement of the wire, to the shapes it makes, to its smell and color.

*Look at the pointy angle you folded in your wire!*

*I'm trying to make a curve with my wire—not a sharp angle, but a shape like the edge of a circle.*

*Do you notice the sharp smell of the wire? I smell it on my hands. It's the smell of metal, of the earth.*

*Can you find a way to take the bend out of the wire? Try pulling on the ends of the wire, and see if that unfolds it.*

*I'm working with wire that's a higher gauge than your wire. That means it's thinner than your wire. It seems easier to bend and shape than your wire. Do you want to trade for a minute, to feel the difference?*

*The brightness of your silvery wire is lovely next to the deep red-gold of my copper wire.*

*How does the type of metal make the wire easy or hard to bend? Let's try a piece of brass wire and a piece of steel wire, and see if we notice any differences between them.*

Some children will immerse themselves in physical exploration of wire's strength and pliability. They'll make many bends, folds, crimps, and twists in the wire. The wire may become tangled, or even break where it's been folded again and again. These children are forging a relationship with wire, learning how it moves and how it holds a shape. The tangles and breaks in the wire can become frustrating, though, and the children can feel at the mercy of the wire. Encourage these children to approach their work as researchers, making observations and exploring possibilities.

*Your wire is looped around and around, and it's crossing over and under and inside the loops. Let's trace it from one end to the other, like we're following a path. That'll help us learn the story of how the wire became tangled.*

*You're figuring out how to bend a piece of wire to make lots of turns and angles. Will you teach me what you've learned?*

*Your wire broke into two pieces! How did you do that? Let's see if you can do it again! Do you have an idea about what you did that made the wire break? Let's try that on a fresh piece of wire and see if it breaks that wire. It's an experiment about how to break wire, and you are the scientist.*

Some children will be eager to "make something" with the wire, impatient with the process of exploration and quick to move to creating shapes. These children see the lines formed by wire as elements of a story, and they want to tell that story by organizing the lines into place. Encourage these children to linger in the open space of exploration.

*Before we start to make sculptures with the wire, let's make a list of all the things you can figure out about how wire moves and how wire makes shapes. Show me what you've figured out, and I'll write it down on a list.*

*There are some things that an artist needs to know before making sculptures with wire, like how to attach two pieces of wire together. Let's practice that before you start making a sculpture.*

As they explore, the children will grow an intuitive sense of the wire's identity; the initial clumsiness in their hands will relax into familiarity and ease. As this happens, they can turn their attention to some foundational skills for sculpting the wire.

## Introducing Tools and Practicing Skills

A few simple tools expand the possibilities for shaping the wire. Unsharpened pencils and dowels in a range of diameters can help shape the wire into coils, loops, and spirals.

*Try wrapping the wire around a pencil. The wire gets very curvy!*

*See what you can discover about how to make tight curls and loose curls with the wire on the dowels.*

Needle-nose pliers become an extension of a child's hand, allowing greater strength and a tighter grip on the wire.

*Needle-nose pliers let you be very firm with the wire. They give you a strong grip and let you be the boss of the wire. Try using the pliers to hold the wire while you bend it. And try using the pliers to squeeze a bend really tight, into a sharp angle.*

*The pliers let you tug on the wire and pull it into the shape you want. They also let you twist the wire.*

A primary challenge with wire sculpture comes in the effort to keep one section of a shape intact while working on another section of the wire. Bending and pulling on one bit of the wire can pull another section out of its carefully formed shape. It's a dance of finesse: work on the new section a bit, go back to the old section and reshape it, turn again to the new section, revisit the old section to tuck things back into place . . . back and forth, shifting attention and effort. Skill comes from practice; knowledge comes from experience.

Another aspect of working with wire is exploring how to connect two pieces together. Possibilities include bending one end of a piece of wire into a hook, catching another piece of wire with the hook, and then twisting the hook until it's holding tight to the straight wire, or crossing two ends of wire into an X and twisting them until they are cinched tightly together.

A challenge with attaching two pieces of wire is that the wire can slip and flop around unless it's tightly cinched together. Pliers are useful for squeezing the wire snugly into place so that it holds its position and shape.

Wire lends itself to silhouettes and outlines. Invite children to explore the possibilities for shaping the wire into representational form by sketching a design first and then sculpting.

*Let's draw a flower and then make it with wire.*

*You can lay the wire over your drawing and trace your drawing with the wire. Follow the lines of your drawing with the wire. Bend it to follow the curves in your drawing, and fold it to make the angles.*

Offer the children materials to combine with wire: beads, feathers, twigs, washers, and nuts. Some of these materials can be threaded onto wire, while others can be wrapped with wire. When threading onto wire, experiment with how to keep a bead or washer in place on the wire by looping the wire through the opening a couple of times, forming a circle of wire around the object.

Some children will make sculptures that they want to keep, while others will be content to leave the wire for another round of work. As children finish their exploration or complete a sculpture, help them peel the tape off the tips of the wire. This gives the finished wire work its full integrity.

## CLEANUP

There's not much to clean up after working with wire. Bits of tape and tangled or broken wire can be tossed into the trash. The unused wire and the tools can be tucked on a shelf with the other art materials.

## DOCUMENTATION AND DISPLAY

Wire is a challenging medium. It has a strong physical identity and stubbornness, not yielding easily to a child's direction. It moves in unfamiliar ways, and can lose its shape in unexpected ways. The story of children's encounters with wire is one of determined effort, patient perseverance, and hard-won mastery.

Tell this story by taking close-up photos of children's hands at work with the wire, cutting it, bending it, shaping it along the lines of a sketch, twisting it with pliers. Capture the effortful focus in children's faces as they lean over the wire. Photograph the many forms a child gives to a length of wire, creating a record of the changes and revisions he creates in the wire's shape.

Take notes as the children work:

- What do they notice about the metal, color, and gauge of the wire?

- Do the children compare the wire to other materials?

- What strategies do the children use for shaping the wire?

- What shapes do the children see in the wire? What shapes do they intentionally form in the wire?

- What challenges do the children encounter during their work? How do they move through those challenges?

- How do the children coach and encourage each other during their work?

Your observations, the children's words, and the images of their determined work come together to tell the story of resolute effort, playful discovery, and new mastery.

In your display about children's encounters with wire, use large photos with simple captions to highlight the skills that the children developed: a photo of a child's hands manipulating a pair of pliers, for example, with a few sentences describing how she used the pliers to attach pieces of wire, or a photo of a child's hands shaping the wire into a zigzag, with the description he offered of how he bent the wire.

Your display can include the story of how a sculpture took shape, step-by-step. Arrange a row of photos that trace the many configurations given to a length of wire, and the steps leading up to the final form.

Invite viewers to experiment with wire by adding a pouch of wire pieces to your display. Pose questions about the wire.

*How would you compare the silver steel wire and the copper wire?*

*Try attaching two pieces of wire. Can you copy the technique illustrated by the child in the photo?*

Include children's actual wire sculptures in your display. You might hang their sculptures from a branch or dowel in front of or next to the display board (use clear thread for this, such as fishing line or picture line). You might use small, U-shaped pins to attach sculptures to black foam core or to a bulletin board covered with dark cloth. Or you might use small slabs of clay as stands for the sculptures, pressing the base of the sculpture into the clay while the clay is moist and letting it harden around the sculpture.

February 6

Cecilia, Katie, Laila, Hattie, Emily, and I gathered this morning in the studio to begin an exploration of wire. How does wire bend? Does it work best to hold it at the ends or closer to the middle when trying to shape it? Once bent, how can wire be straightened and reformed? How can we make zigzags, curves, and angles? How can we connect two pieces of wire, or form a closed loop with wire? How do tools like wire cutters and needle-nose pliers work? These were the questions we explored today.

Angles inspired squares . . .

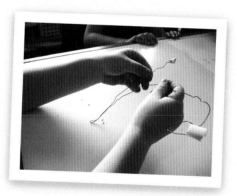

And zigzags reminded Cecilia of the fingers on a hand.

Squares, zigzags, and curves launched efforts to form sculptures. Laila experimented with laying the wire over a drawing and bending it to follow the lines of her sketch, "tracing" her drawing with wire. Cecilia practiced shaping one section of her wire while keeping the other sections intact, gradually forming a sculpture of a hand, finger by finger.

Today, the children began to understand the qualities and properties of wire, working through challenges to grow a sense of competence and skill.

## WAYS TO BUILD ON THIS EXPLORATION

You might use wire:

- when children are exploring silhouettes and lines;
- when children are investigating structural forms.

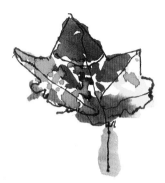

# REPRESENTATIONAL DRAWING AND PAINTING

Still-Life Portraits

Self-Portraits

Murals

In our work with these art experiences, we strive to:

* honor children's eagerness to communicate their experiences, ideas, stories, and feelings;

* encourage children to look closely and to notice details;

* strengthen children's ability to collaborate with each other as they offer each other feedback on their work and craft a piece of art together.

When children draw, they create representations of their experiences, observations, theories, and emotions. Their images tell stories and communicate particular perspectives. Loris Malaguzzi, who founded the preschools of Reggio Emilia, Italy, describes the power of drawing and painting: "Drawing, painting (and the use of all languages) are experiences and explorations of life, of the senses, and of meanings. They are an expression of urgency, desires, reassurance, research,

hypotheses, readjustments, constructions, and inventions. . . . They offer interpretations and intelligence about the events that take place around us" (2005, 9). Drawing and painting are powerful tools for children.

During their work with still-life portraits, self-portraits, and murals, children grow skills for looking closely and for communicating what they see and think. They can use these skills in other ways: For example, they might sketch a block structure they built, using their drawing as a blueprint for rebuilding it another day. They might sketch their ideas for how to arrange the drama area as a house, making their ideas visible for each other. They might illustrate a book that captures a story line from their play at the dollhouse, honoring the drama that they created together. After developing the foundational skills during studio explorations, children can turn to drawing as a tool for thinking and communicating.

I encourage you to use very-fine-tip black permanent markers in the explorations in this section. Black fine-tip markers make a distinct line and don't bleed into the paper, unlike other kinds of markers. Their clarity of line and simple color call attention to shape, outline, and detail. These markers demand a commitment. They ask children to take risks and to make strong statements. As a result, they cultivate in children the disposition to see drawing as an expression of an idea, rather than as an effort toward

representational perfection: the emphasis is on clear, forthright communication rather than aesthetic beauty. A final reason to use these markers is that they photocopy and scan well, so copies of a drawing can be put into a journal or portfolio, included in written documentation and in display, and offered to a child to use for further work.

# STILL-LIFE PORTRAITS

In creating still-life portraits, children form an intimate relationship with their subject. They spend time looking closely, aligning themselves with the subject of their work. Then they translate their understandings of the subject to paper, first sketching with black pen and then adding color.

## MATERIALS FOR THE EXPLORATION

- a subject for the portraits: choose a subject that is visually engaging (with vivid color, form, and texture) and structurally interesting (with clear lines and distinct elements). Possibilities include gourds arranged in a flat wicker basket; a few stems of lilac blossoms or flowering quince in a tin bucket; several sunflowers in a tall vase; or an arrangement of colorful feathers in an earthenware jar.

- black ultrafine-tip permanent markers or other black drawing pens

- a color medium and the tools it requires (see chapter 3, "Exploring Color," for details); watercolor paint, oil pastels, or chalk pastels work best for this type of portrait

- white paper: if the children will be using oil pastels or chalk pastels, use heavyweight drawing paper; if they'll be using watercolor paints, use watercolor paper

- a drying rack or shelves for finished portraits

- jeweler's loupes or other magnification tools (optional; for information about jeweler's loupes, see www.the-private-eye.com)

## MATERIALS FOR THE CLEANUP

- materials needed for the color medium (for details, see chapter 3, "Exploring Color")

## SETTING UP THE STUDIO

Arrange the subject of the still-life portrait and set it in the center of the table. Imagine that you are creating a display for an art gallery or for a botanical garden, a display that will captivate the senses and engage the hearts and minds of people who encounter it.

The table should be empty, except for the subject in the center.

Have paper and drawing pens ready on a nearby shelf or table. Set the color medium and the tools it requires on a tray or shelf, ready to be used but out of the way. If you've got jeweler's loupes or magnifying glasses, tuck those aside in a basket or on a tray.

Set out the materials for cleaning up the color medium.

## EXPLORING AND CREATING

Welcome children into the studio by introducing them to the subject as though you're introducing two dear friends, eager for them to know each other's stories.

*These sunflowers had a long journey to get here. They began as tiny seeds in the dark earth. Small, white roots cracked the seeds open and took hold in the ground. A stem pushed up through the earth. The first leaves began to uncurl, and the flower took shape. At first, it was a tight fist of green holding all this yellow inside, but then the fist opened slowly to the sun, and the yellow petals stretched and grew. The deep brown center of the flower turned toward the warm, bright sun. That's how the sunflowers were born.*

*A farmer cut the flowers and took them to the market, where I saw them. I thought of you when I saw the sunflowers—I thought, "The*

*children would be happy to know these sun-flowers, and these sunflowers would be happy to know the children." So I bought the sunflowers to bring to you.*

## Looking Closely

Invite the children to step into a relationship with the subject, looking closely, touching it, and smelling it.

*What does the stem feel like? Can you feel the rough hairs that run up the stem?*

*What do the petals feel like? Touch them to your cheek—feel their softness on your skin.*

*Do you notice any smell with the petals? The stem? The leaves?*

Point out details of color, texture, line, and form. Offer magnifying glasses or jeweler's loupes to the children, if you've got them handy.

*Do you notice that the leaves are thick and round, then pointy at the tip?*

*Look at the shape of a petal: long and thin, with curving sides.*

*The yellow of the petals fades nearly to white where they attach to the center. Do you notice that?*

*The center of the sunflower is dark brown. It looks like it's made of hundreds of tiny hairs!*

Call attention to the relationships among the elements of the subject.

*Notice how the petals connect to the center of the flower.*

*Do you see how the leaves point straight up and out from the stem?*

Suggest new perspectives from which to look.

*Let's trade places with each other so we can look at the sunflowers in new ways.*

*If you lay your head down on the table, you can see underneath the flowers. There are gigantic green petals under the yellow ones!*

*Try standing on your chair and looking at the sunflowers from above. What do you notice about them when you look from up high?*

Encourage the children to share their observations with each other.

*One of you is looking underneath and one of you is looking on top. I wonder how the sunflower looks different for each of you.*

Don't rush toward the drawing, but leave plenty of time for the children to come to understand the subject's character. Their understandings will be important for their drawing, as they capture the lines, shapes, and spirit of the subject.

## Drawing

After substantial time building a relationship with the subject, invite the children to settle into their work spaces around the table and prepare to create a portrait of the subject.

*We'll use drawing pens to sketch the sunflowers. Our drawings will help people get to know the sunflowers.*

Offer each child a piece of drawing paper and a black drawing pen; help him orient the paper at his work space in a way that fits best with the subject. Paper laid vertically on the table works well for portraits of tall subjects, and paper laid horizontally on the table makes most sense for wide subjects.

Remind the children about the difference between sketching or drawing and coloring.

*When you draw an idea, you make the lines that show its shape. When you color, you put color and decorations inside and on top of the lines.*

*Drawing pens are best for drawing the shape of something. They make strong, clear lines. Paint and pastels are best for adding color to a drawing. First, we'll draw with drawing pens, then we'll use watercolor paints/oil pastels/chalk pastels to add color.*

You might demonstrate the difference between drawing and coloring.

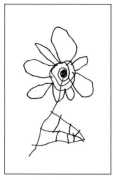 

Drawing         Coloring

The intention in emphasizing drawing rather than coloring is to call children's attention to the structure, the "bones" of a subject: its lines and form. Once the skeleton of the subject is captured on paper, color can be added to bring a subject fully to life.

Invite children to begin their drawings.

*We'll start our portraits of the sunflowers by sketching their shapes—the outside lines of the petals, the center, the stem, the leaves, and the vase that the flowers are in.*

*Look a little, then draw a little. Look and draw . . . Keep studying the sunflower while you draw so you get all the details you can in your drawing. You can take all the time you need to look and draw.*

As children begin to work, move from person to person, offering quiet support and gentle provocation. Point out details of the subject and help a child think about how to include those in her sketch.

*Remember the tiny, rough hairs on the stem? Look closely at those again and feel them on your hand. How might you include those in your portrait?*

Respectfully call attention to missing or incongruous elements in a child's drawing.

*I see in your drawing that you made petals that are very round. But the petals on the sunflowers are thin, with a pointed tip. Let's think about how you might make petals in your portrait that are more like the petals on the sunflower. Do you want to practice that shape on some scrap paper?*

Some children will fall back on "default" images as they draw, instead of sketching the specific details of the subject; for example, a child might draw her typical flower with big, looping petals, a stem, and two big leaves at the bottom. Call these children back to the particulars of the subject.

*You know how to draw an idea of a flower—it's a flower you've practiced many times. Today, we're drawing these sunflowers. They have a different shape than your idea of a flower. It's harder work than drawing your usual idea of a flower, but you can do hard work. I'll stay with you and help.*

Children will likely encounter elements of a subject that are challenging to capture on paper. Stay close during these difficult moments, offering coaching about how to move through them. Break the challenging element into its component shapes and lines.

*The green leaves are hard to draw, you're right. Let's look at the shapes we see in them. Do you see skinny triangles? That's what I notice. They look similar to the shape of the yellow petals, only much bigger.*

Occasionally, a child will feel really frustrated with her sketch. Help her articulate the problems she sees in her sketch, remind her that she can start again, and that you're right there to help.

*What is it that you don't like in your sketch?*

*We've got plenty of paper, if you'd like to start again. Let's think about what you want to do differently next time. I'll help you remember the changes you want to make.*

*Let's practice that shape on some scrap paper until you feel ready to put it in your portrait.*

Watch closely for cues that a child is done with her sketch. Children sometimes keep drawing after they've finished a portrait—"doodling" over the lines, or starting to color in their sketch with the drawing pen, or adding unrelated details (a sun, a house). We can help children see the integrity of their work.

*It looks to me like you've just about finished your sketch of the sunflowers. Let's step back*

*a minute and look at your drawing and at the sunflowers to see if you've got all the details you want.*

*Is there anything else you want to add to the sunflowers or the vase? If not, let's put your drawing pen away and get ready to add color to your portrait.*

### Adding Color

As children finish their line drawings and put their drawing pens away, invite them to consider the colors they want to add to their portraits.

*I see different shades of yellow in the sunflowers' petals. Do you notice that? Let's think about how we can get those shades of yellow in the portrait.*

Help children get set up with the color medium, arranging their work spaces for watercolor painting, or for using oil pastels or chalk pastels. Since the children will likely finish their drawings at different rates, you will probably help one or two children at a time get set up. Encourage children to select a palette of colors that reflects the subject, emphasizing again that this work is about creating a portrait of this specific subject, with its unique colors and shadings.

As children begin to add color to their portraits, invite them to move with the same gentle and deliberate pace that they used as they sketched.

*Look and paint, look and paint . . . You can take all the time you need to add color to your drawing.*

*You're bringing your drawing to life with color! I see you looking closely at the center of the sunflowers, and taking the time to create just that shade of brown on your portrait.*

Stay alert to cues that a child is finishing his work. Suggest that he step back and look at his portrait, pausing to evaluate his work.

*It seems to me that you're nearly done adding color to your portrait. Put your brush down and take a step back from the table so you can look at your work with fresh eyes. Is there anything else you want to add to your portrait?*

When a child decides he's finished with his portrait, help him hang it on the drying rack or lay it on the drying shelf. Then ask him to clean up the color medium as appropriate.

## CLEANUP

Make sure the drawing pens are tightly capped so they don't dry out.

Keep the subject close to the children over the next days, so they can continue to grow relationships with it. You might tuck the sunflowers into unexpected places on the playground, for example, or set the vase of flowers in the drama area. You might invite children to look at the subject from other perspectives, creating a little book that tells the story of the subject's experience of being looked at closely and being beautifully sketched. Use the subject with dough or clay, pressing it into the receptive medium to create imprints. Or you might invite children to create wire or clay sculptures of the subject, moving into three-dimensional representation.

## DOCUMENTATION AND DISPLAY

Creating still-life portraits is an intimate process. The portraits speak eloquently about the subject and about the artist. The story of their creation is the story of serious attention and sweet surprises. Children give themselves over to the subject, which in turn opens itself to them. In the language of *The Little Prince,* "An ordinary passerby would think that my rose looked just like you—the rose that belongs to me. But in herself alone she is more important than all the hundreds of you other roses: because it is she that I have watered; because it is she that I have put under the glass globe; because it is she that I have sheltered behind the screen; because it is for her that I have killed the caterpillars (except the two or three that we saved to become butterflies); because it is she that I have listened to, when she grumbled, or boasted, or even sometimes when she said nothing. Because she is *my* rose" (Saint-Exupery 1943, 73).

In the children's efforts to create portraits of the subject, the subject becomes unique to them. Their

portraits capture the ways in which they come to know the subject's identity. Your written documentation and display can tell the story of this deep and honest relationship.

Take a close-up photo of the subject to anchor the story in your written documentation and display. Photograph the children as they study the subject, with attentive faces and inquisitive hands. In your photos of the children drawing and painting, try to include a bit of their work and a bit of the subject; this brings all the actors in the story together.

Make notes about the children's work:

- What catches the children's attention about the subject? What surprises them about it?

- How do the children describe the subject?

- What challenges do the children encounter in their sketching? How do they navigate those challenges?

- How do the children coach and support each other as they work?

Ask children for their thoughts about the subject.

***What if someone had never seen a sunflower? What should she know about sunflowers?***

In your display, use a full-sized photo of the subject, or set the subject on a shelf alongside the display: a vase of sunflowers on the shelf below the bulletin board, for example. Intersperse children's still-life portraits with photos of the children getting to know the subject and working on their portraits. Include the children's reflections on the identity of the subject.

Consider including a poem or other literary text in your display; the poetry of writers such as Mary Oliver, Wendell Berry, and Pablo Neruda brings elements of the natural world to life. You might include the brief quote from *The Little Prince,* cited earlier. When we locate poems and other writing alongside children's work, we respect children's place in the lineage of artists—people who feel deeply about the natural world and give expression to their feelings with language and imagery.

Invite viewers to study the children's portraits, offering a few questions for reflection.

*These portraits tell the story of sunflowers. What story do you see in this child's painting?*

*These portraits also tell the story of the artists. How does this portrait help you know the child who made it?*

*What does this portrait tell you about how this child sees the world?*

November 20

"You first need to know a sunflower before you can paint its portrait," I commented as Lukas, Raven, Mahalia, and Henry gathered in the studio this morning. "We'll take time to look closely at the sunflowers. Notice the shape of their petals and their leaves. Study the way that the stem holds the flower. Feel the softness of the petals against your cheek. When we feel like we understand these sunflowers, we'll create portraits of them."

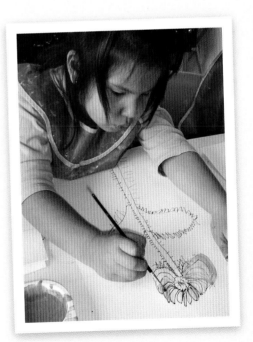

After studying the sunflowers up close, the children used fine-tip permanent markers to create a sketch of the

sunflowers. Then we mixed tempera paint in shades of yellow-gold, deep dusty green, and rich brown. The children added color to their line drawings, adding a bold vitality to their sketches.

The children's portraits of the sunflowers are full of life, communicating the children's understanding of the nature of sunflowers. "A flower is relatively small," writes the painter Georgia O'Keeffe. "Everyone has many associations with a flower, the idea of flowers. You put out your hand to touch the flower and lean forward to smell it, maybe touch it with your lips almost without thinking, or give it to someone to please them. Still, in a way, nobody sees a flower really, it is so small, we haven't time. And to see takes time like to have a friend takes time."

Today, Lukas, Raven, Henry, and Mahalia became friends with sunflowers, opening themselves to the flowers' color, line, texture, and heartbeat, embracing and embraced by the sunflowers.

## WAYS TO BUILD ON THIS EXPLORATION

You might invite children to create drawings of objects:

- to call their attention to details of the object: sketch a block castle to draw attention to the symmetry of the structure, for example;

- to take different perspectives: invite two children to sketch a block castle, each from a different side of the castle;

- to illustrate a set of directions for a construction;

- to sketch the steps in a physical skill: have a child pose with a baseball bat before a swing, and again after a swing, while another child sketches her stance.

# SELF-PORTRAITS

As we move through our days, we experience ourselves from the inside looking out. It can be startling to catch an image of ourselves in a mirror or a window, a brief glimpse of ourselves from the outside. When we invite children to create self-portraits, we offer them mirrors and encourage long, sustained study of their faces from this unfamiliar perspective. Then we ask them to re-create themselves on paper, weaving together the image that they see in the mirror with the person they experience themselves to be. Their portraits are eloquent statements of self.

### MATERIALS FOR THE EXPLORATION

- black ultrafine-tip permanent markers or other black drawing pens
- plenty of white drawing paper
- a mirror for each child: free-standing cosmetic mirrors work well

## SETTING UP THE STUDIO

Set a mirror at each work space around the table—a simple, provocative invitation. Experiment to get the angle of each mirror just right: sit in the chair, hunch down to the children's height, and adjust the mirror until you see your face in it. Do this so that the mirrors are ready to capture the children's faces as soon as they sit at the table.

Keep the drawing pens and the paper on a nearby shelf or table, handy but out of the way.

## EXPLORING AND CREATING

### Looking Closely

Welcome children into the studio with a lighthearted invitation.

*Find a work space and look in the mirror waiting for you. Whom do you see looking back at you? We're going to create portraits of the person you see in the mirror!*

Invite the children to study their images in the mirror. Likely, they'll already be calling out to each other about what they notice about themselves, and making all sorts of silly, scary, sad, and angry faces in the mirrors. Allow plenty of time for this playful exploration.

*Look at that goofy grin! That makes me smile—and my smile appears in my mirror. Look in my mirror and you can see my smile about your silliness!*

*You're sticking out your tongue at yourself in the mirror! What do you notice about your tongue when you look at it in the mirror?*

*Your eyebrows change a lot when your face moves from scared to mad. They start way up high, then scrunch up low. Do you notice that?*

*Look at your friend's face in his mirror—and now there you both are in his mirror!*

After a satisfying stretch of time playing with the mirrors, invite the children to focus more specifically on details of their faces. Quietly and slowly lead the children through a step-by-step examination of their faces, pausing after each question to allow silence and time for the children to look closely at themselves in their mirrors.

*Let's each look in our own mirrors now and study the details of our faces.*

*Notice the shape of your face. Is it round? Oval? Is your face thin? Long? What is the shape of your face?*

*Look at the shape of your eyes. What shape are they? Inside your eyes, do you see a circle of black inside a circle of color? What color are your eyes?*

*And do you see the eyelashes around your eyes? Some people have short, straight eyelashes. Some people have long, curling eyelashes. What kind of eyelashes do you have?*

*Notice the shape of your eyebrows. See how they curve over your eyes.*

*Notice the shape of your nose. Look at the slope of your nose, and the way your nose opens into nostrils. What's the shape of your nose?*

*Look at the shape of your mouth when you're not smiling, but just looking. How do your lips fit together? Look at how your top lip curves. Do you see the little indentation between your lips and your nose, like a very faint line?*

*Notice the shape of your chin. How does your chin fit below your lips?*

*Observe the shape of your cheeks. Are your cheeks rounded? Can you see the shape of the bone under the skin on your cheeks?*

*Notice the shape of your ears. Can you see your ears, or does your hair cover them? If you can see your ears, look at their curving lines. Can you see the opening in your ears?*

*Notice the shape of your hair. Is your hair curly? Straight? Does your hair come onto your forehead in bangs? Is your hair pulled back so you can see a line above your forehead where it grows on your head? Does your hair cover your ears? Touch your shoulders?*

The tone of this litany of questions is one of quiet respect. It is a call into study rather than a forceful interrogation. These questions—and time to linger with them—are a way to honor each child; with our questions, we say: "Look at yourself, you beautiful, marvelous person. Look at your unique and precious eyes, nose, mouth, ears. In all the world, only you look like this. You are a gift to us. You are worthy of close and careful study."

## Drawing

After this time of quiet, intimate reflection, invite the children to capture their observations on paper.

*We've looked closely at our faces in the mirror, and now we'll sketch our faces on paper. When*

*an artist makes a drawing of herself, it's called a self-portrait. We'll each make a self-portrait.*

Offer each child a drawing pen and a sheet of white paper. Help each child arrange his work space so that the paper is directly in front of him, with the mirror near the upper edge of his paper. Adjust the angle of the mirror so that it captures the child's image.

Remind children about the difference between drawing and coloring.

*When you draw your face, you make the lines that show its shape. When you color, you put color inside and on top of the lines.*

*Drawing pens are best for drawing the shape of something. They make strong, clear lines. We'll use drawing pens to make our self-portraits.*

Invite the children to begin their sketching, offering them a simple rhythm for their work.

*Look and draw, look and draw . . . look closely at your face in the mirror to see its shape. Then draw the shape you see. Then look again in the mirror to see the shape of your eyes. Draw the shape you see. Look and draw, a little bit at a time.*

Help children decipher the lines of their faces.

*Your ear has long, curving lines. Let's look at the outside edge of your ear. It curves way up, then slopes back down to meet the side of your head. Near the bottom, just before it touches your head, it curves gently downward.*

Call children's attention to elements that are missing from their portraits.

*I'm noticing that your eyes in your portrait don't have eyelashes. Take a look in the mirror to see how your eyelashes fit around your eyes. How can you include eyelashes in your portrait?*

Occasionally, a child struggles with the intricacy of this work and begins to "default" to her standard drawing of a generic face. When this happens, gently and respectfully call her back to the challenge of the work.

*I notice that you're starting to draw a face like you usually do when you draw. But today, we're*

*working with mirrors so that we can draw our own faces. I'd like you to stick with this work and try this new way of drawing a face. Let's get a fresh sheet of paper and start your self-portrait again. This time, you can look and draw, look and draw, one bit at a time. I'll sit with you and help you figure out the hard parts.*

Watch closely for cues that a child is done with her self-portrait. Children sometimes keep drawing after they've finished—"doodling" over the lines, or starting to color in their sketch, or adding unrelated details. Help children see the integrity of their work.

*It looks to me like you've just about finished your self-portrait. Let's put the cap on your drawing pen for a minute and look in the mirror and at your drawing. When you look at your self-portrait, is there anything you want to add or change?*

*If you'd like to keep drawing, let's get a fresh sheet of paper. This sheet of paper is just for your self-portrait.*

Sometimes, children are eager to create several self-portraits, immersed in the richness and pleasure of the experience and excited to deepen their skill. As a child finishes his self-portrait, ask if he'd like to sketch another.

*You made a detailed self-portrait. Do you feel done with this work, or do you want to draw another self-portrait?*

Gather children's portraits as they finish, tucking them away for display and for their portfolios or journals.

## CLEANUP

Cleanup for self-portrait work is minimal. You might tuck the mirrors safely into a basket or box, or you might set them out on shelves around the classroom where they'll catch images of the children at play, inviting the children to continue to interact with their reflections.

## DOCUMENTATION AND DISPLAY

A self-portrait is an intimate, bold declaration of identity. In her self-portrait, a child offers herself as both subject and artist. When we look at her self-portrait, we see a child as she sees herself. The story of self-portrait work is a tender story to tell.

Take photos that capture the children's playful exploration with the mirrors, as well as their more focused study of their faces. As children look and draw, record their work with photos that include both their sketches and their faces reflected in the mirrors.

Make notes about your observations as children work:

- How do the children interact with their images and with their friends' images as they first begin to play with the mirrors?

- What similarities and differences do the children notice among themselves as they look in the mirrors?

- How do the children describe themselves as they look in the mirrors?

- What sorts of details do children include in their portraits right away? What do they forget until you nudge them?

- What challenges do the children encounter while they sketch? How do they move through those challenges?

- In what ways do the children encourage or coach each other during their work?

To display the children's self-portraits, frame each drawing by putting a black piece of paper behind it. Intersperse the children's self-portraits with large photos of them at work. Consider placing photos of children's faces next to their self-portraits. In your display, include comments that children make about themselves as they look at their faces in the mirrors.

Invite viewers to make meaning of the children's portraits.

*These self-portraits are windows into the children's identities. Their details tell us how the children see themselves and what they choose to emphasize in their drawings about themselves.*

*What can you learn about this child from his portrait? How does his portrait help you know him better?*

Consider including prints of other artists' self-portraits, representing a range of styles: Pablo Picasso, for example, or Vincent van Gogh, Frida Kahlo, or Andy Warhol. This sets the children's work in the context of the ages-old effort to capture in portraits the essential aspects of our identities.

Consider including a mirror in your display, alongside questions that invite viewers to study *their* faces.

*What do you see when you look in the mirror? What stories does your face tell?*

*How would you describe the shape of your face? Your eyes? Your nose and lips?*

*What do you love about your face?*

June 9

Alex, Ana, Beck, and Angus crafted self-portraits in the studio this morning. Before drawing, the children gazed long and hard at their images in mirrors, noticing details of their faces: the shape of eyes, noses, lips, ears. They studied the relationships among these distinct elements of a face, exploring the way that the space between eyes becomes the bridge of a nose, for example, or the way that the indentation between nose and upper lip echoes the line between

nostrils. They looked closely at the way that their hair falls around their faces, and whether their ears are hidden or visible.

And then the children translated their images onto paper with black drawing pens. They moved between looking closely in the mirror and drawing what they saw: "Look and draw, look and draw": this refrain marked the rhythm for their work.

The children's self-portraits are revealing and tender. In their drawings, the children make visible the intimate details of their faces and capture their spirits.

Alex

Ana

Angus

Beck

## WAYS TO BUILD ON THIS EXPLORATION

You might invite children to create portraits of themselves:

- during an exploration of identity, life cycles, or family;

- during a study of emotion: create an angry self-portrait, a joyful self-portrait, a frightened self-portrait.

You might offer children other art media to use for their portrait work, such as:

- clear plastic, like a transparency: children can draw on it and then wear it as a mask (make sure to cut a hole near the mouth and nose so children can breathe);

- fabric: children can draw on it to create the head of a stuffed doll;

- clay or wire: children can use a sketched self-portrait as a guideline for a sculpture made of clay or wire.

You might turn to portrait making to deepen relationships:

- Invite children to draw portraits of friends or people in their families.

- Create a book of self-portraits—bind copies of children's portraits, then cut the pages into thirds: forehead to eyes; nose, cheeks, and ears; mouth and chin. Children can assemble composite images made of several friends' features.

# MURALS

When children collaborate on a mural, they bring an expansive idea to life. In this process, they take new perspectives, looking through each other's eyes to negotiate the size, location, and scope of the images in the mural. Murals collect multiple ideas in one place, summarizing and expanding a group's thinking. The art of mural making is both visual and relational.

### MATERIALS FOR THE EXPLORATION

- a large piece of paper or canvas: a length of butcher paper works well, or an artist's canvas that's been treated with gesso and stretched onto a frame (most commercial canvases are pretreated and framed)
- a clean drop cloth, newsprint, or butcher paper to cover the floor
- black ultrafine-tip permanent markers or other black drawing pens
- a color medium and the tools it requires (for details, see chapter 3, "Exploring Color")
- trays to hold the color medium and its tools
- space for the mural to dry flat
- examples of murals from art books or posters (optional)

**A note about choosing a color medium:** All color media will work fine on paper, while only tempera or acrylic paints lend themselves easily to canvas. On paper, watercolor paint lets the black pen lines show fully and brings a vibrant glow to a mural. Oil pastels add bold color, but cover over small details. Both oil pastels and chalk pastels add interesting texture to a mural, but become tedious for filling large spaces. Tempera paint tends to obscure the lines of drawings and "blurs" the images in a mural. You might choose one medium that fits well with the size or subject of the mural, or you might work with several media: a watercolor wash over oil pastels makes a lovely full-color background, like a sky or the ocean's water. There are many possibilities to try—a good reason to create murals often!

### MATERIALS FOR THE CLEANUP

- materials needed for cleaning up the color medium (for details, see Chapter 3, "Exploring Color")

## SETTING UP THE STUDIO

It's easiest to create a large mural on the floor rather than on a table, which can restrict children's reach and movement. Move the table and chairs to the side to clear a large work space on the floor. Give the floor a quick sweep, then cover it with a drop cloth, newsprint, or butcher paper. The drop cloth or other floor covering should extend several feet out from the mural on every side, creating a work space around the mural. There should be plenty of room around the floor covering for you and the children to sit on the floor and to walk around the mural.

Lay the paper or canvas for the mural on the floor, centered on the drop cloth. This is a bold enticement: the floor, usually hidden underneath table and chairs, now holds a large, blank invitation.

Set drawing pens for each child to the side, ready to use but initially out of the way.

Arrange the color medium and the tools it requires on trays, creating portable workstations. You might decide to create a color workstation for each child or set up workstations for children to share. If you decide to have children share workstations, it's easiest to have two children share one station; more than that becomes challenging for the children to reach the materials. Set these color workstations to the side.

Set out the materials for cleaning up the color medium.

## EXPLORING AND CREATING

Invite children into the studio in the spirit of a grand adventure.

*Look at the studio! The floor is holding a big paper/canvas for us.*

*That big paper/canvas can tell a big story. We're going to tell that story together, by making a mural.*

Ask the children to take off their shoes; this protects the work space.

Gather with the children around the paper or canvas on the floor. If you anticipate that the mural will have a bottom and top (earth/sky, above-ground/below-ground, for example), invite everyone to sit along one side to begin to establish a perspective on the mural.

Introduce the notion of a mural.

*A mural is a really, really big picture, made up of lots of smaller pictures. Sometimes a mural is as big as a wall!*

If you've got examples of murals in art books or posters, share these now. With the children, notice elements of a mural.

*Each of these murals tells a story or an idea. Let's see if we can figure out their stories and ideas.*

### Making a Plan for the Mural

You may already have a particular subject in mind for the mural: springtime, an ocean lagoon, or the neighborhood. If you have an idea in mind, describe it to the children.

*We've been paying such close attention to the changes outside as winter ends and spring begins. We've been noticing the buds forming on tree branches, and the little purple crocuses poking out of the earth. I thought we could create a mural that tells the story of spring.*

If you don't have a particular subject in mind for the mural, launch a discussion with the children about possibilities.

*A mural is about one big idea that all the artists will work on together. What ideas do you have for our mural?*

There will likely be a wide range of suggestions! You might take notes as the children offer their ideas, creating a list that you and the children can use to track possibilities. The children may come to quick agreement about a subject for the mural, or there may be lengthy debate. As the children suggest possible subjects, listen for proposals that allow for a diversity of images, that fit with the community's values, and that promise to offer a rich visual experience. Participate in the discussion, offering your thoughts about the children's suggestions in light of these considerations.

*When I think about the mural, it's important to me that it tells a kind, peaceful story. A mural about fighting bad guys isn't a peaceful story.*

*Your idea about a forest makes me curious. I can imagine all sorts of drawings and paintings in that mural—trees, bushes, streams, sky, animals, birds. I'd like our mural to have lots of small pictures that help tell a story.*

Once you've settled on a subject for the mural, invite the children's thoughts about what to include in the mural. Make a list as the children offer their ideas.

*What would be important to include in a mural about spring? We can think about what we've been noticing outside the last few weeks.*

During your conversation, nudge the children to refine and sharpen their ideas.

*We put "trees" on our list. Let's think about trees. What sort of trees should we include? How will trees tell the story of spring?*

Children may offer ideas that don't fit with the mural's focus. They may get excited about simply listing things they like, or like to draw! Challenge them to stay focused on the mural's subject.

*This mural is about spring. I don't think of dinosaurs when I think of spring. I imagine dinosaurs in a different mural.*

Once you and the children have generated a substantial and detailed list of important elements to include in the mural, invite each child to consider which elements he'd like to add to the mural.

> *We'll make this mural together. Each of us will draw and paint ideas from our list on the paper/canvas. I'll read the whole list for us. While I read, think about which idea you'd like to put on the mural.*

Ask each child which ideas he wants to draw on the mural. As children choose the elements that they'll draw, review with them the details you've discussed.

> *You want to draw a tree on the mural. Remember that we decided that the tree would have tiny green buds along the branches and a few pink blossoms.*

Finally, before diving into the drawing, make a plan together about how the elements will fit together on the paper/canvas: Will there be a bottom and a top, or is any orientation fine? Some subjects make most sense with a clearly defined bottom/top perspective (springtime), while others can take shape with a mix of orientations (a mural about butterflies, for example, or an underwater scene). If your mural will have a clear bottom and top, make sure all the children understand which edge of the paper is the bottom before anyone starts drawing!

Help each child find a work space around the paper/canvas that fits with the element she's chosen to draw: a child drawing birds in flight can sit along the top edge of the paper/canvas, while a child drawing roots spreading underground ought to sit along the bottom. Make sure each child has plenty of room.

## Drawing

Once children are settled into work spaces around the paper/canvas, offer drawing pens. Remind children about the difference between drawing and coloring; for details on this distinction, see pages 88–89 in the "Still-Life Portraits" section.

> *Our first job is drawing our ideas on the paper/ canvas. We'll use our drawing pens to do that. Then we'll add color with the paints/pastels/ pencils.*

An exception to this rule: If the mural will have a solid background—ocean water, for example, or the earth below ground and the sky above ground—children can add a color wash to the paper/canvas before beginning to draw. On paper use watercolor paint or tempera paint that's been diluted with water. Thinned tempera or acrylic paint also makes a fine wash on canvas. The background wash will need to dry before children can begin drawing; you might decide to do the planning and the wash one day, and add the design elements another day. Or you might do the planning and the wash in the morning, and return to it in the afternoon, when the paper or canvas is dry.

Murals involve quite a bit of collaboration and negotiation. As children begin to draw, stay close to offer support and coaching.

Help children locate their drawing on the mural and in relation to other children's work.

> *Let's see, you're drawing a tree for the mural. How about starting near the bottom of the mural and reaching into the sky?*

> *Your tree could go in the middle of the mural or on one side, couldn't it? Let's talk to the other children who are drawing bushes and trees, and hear their ideas about how your tree can fit with their trees and bushes.*

Help children think about scale.

> *I notice the flowers that your friends are drawing here next to your tree. I bet your tree will be much bigger than those flowers!*

> *Here's a bird flying to the tree branch. How big will her nest need to be, so it's just the right size for her?*

Help children navigate around each other's work.

> *Notice those butterflies on the mural over there. Be sure to stop drawing before you get to them so that your tree branch doesn't cover them up!*

Help children offer each other feedback and suggestions.

> *Your friend is concerned that your bird is too small. Will you talk with her about that? I'll*

*be in the conversation, too, so we can all think together about the bird.*

Call attention to possible relationships to explore.

*Your bird is flying right toward your friend's tree! Does the bird have a nest in that tree? Or friends waiting there for her?*

When a child finishes drawing the first element that he chose, invite him to choose another idea from the list, moving again through the process of locating that element on the mural, sizing it to the scale of other elements, and navigating its relationship with the other elements.

Eventually, the mural will hold a substantial number and variety of elements. It may become visually "full" before all the ideas have been transferred from the list to the paper or canvas. Invite the children to step back and look at the mural, evaluating it.

*Let's look at it from a little distance. Does it tell the story of springtime? Is there anything missing or anything we need to change?*

*I know there are a few things left on our list, but the mural looks full enough to me. What do you think? I don't want it to become too crowded. I want people to be able to see the details you've created. I think we should stop drawing and start adding color.*

## Adding Color

Once you've agreed that the line drawings are complete and that it's time to add color, help the children get situated near the elements with which they'll be working. Sometimes, children want to add color to the elements that they've drawn, and other times, children are eager to add color to other elements. The background will need color, as well, if you haven't done an overall wash; some children will be excited to add these big expanses of color.

When children are settled around the mural, set the trays with the color medium near each child to create individual or shared work spaces. If you've decided to have children share a tray, set the tray between the partners so that they can both reach the tools and the color medium easily. As you arrange the work spaces, remind children about the practices

particular to the color medium; for details, see chapter 3, "Exploring Color." Then invite the children to add color to the mural, honoring the integrity of their drawings:

*You've created some strong drawings that start to tell the story of springtime. Now you can use color to tell more of the story of springtime.*

*Let the lines of the drawings tell you where to put the color.*

As children add color, there will be some negotiating and navigating of space and design, just as there was earlier when they sketched. There will also be the added energy that comes with color and with the texture and fluidity of the media: paint might drip from one child's brush onto another child's drawing, or one child's broad stroke with an oil pastel might collide with another child's equally expansive gesture. These encounters are part of the work of collaboration. As they negotiate space and design, the children also negotiate their relationships.

Help children choose appropriate tools for the size of the space they'll be working on. When a child is covering a large area with paint, offer her a large brush; when a child is working on a small, detailed section, offer fine brushes. With pastels, coach children about how to cover large areas and how to work in small spaces (for example, using the length of an oil pastel to fill in a big space, and a sharp edge to add color to a detailed section).

Every so often, invite children to step back and look at the mural from a new perspective.

*We've each been looking really closely at the bits we're working on. Let's all stand up and look at the whole mural. It's coming to life!*

Eventually, the mural will be full of color, vibrant and expressive. Help each child end her work.

*When you get the last bit of tree trunk painted, I think you'll be done! Step back with me and see if there's anything else you need to add to your tree before you finish.*

*We've been working and working! Sometimes it's hard to stop painting. But if we keep adding color, the mural will become muddy and the story will be hard to see, so we should stop now.*

As children put down their brushes or pastels, have them gather to one side of the mural. Celebrate the work you did together! Raise a cheer, slap high-fives, or share a hug. Creating a mural is an enormous undertaking, and it deserves some whooping and hollering!

## CLEANUP

Clean up the color medium as needed.

Let the mural dry flat. If your space allows, leave it on the floor until it's dry. Keeping the mural flat and on the floor covering while it dries prevents color from running or dripping, and protects the paper from ripping or wrinkling. It's a good idea to gently lift the mural a few inches from the floor covering, and then set it back down to dry; this keeps it from sticking to the floor covering as it dries.

## DOCUMENTATION AND DISPLAY

A mural is an all-encompassing immersion into a shared world: the landscape of springtime, ocean depths, or the city neighborhood. As they plan and realize their vision for a mural, children steep themselves in the smells, gestures, textures, colors, and images of the mural's subject, creating a vibrant visual story.

A mural also tells the story of collaboration and relationship. Through the exchange of ideas, suggestions, and critiques, the children bring another world to life. Your written documentation and display can tell both these stories.

While the children work on the mural, take photos that capture their effort and their collaboration: a child bent low over the paper or canvas, carefully sketching details; several children's hands working close, nearly intertwined; children engaged in serious discussion about an aspect of the mural. With photos, record the step-by-step transformation of empty paper or canvas into a lively mural.

Take notes as the children work, recording your observations about their collaboration:

- What decisions do the children make about the design of the mural? How do the children take each other's ideas into account as they plan the mural?

- What memories and stories do the children share with each other as they plan for and work on the mural? What similarities and differences do they notice among their memories and stories?

- How do the children make room for each other around the mural? How do they navigate around each other's bodies, arms, hands?

- What sorts of suggestions and encouragement do the children offer each other as they sketch and add color?

When you hang the mural for display, include photos and text that tell the story of the children's collaboration. Consider including the original list of elements that you and the children wrote and invite viewers to find those elements in the mural.

You might invite the children to create a simple poem or a prose reflection related to the mural's subject, giving voice to the smells, textures, meanings, and emotions that they encountered as they worked on the mural. Add this poem or prose to the display.

April 11

A mural about spring . . .

"What tells the story of spring?" I asked Elena, Abby, Marc, Olivia, and Henry, gathered in the studio this morning. "What do we need in a mural about springtime?"

The children were quick to offer images:

- flowers blooming
- the sun shining—and a rain cloud
- birds singing beautiful songs
- butterflies with lots of colors
- trees that are just getting leaves
- roots growing under the earth
- underground creatures like worms and centipedes
- soft dirt, not frozen anymore

With this list as our guide, we began to work on a mural that tells the story of

springtime. Children scooted in close around the butcher paper on the floor, which meant some negotiating as they bonked into each other and spilled out into each other's work space. They began to sketch the ideas from the list onto the paper—which required more negotiating:

"I need room for my tree!"

"The sun has to be really big."

"But there has to be room for my tree—it can't take the whole sky."

"You could make your tree on the other side, away from the sun."

"Your butterfly is as big as the bird! It's as big as the sun! It's too big!"

"make a lot of worms, because they make the plants grow. And in springtime, that's what happens: plants grow."

"But now the worms are as big as the birds! How would a bird eat such a big worm?"

Through their negotiation and conversation, the children forged a shared commitment to their mural. They immersed themselves in the vitality of springtime as they sketched and painted, bringing to life the colors, energy, and expansiveness of spring.

I asked Elena and Abby if I could write down bits of the conversation they had during our work together. Their description of springtime adds new dimensions to the vibrant images in the mural:

In spring, oranges are sweet.

Lavender blooms.

Spring is tulips.

Fall is nice because of its leaves.

Winter is nice because of its snow.

Summer is nice because of its warmness.

Spring is my favorite.

## WAYS TO BUILD ON THIS EXPLORATION

You might invite children to create a mural:

- to explore stories from the community;
- to move from individual to collaborative work;
- to tell of a shared experience in a way that honors each person's perception of the event;
- to revisit a story played out in a drama game;
- to reflect the perspectives of different characters in a book or story: paint murals on sheets of transparent plastic, each mural capturing one character's perspective; layer the murals together when you hang them to call attention to the ways in which individual perspectives come together in one story.

# MOVING ART FROM THE STUDIO TO THE CLASSROOM

In part 2, we move from the studio into the classroom. Children can employ the skills and expertise they gained in the studio explorations to use art as a tool for critical thinking. In chapter 6, we look at how to use art in everyday interactions in the classroom to grow a culture of inquiry. When you are comfortable using art in your everyday practices, you might think about expanding on your inquiries to build long-term investigations. Chapter 7 looks at how to use art to grow long-term, in-depth investigations. Finally, chapter 8 tells the story of a long-term investigation of leaves, incorporating the principles from chapter 7, as well as many of the other ideas from this book.

# GROWING A CULTURE OF INQUIRY THROUGH ART

The art explorations that we offer children in the studio give children fluency with art media. The children carry this fluency into their work and play in the classroom. Art spills out of the studio and into the children's lives, as the language of art becomes the language of learning. Art can become a tool for investigating, asking questions, forming and testing theories, collaborating, and exploring an idea from a range of perspectives—art can grow a culture of inquiry in our programs.

When we put children's inquiries at the heart of our classrooms, we organize our curriculum around teacher observation, study, and responsive planning. We pay close attention to children's play, taking notes and photographs, recording what we see and hear. We study our notes and photos to unearth the meanings in the children's play: What theories are the children exploring through their play? What questions are they asking? What relationships are they building? From our observation and study, we plan ways for the children to explore their theories, expand their questions, and strengthen their relationships. As we plan next steps, we can turn to the languages of art.

A teacher might observe, for example, three children trying to build a really tall tower with wooden blocks—an ordinary moment in an early childhood classroom. The children's tower tumbles and they begin to rebuild it, debating with each other about why it fell and what they ought to do differently this time. As the children talk and build, the teacher takes notes and makes a few sketches of the tower's evolution. The children carefully, hopefully set blocks in place, and the tower grows taller, taller, taller . . . The children discuss how tall the tower should be. One child says that they should aim for the ceiling, stacking the blocks right on top of each other for sturdiness. Another child argues for caution, saying they ought to stop after just a few more blocks because the higher the tower goes, the more likely it is to collapse. The third child suggests a way to stabilize the tower by adding blocks to either side of the tall pinnacle, like support columns.

The teacher jots down the children's arguments, intrigued by their understandings of stability, balance, and symmetry. She sees that the children don't fully grasp each other's thinking, and decides to intervene. She comments, "You have different ideas about how to build this tower. Ty wants to stack the blocks one on top of the other, higher and higher, all the way to the ceiling. Natalie wants to keep the tower steady by not adding too many blocks. And Stu wants to put blocks on both sides of the tower to keep it steady. Let's draw your ideas so that we can understand them better." The teacher offers each child a clipboard with

paper and pens, and asks, "Can you show us your idea about how to build the tower?"

The children dive into their sketching, making marks on their papers to represent their ideas. When their drawings are complete, the teacher invites the children to show each other the sketches of their ideas. The drawings launch a discussion as the children point out different elements and debate the pros and cons of each of their ideas. They can see each other's thinking now and are able to talk together with more understanding. While the children talk, the teacher stays nearby, mostly listening. The children are deeply involved in figuring out a course of action for their block construction and don't seem to need much from her. Eventually, the children decide to add more blocks to their tower, stacked carefully so that the edges line up. They let go of the idea of supports at the sides, and commit to reaching almost to the ceiling.

When the children return to building, the teacher gathers their drawings to keep them safe for later reference. A few minutes into the renewed construction effort, the tower sways as a block is added to the growing stack. The children hold their breath—and exhale in relief when the tower grows steady again. The children take this near miss as a sign that their tower is tall enough! They agree to stop building—and howl with delight at the idea of knocking their tower down in a big crash. But before they give it a push, the teacher steps in. "Before you crash your tower, let's draw it, so you remember your work. You might want to build a tall tower like this again, and your drawings will help you remember how to do it." She offers them the clipboards and pens again. "Let's take a minute to each make a sketch of this tower." She helps each child settle on the floor with a clipboard, positioned so he or she can see the tower clearly. She sits with the children, pointing out details of the tower as she creates her own sketch, and helping when children feel stymied by how to record some aspect of the tower.

As the children finish their sketches, the teacher adds these drawings to the earlier sketches. She's already thinking about possible next steps for the children's exploration of height, balance, symmetry, and stability. She expects that these visual reminders of the children's theories will be useful for extensions of their work, though she doesn't yet know exactly what those extensions will be.

After the teacher collects the drawings, she asks with a grin, "Are you ready to crash your tower?" The

children answer with whooping and clambering. They leap to their feet, toss their clipboards aside, and, together, tumble the tower with a wildly satisfying crash.

When the children's parents arrive at the end of the day, the teacher shares with them the children's drawings and her notes about the project. They talk about the theories the children generated as they built: theories about how blocks balance, what makes a tower tip over, and how symmetrical supports can stabilize a tower. They consider ways they might extend the children's exploration about height, stability, and symmetry, and decide to invite the children to work with cardboard boxes and other "loose parts" in the studio.

The teacher plans to offer the children their drawings to revisit the thinking they did as they built their block tower and to use as blueprints for building towers out of cardboard boxes. She expects their studio work will nudge them to reconsider their theories and to work out some of the kinks in their thinking. She plans to have the children sketch their cardboard box tower, then use that sketch to build again with blocks. They'll use the refined theories and deepened understandings from their studio work to help them build with blocks. The teacher is not sure what will happen after that. She only plans one or two steps, but knows that's enough. She trusts that new possibilities will unfold as she and the children take their next step into this exploration of the dynamics of height.

Through this cycle of observation, reflection, and next steps, a culture of inquiry grows. Teachers, children, and parents are all involved. Teachers move between receptive and active roles. Sometimes, teachers listen, observe, make notes, take photos, and collect traces of children's thinking. Other times, teachers offer activities and materials to deepen and challenge children's thinking. And, often, the activities and materials that teachers offer involve art media.

In growing a culture of inquiry, our focus is not on teaching children information and facts, or to get at some eventual "right answer." Rather, we aim to uncover the questions and theories that underlie children's play and to help the children pursue those questions and theories. We want to support their dispositions to be learners: the disposition to be curious, for example, and to dig deeply into an investigation, embracing new questions as they arise; dispositions to collaborate, to challenge, and to be challenged.

In a culture of inquiry, we stay present to what's unfolding, not trying to see into the future or make plans far in advance. Curriculum anchored in inquiry grows moment by moment, one step at a time, with the authentic participation of everyone in the community. This is invigorating work for teachers, and calls us to be critical and creative thinkers. To do this work, we need to strengthen our skills in observation, reflection, and planning, and in the use of art media to represent ideas and emotion.

Let's look in more detail at the cycle of observation, reflection, planning, and documentation that grows a culture of inquiry. From there, we'll turn to principles, guidelines, and strategies for using art to propel the cycle of inquiry forward.

## HOW DO WE GROW A CULTURE OF INQUIRY?

We *observe* the children's play and *listen* to their conversations carefully. We make notes, take photos, make sketches, and collect other traces of their work.

We *study* these traces of children's thinking to help us interpret the meaning of their play. Through our study, we develop hypotheses about the children's theories, questions, and pursuits.

We *plan next steps* to extend and sustain the children's pursuits. As part of our planning, we consider how we might use art media to deepen children's exploration and collaboration.

We *observe* and *listen* to the children as they take up our invitations and engage in the experiences that we've planned. We make notes about our observations and start another round of study and planning.

Throughout this cycle of observation, study, and planning, teachers make their observation and thinking visible to the children, families, and each other with written documentation and display.

This process becomes a spiral that carries teachers, children, and families more and more deeply into investigation, collaboration, and relationship. Like life, it unfolds moment by moment, one step at a time, with surprises and detours and new questions to take up. And, like life, it is anchored in everyday, ordinary moments in our classrooms.

## Observing Children's Play

As teachers committed to inquiry, we strive to pay attention to the ordinary moments of each day. These ordinary moments are the fabric of children's lives: they offer glimpses into the children's hearts and minds. When we pay attention to ordinary moments, we begin to know the children deeply. Listening, watching, taking notes: observation is the beginning of inquiry.

We can record our observations with written notes, audiotapes of children's conversations, sketches, flowcharts, photographs, videotapes, and copies of children's work. These records provide the raw material for our reflection and planning.

This is engaging, exciting work! It invites us to immerse ourselves deeply in the children's play, paying close attention to their words, gestures, and expressions, and capturing the details of their play. This work helps us know the children intimately. It enables us to be intentional in our planning for children's play, investigation, and learning.

As you observe and take notes, strive to:

- record specific details;
- record direct quotes.

When you take photos, strive to:

- capture the action, rather than arranging a posed picture;
- move down to the child's level, rather than framing the photo from above;
- get up close, capturing a child's expression or a child's hands at work.

If children create a drawing, writing, or other work, ask if you can borrow it to make a copy. Your initial notes, sketches, photos, copies, and audio recordings provide the raw material for your study and planning. They should contain enough detail to help you answer the following questions:

- Who was involved in this play?
- What materials did the children work with?
- What specifically did the children do?

Your notes should describe the interaction among the children. Did they talk with each other? What did they say? As much as possible, try to record direct quotes.

## Studying and Making Meaning

We study our observations to understand the underlying meanings of children's play. With co-teachers and with children's families, we reflect on children's pursuits and questions.

Use questions like these to guide your understandings of children's play:

- What are you curious about in the children's play?

- What are the children curious about? What are they trying to figure out?

- What knowledge are the children drawing on? What theories are they testing?

- How are the children building on each other's ideas and perspectives?

- Do you see any inconsistencies in the children's thinking? Are there loosely formed ideas that need further exploration?

- What do you want to learn more about, after watching and listening to the children?

- What goals and values come up for you related to this play?

## Planning Next Steps

Once we have a sense of what the children's play is "about"—the underlying questions, theories, and emotions—we consider how we might extend or challenge their thinking. We plan one or two next steps, concrete action that we'll take with the children to help them deepen their exploration. Our intention is to create more questions and extended study, not to give the children information or lead them to "right answers." The teacher watching the children's block tower construction, for example, could have stepped in with a lesson about stability and height; instead, she gathered the children's thoughts about what makes a tower sturdy and made plans to help them test and revise their thinking by building with different materials. She offered the children an opportunity for expanded inquiry.

Questions to help you plan one or two next steps to extend and challenge children's thinking:

- What changes could you make to the classroom environment to invite children to look at their pursuit from a new perspective?

- What materials or "provocations" could you add to the classroom?

- How could you participate in the children's play?

- How could you invite the children to use art media to deepen or extend their thinking?

- How could you use your notes, photos, and sketches to help the children revisit and extend their play?

- How will you be in dialogue with families about this exploration to invite their reflections and to let them know what you're thinking and wondering?

# USING ART AS A TOOL FOR INQUIRY

When we're planning next steps, we turn to art. Children use their fluency in a range of art languages to make their thinking visible to themselves and to others, to construct new understandings, and to unearth new questions. Work with art media fans the flickers of possibilities in ordinary moments, sparking the fire of inquiry.

George Forman writes, "Art is an interpretation of experience. . . . Art can help us look at how we look at life. . . . Art becomes a tool for thinking" (1996, 56, 58). Using art as a tool for thinking, children can:

- make their theories and questions visible;

- take new perspectives;

- represent and explore emotions;

- study properties of the physical world;

- deepen their relationships with each other.

## Use Art Media to Make Thinking Visible

Children's ideas—like adults'—are often vaguely formed, not fully defined or clearly articulated. Sometimes, children's work is anchored in intuition or instinct; they aren't so much *thinking* about what they're doing as simply *doing* it. A child can give an idea form by drawing, painting, sculpting, or building it. In doing so, she can begin to clarify her ideas; she considers details and wrestles with inconsistencies. When her idea is visible, other children and adults can engage with it, thinking with her about its nuances and complexities, its gaps and incongruities.

Aaron worked long and hard with a set of cylinders that could be organized by height. He developed a rhythm for his work: first, he'd set the cylinders in place, then test his arrangement by laying his hands on the tops of the cylinders, feeling for cylinders that were out of place and making adjustments, then running his hands over the cylinders again. Finally, after much effort, Aaron sequenced the cylinders from smallest to tallest; his pride was evident in his wide grin.

To call attention to his thought process in sequencing the blocks, and to move from intuition to conscious understanding, I asked Aaron to draw the sequence he had created. Aaron leaped right into the drawing, but surprised me by representing the size gradations by making circles that were increasingly big in circumference, each one taking up more room than the one before. (I'd expected a series of lines that grew taller across the page.) In his drawing, Aaron created a symbol system with circles to represent his intuited understanding that each cylinder was bigger than the one before it in the sequence. He moved from an intuitive and experiential understanding of the sequence of the cylinders to a more conscious awareness of size and order.

## Use Art Media to Take New Perspectives

What does the world look like through another's eyes? What does an experience feel like to someone else? What is it like to be tiny? To be huge? These are abstract questions, difficult to imagine oneself into. But we can make these sorts of questions concrete by asking children to draw, paint, sculpt, or build from another perspective.

Nicole began to catch ants on the playground, putting them in a bucket with a plan to take them home at the end of the day. I wanted to invite her to take the ants' perspective on this dramatic change in their lives, from free-range playground to the narrow confines of a red plastic bucket.

I asked Nicole, "Where do you suppose the ants come from? You're staying close to the crack in the sidewalk. Is that where they're from?"

Nicole nodded. "The ants are in the hole talking. If they hear loud noises, they won't come out. We have to be very quiet! If they see us, they stay in because they are scared. When one ant was not looking, I got him! I'm faster than them—that's how I catch them."

"Ah," I said. "What's in the hole that the ants come from?"

Nicole shrugged. "I don't know. Maybe their family?"

I offered Nicole my clipboard and pen. "Do you want to draw your idea about what's in the hole?"

Nicole nodded, and began to sketch. She reflected on the ants' lives as she drew: "They're a family. They talk to each other and bring food to their baby."

"The ant's family is in the hole," I repeated. "There's a baby in the family, and the family brings the baby food. Is there anything else in the hole?"

Nicole flipped to another piece of paper on the clipboard and drew. "In the house, there's food and a table and a bed and a seat."

"I see," I commented, looking at Nicole's drawings. "The ant family lives in the hole, and there's furniture in the hole for the family."

Nicole studied her drawings for a few moments. Then she looked into her bucket. "There are fifteen ants in the bucket! That's more than one family. That's a lot of families. They share one house in the hole. The ants come not fast because they're talking, saying their plan to come out to see what is outside. They want to find their family that's in the bucket."

I asked about that idea. "The ants in the hole want to find their family in the bucket. What do the ants in the bucket want?"

Nicole said, "They want to get out of the bucket and go to their family! I'm going to take them to their home."

Nicole moved the bucket close to the crack in the sidewalk and turned it on its side. "Go home, ants! I'm trying to help them. Let them go to their home!"

Nicole had initially struggled to take the ants' perspective; it's an awfully abstract idea for anyone, particularly a young child. I hadn't wanted to deliver a lecture about letting the ants go free, demanding that Nicole release them and squelching her curiosity and concern for the ants in the process. Nor was I interested in a science lesson about ant tunnels and social groups. Instead, I wanted to support Nicole's interest in the ants by helping her take the ants' perspective. The invitation to draw about the ants allowed

Nicole to step into their lives, to see the bucket from the inside as well as from above. This new perspective deepened the relationship that Nicole had begun building with the ants when she noticed them coming from the crack in the sidewalk, and strengthened her sense of herself as a kind and compassionate person.

## Use Art Media to Explore Emotion

Art can be a tool for thinking about emotion. Color's boldness and delicacy can bring to life a range of emotion, and clay and wire's responsiveness helps children explore the power of their emotions. When children give form and expression to their feelings, they can look at them with new awareness and better talk about them with each other.

Several children—Rowan, Jad, Sean, and Patrick—played about being scary monsters day after day. They roared and flashed their claws and bared their teeth at each other. Their favorite book became *Where the Wild Things Are,* and they dedicated themselves to bringing that book to life in their play. Over time, they expanded their scary play to include pirates—and to concoct plans for frightening Patrick's older sister. The children's teacher, Kirstin, and I watched the children's play, taking notes about what they said and did to help us understand what was important to the children about monsters and pirates. We hypothesized that the children were exploring the power of ferocity, anger, meanness, and fear. We wanted to honor their exploration and give them tools to help them reflect on the emotional landscape of wild things and pirates. We decided to invite the children to transform themselves into these fierce beings through photographs.

We enlarged some photographs of the children's faces, covered them with sheets of plastic and gathered a full set of colored permanent markers. Then we invited the children into the studio. "You've been changing yourselves into wild things and pirates," Kirstin said. "I've heard you transform yourselves by growling, and by curling your fingers into claws, and by dressing up, and by using fierce words. Today, you can transform yourselves by drawing fierce faces on top of your usual faces in these photos."

After a flurry of conversation about the scariest, most ferocious creatures they could be, the children began to draw on their photos.

flows. Animal skeletons press into the earth, forming fossils. Children jump, run, tumble, wrestle, climb, roll, skip, spin, and lie panting on the ground. We can investigate and honor physical structures and movement in sculpture, drawing, and painting. This work fosters children's engagement with the physical world and encourages their full-bodied play.

Cecilia, Laila, Hattie, Katie, and Sophia spun cartwheels like crazy one morning in our front yard. The girls had varying levels of mastery: Katie and Hattie were quite skillful, while their companions were new learners, trying to figure out how to spin all the way through a cartwheel rather than crashing to the ground midway. A few days after this front-yard cartwheel extravaganza, the children's teacher, Emily, and I invited the girls to gather in the studio to draw the process of spinning a cartwheel. We wanted to honor their big physical efforts and to call their attention to the steps involved in a cartwheel, thinking that this would help them figure out the movements needed to master a cartwheel. We took photos of the girls at each point in a cartwheel: poised to flip over, sideways with one arm on the ground, upside down, back on the ground, and standing at the end of the process. From these photos, each of the girls sketched herself in the discrete physical poses. Their drawings helped them see what their bodies were doing.

This work launched us into several months' study of cartwheels, during which the girls sculpted cartwheels with wire, wrote directions for how to do cartwheels, and drew some more. During all this work, the children did cartwheel after cartwheel, becoming increasingly skillful. Their drawings and sculptures became reference points, shaping their understandings of how to move their bodies through a cartwheel. By drawing and sculpting cartwheels, they could see, in slow motion and fine detail, what they were aiming for with their bodies—nuances they couldn't catch just by watching each other or listening to verbal coaching. Cecilia, Laila, Hattie, Katie, and Sophia became masterful acrobats, spinning cartwheels with great panache. A comparison of their drawings—the first round of drawings, done early in their study, and the last round of drawings, made after several months of practice and study—capture the depth of their physical understanding.

As they worked, the children lifted the plastic that held their drawings, studying their regular, smiling faces, then laid the plastic back down, transforming their familiar faces into wild things. Color and line transformed a relaxed smile into a roaring mouth with bared, jagged teeth. It transformed gentle eyes into wild eyes, and smooth skin into a leathery green hide. Through art, the children looked at the emotional landscape of mean, angry ferocity from the "outside," complementing the ways in which they had been exploring it from "inside" with their drama play.

## Use Art Media to Study Properties of the Physical World

Art can be a tool for understanding action and physicality. Buildings reach skyward, supported by an intricate infrastructure. Volcanoes erupt and lava

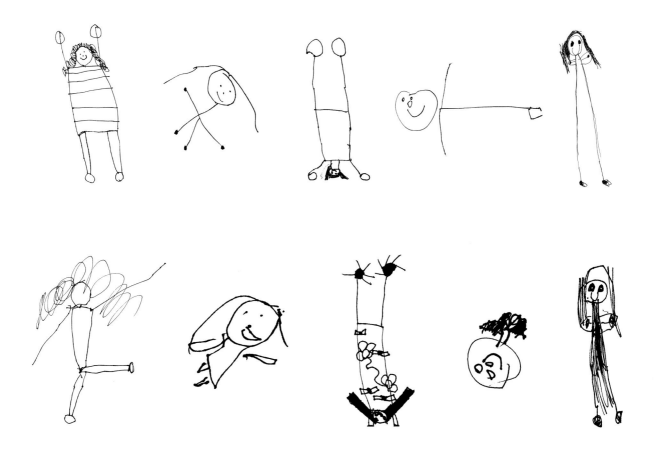

## Use Art Media to Deepen Relationships

As children play together, they encounter moments when they just don't understand each other's thinking. These are moments of tension and conflict, when ideas collide. Children flounder, uncertain about how to proceed. These moments can fracture relationships, or they can deepen them. When children use art media to communicate their ideas, tensions can ease and new connections grow. The frustration of not understanding or not being understood dissolves when children can literally see each other's thinking. And, in these moments, children begin to construct shared understandings, seeing each other anew as collaborators and friends.

Carl and Andrew worked together most days to construct houses or forts in the drama area, using tall cardboard forms as "pillars" to hold up roofs made of large pieces of foam core. One morning, Carl proposed that they try something new. "Let's make a house, but not the usual kind of flat roof. More like a real house."

Andrew objected. "We *do* make real houses! We make them big and go inside them. That's real!"

Carl shook his head. "That's not what I mean. Not that kind of real. Real like not with a flat roof. You know, a *real* roof. I don't want to make a dumb house again."

Andrew grew angry. "Don't say dumb!"

Carl persisted. "Let's make a real house, with a real roof."

Andrew tried to understand. "Do you mean like a tent?"

Carl was beginning to get angry now. "No, not a tent! A house!"

I'd been listening, slowly understanding what Carl meant, and seeing that Andrew's analogy of a tent indicated that he, too, was beginning to understand what Carl meant. The two boys were using different language to describe the same idea, and their different language was dividing them, rather than bringing them together. I made a suggestion. "Carl, can you show Andrew what

you mean?" I offered him a clipboard with paper and a pen, and he whipped out a sketch.

[ Carl's idea for a house
with a roof like a real house ]

Andrew looked at Carl's drawing, and smiled. "I think I know your idea! Is it like this?" he asked. And he took the clipboard and drew his understanding of Carl's idea.

[ Andrew's understanding
of Carl's idea for a house ]

Carl was tickled to see his idea reflected so accurately in Andrew's drawing. "Yeah, *that's* the kind of house I think we can build!"

Andrew and Carl were allies again, buddies united in a shared undertaking. They began to build, tossing ideas back and forth about how to create an angled roof on their house. Sketching their ideas had made their thinking visible. The language of drawing was articulate and specific, where their verbal language wasn't. It broke the impasse that was quickly derailing

their construction effort, and created a link of understanding between them.

# DAILY CLASSROOM PRACTICES FOR USING ART AS A THINKING TOOL

To move art from the studio to the classroom, you needn't revamp your whole program. You can begin by making the following simple changes in your program.

Create an environment in which drawing materials are always available. Make clipboards and drawing pens available throughout the room so that they're handy for you and the children to use to sketch and make notes.

Take the lead in using art media to represent children's work and play. Draw sketches of the children's construction.

> *What a complex design you've created with the mosaic pieces! I'm going to draw a picture of it so that we can remember it. You might want to make this design again, and the drawing will help you build it.*

Make a map that represents the places children travel to during the course of a dramatic play game. Offer children the map the next time they play in the drama area.

> *Here's a map that shows the trip you took last time you were a cat family in the drama area. You went from your home to the doctor to the grocery store to the park, then back home again. You might use this map to help you find your way to those places again.*

Sketch a few scenes from children's drama play and use them as a basis for a book.

> *I wonder if you want to add pictures or words to this story. It's the story that you played about in the drama area this morning.*

Write down the "recipe" that children invent as they pretend to make cake with playdough, and illustrate the recipe with a few simple sketches.

> *First you mixed sugar and milk, then you put in chocolate and candy and chocolate chips. I wrote down the words that tell cooks what to do, and*

*now I'm going to draw pictures to show mixing sugar and milk, and putting in sweet stuff.*

Invite children to use art media to deepen or extend their thinking.

*Could you draw directions for how to play this game?*

*How about drawing what you built to help you remember it?*

*Let's take your easel painting of a castle to the blocks so you can build what you painted. That'll be a way to try your idea in real life.*

*Let's make a book that tells the story of your drama game. I'll write down your words, and you add the pictures.*

Revisit sketches and notes, inviting the children to re-engage with earlier work. Display drawings with the materials represented in the drawings. For example, post the cake recipe the children invented with the playdough they used to make the cake.

Suggest that children use sketches as "blue-prints."

*Here's the drawing I made of your spaceship last week. This can remind you of the important parts of your spaceship, so that you can build it again today.*

Print children's drawings onto transparencies or as slides and project them into the room. Children can interact with these larger-than-life images.

Carla Rinaldi writes, "The whole school has to be a large *atelier* [studio], where children and adults find their voices in a school that is transformed into a great laboratory of research and reflection" (2005, 170). In a culture of inquiry, art moves from the studio into the classroom. It becomes a mind-set, a way of seeing and engaging with experiences, ideas, and each other. When art spills out of the studio and into daily life, it becomes a tool for making thinking visible, for taking new perspectives, for exploring emotion and physicality, and for deepening relationships.

In the next chapter, we'll discuss how we can build on these everyday experiences with art media to create long-term, inquiry-based investigations.

# USING ART MEDIA TO GROW LONG-TERM INVESTIGATIONS

When we organize our classrooms around inquiry, we begin to see many possibilities in the most ordinary moments. As we fan the flickers of these possibilities, these ordinary moments can grow into investigations that lead us to unexpected places. A child's sketch of a block tower can launch us into a study of symmetry, stability, and height; children's freewheeling cartwheels on the lawn can draw us into a long-term study of movement and balance; children's fierce drama play can inspire a study of anger and its sister emotions. Round by round, we move through the cycle of inquiry: observing, reflecting, planning our next step, observing, reflecting, planning another step. In this way, one step at a time, a long-term investigation unfolds. Art becomes the language of these investigations, the language of inquiry.

## FOUNDATIONAL PRINCIPLES FOR LONG-TERM INVESTIGATIONS

There are a few foundational principles that can guide you as you begin to use art media to grow in-depth investigations.

### Work in Small Groups to Focus an Investigation

Create small study groups of children who share an interest or question, or who offer different perspectives and skills that will be particularly useful to a study. For example, in an investigation about height, some children will be excited to figure out how to build really tall structures, and others will be focused on the vistas that can be sighted from the top. Some children will be engaged by structural questions, and others by existential ones. Some children will be most skilled in three-dimensional representation and others in the art of storytelling. Bring together children with different skills and perspectives to make for an enriching investigation.

### Build Your Investigation on the Underlying Questions and Theories in Children's Play

Develop your line of inquiry from the questions that children ask in their play, rather than the topical themes. When children play a game in drama about kitties running away from their mama cat, for example, they're likely pursuing questions about obedience and disobedience, or safety and risk, or separation and

reunion. We can invite the children to consider those questions, rather than launching a study about cats. When investigations grow from the big questions that children take up in their play, children engage deeply and eagerly.

## Match the Question to the Art Medium

Each art medium has particular properties and calls attention to specific aspects of the subject under consideration.

Drawing gives form and shape to any idea, however unlikely or complex. It creates a record of an experience or construction, and also captures the perspective of the person making the drawing. With drawing, though, dimensionality is a challenge.

With three-dimensional media such as clay, wire, and found materials, children can test their sketched ideas to see how they work in "real life."

Clay and wire are responsive media; they hold the shapes children give them. Clay works well to capture dimensionality and movement, which is possible with wire, too, though wire is more challenging for children to manipulate. Wire is particularly useful for depicting outline and the dynamics of line.

Found materials, such as cardboard boxes and tubes, corks, and bottle caps, are more structural than clay and wire. They illustrate the dimensionality of an idea, as children build them up and out and under and above. They demonstrate balance and the physics and mechanics of how materials bind together.

Color calls attention to emotion. It can be used for representation, or it can be used more fancifully. It is bold and engaging, and can bring an idea to life.

### Using Color Media as a Tool for Thinking in Long-Term Investigations

A group of just-turned-three-year-olds were fascinated with questions about power: Who has power? Boys and girls? Little kids or only "big kids" and adults? Do elderly people have power? How does a person gain power? What forms does power take? For example, how does the physical strength of superheroes compare with the feminine wiles of Sleeping Beauty and Snow White?

The children wrestled with the relativity of power: certainly, they themselves were more powerful than babies, but less powerful than their older siblings, who, in turn, were less powerful than their parents. But how could they situate the relative power of elderly people? The children's investigation included work with photos, with clay, with dramatic expression, and with construction.

As part of their investigation of power, we invited the children to mix tempera paints into colors that are "powerful" and colors that are "not powerful." We wanted to nudge the children to consider what power looks like in its most elemental form. This was abstract work, and challenging. We didn't offer this right away in the investigation, but waited until the children had explored power through a range of activities. We wanted the children to have a solid sense of their ideas to anchor their work with color. The children's teacher, Molly, and I thought carefully about how we would talk with the children to invite them into this exploration, aiming to be as concrete as possible: "What color is power?" "How much room does power take on a piece of paper?" "What if there's no power? What color would show that?"

Unsure what would happen during this abstract and challenging exploration, Molly and I were both startled by the ways in which the children used color to express power. We came away from this experience with deep regard for children's competence as thinkers and communicators.

January 17

Rachel, Anna, Jessa, and Hattie gathered in the studio today to continue their exploration about the meaning and forms of power. Molly and I welcomed them into the studio with an invitation: "You've been thinking a lot about power. Today, we're going to paint

pictures of power. We'll use tempera paint to show what power looks like."

"We do know about power," said Rachel.

"We know how to make power colors," added Hattie.

And with that, the girls settled into their work spaces around the table and began to scoop and mix paint in their mixing trays. We've worked with tempera paint throughout the year, using the primary colors to create new colors and shades; it's a familiar medium to these children. They drew on their knowledge of color this morning.

Each child was clear that red was an essential ingredient in a powerful color. Jessa added yellow to red to create a bold orange, while Rachel added lots of blue to create a dark, solid purple. Anna and Hattie saw elemental red as the color of power, with no additions needed to its forceful presence.

After creating a palette of powerful colors, we invited the children to "mix paint to make colors that don't have power." The children shifted their efforts, making green, orange, purple. Interestingly, these are all secondary colors. Unlike red, they all are made from combining colors; none exists on its own. Is this part of the story of why these colors lack power?

Once the children had filled their palettes with color, we offered them paper for painting: "We put a line on your paper, right down the middle. On one side, you can paint a picture that shows lots of power. And on the other side, you can paint a picture that doesn't have power."

The children didn't say much, but dove right into their painting. They were quiet, focused, and clear in the ideas they aimed to express. The left side of each of their paintings is the side with no power; the right side communicates power.

The paintings are eloquent in the stories they tell about power. Power fills space, it is bold, eye-catching, and fiery, with the intensity of red and swirling, strong motion. In Hattie and Jessa's paintings, the addition of red transforms "no power" to "power."

Hattie

Jessa

Rachel and Anna use color in contrasting ways, but for both children, "no power" is a mix of colors, while "power" is a steady, strong unified force of color from edge to edge, top to bottom.

Anna

Rachel

The language of color offered the children a vocabulary for communicating the presence and identity of power.

## Revisit and Revise Work Often

Each medium calls attention to a particular aspect of an idea, so using a range of media is important in exploring an idea in depth and from multiple perspectives. For example, children can use drawings to guide sculptural work, then revise their sketches based on what they discover while sculpting. Each time children revisit their work, their thinking deepens: they recognize inconsistencies, notice new details highlighted by a particular medium, see things from a new perspective, or discover connections among ideas.

When children revisit their work, gently point out contradictions and incongruities in their thinking. This is different from correcting children's misunderstandings or errors, or giving them the "right" information. Stay firmly anchored in the realm of children's thinking and theorizing. Use the language and images that they are using to point out contradictions or irregularities in their thinking.

> *Your first drawing showed color dripping from clouds onto the leaf. But this drawing has a color machine in the sky, next to the sun. What happened to the color in the clouds? Is that still important?*

As they wrestle with inconsistencies and contradictions, children strengthen their theories.

Your written documentation is an important tool for helping children revisit earlier work. Stories and photos about their work often reignite children's interest and spark new investigation and discussion.

## Revisiting Work in Long-Term Investigations

Katie, Laila, Sophia, Hattie, and Cecilia sketched cartwheels several times during their in-depth investigation into this acrobatic movement. With each round of drawing, the children saw the poses involved in cartwheels with increased clarity. But sketching takes place in two dimensions, and we wanted to emphasize the way that the children's bodies extended muscularly and gracefully up and out into space. We decided to move from sketching into three-dimensional media, inviting the children to revisit their thinking from a new perspective.

We chose wire for our three-dimensional work. Wire is all about bending and folding, just like cartwheels. We thought it would lend itself well to sculpting both the angularity and the extended limbs of cartwheels, opening up new ways for the children to think about the poses involved in cartwheels.

February 24

The cartwheel work team—Laila, Sophia, Cecilia, Hattie, and Katie—came together this morning to begin sculpting wire into the form of a cartwheel in motion. The children have worked with wire before, exploring how it feels, smells, and moves. We began our work today by revisiting their earlier experiences with wire.

Ann: "What do you remember about wire and how to shape it?"

Hattie: "My first time, I was very frustrated about my sculpture, but when I figured it out, it was very easy."

Ann: "What was the frustrating part for you?"

Hattie: "The head of my girl was really loose. It was hard to attach it to her body."

Ann: "What helped you figure out the frustrating part?"

Hattie: "I took it all off and rounded one side of the wire and rounded the other side."

Cecilia: "You can bend wire if you put your fingers in and curve wire around your finger."

Katie: "With wire, you keep curving and bending and curving and bending."

Laila: "It is pretty tricky how to bend it. Where you want to bend it, if it goes there, it means you're the boss of the wire."

Sophia: "It is hard work and tricky. I noticed that I can do wire with my body doing it, then I thinked in my brain that I can do it another way."

Laila: "It takes a long time to get it just the way it needs to go."

Hattie: "You might get a little disappointed at first because when I was practicing I thought I would never make it, but then I figured it out and now I feel proud."

Ann: "Remember that feeling of working hard and sticking with tricky parts until you figure them out—that'll help you today. We're going to use wire today to make sculptures about cartwheels. It'll be hard work, but you know how to do hard work with wire, just like you know how to do hard work with cartwheels."

We first studied the children's drawings about cartwheels, noticing details that we wanted to be sure to capture in wire: How were the arms positioned? Were the legs straight or bent? Where did the head focus? What was the relationship between the body and the arms and the legs?

Each child then cut a length of wire and began her work. We'd agreed on an approximate size for the torso of each sculpture, and made a simple outline on paper for each child to use as a guide. The work of forming the wire into the torso shape became the first step in each sculpture. From there, children added limbs: arms and legs extending, bending, and reaching, mirroring the positions in the sketches. The girls angled the wire and curved it. They attached one piece of wire to another, twisting the ends tight to create a solid joint.

There were some significant challenges as the children worked.

Sophia struggled to create proportionality among the elements of her sculpture, matching head size to body to limbs. She figured out that it worked best for her to loosely shape the wire into an arm or leg, and measure it alongside the rest of the sculpture. She'd then make the leg or arm bigger or smaller to fit with the rest of the sculpture, then tighten the angles and cinch the ends in place.

Katie wrestled with getting the angles just right. She tended to overpower the wire, bending it so firmly that it created a sharper or deeper angle than she intended. She softened her grip and force, becoming more attuned to the wire, listening to how it moves and accommodating both its flexibility and its will.

Laila struggled to cinch the wire into place. Wire is sturdy and resistant; it requires force to twist one end tightly around another piece of wire. Laila tapped into strength she initially didn't think she had to twist the last half inch of wire into place each time she attached a limb to the torso.

Sculpting the steps of a cartwheel with wire demanded that the children be really clear about the particulars of each pose: How exactly does the raised arm bend? How does the anchoring foot plant itself on the ground? Using a three-dimensional medium encouraged the children to think about cartwheels in three dimensions, considering the form, momentum, and muscle effort involved in doing cartwheels.

## Move from Individual to Collaborative Work

It's useful for children to begin an investigation by getting clear about their initial thoughts. Individual drawings or sculptures provide a way for children to make their thinking visible to themselves, so that they have a starting place for their work.

Children can study each other's individual works, offering and listening to comments, questions, and critiques, revising their ideas in light of what they hear from their companions. As their individual thinking becomes more solid, they can begin to collaborate with other children, weaving their ideas together: writing a book together, for example, or creating a collaborative mural or clay sculpture. Creating a collaborative art piece sparks a dialogue that calls attention to similarities and differences in their understandings and that strengthens the relationships among the children as, together, they construct new knowledge.

### Moving from Individual Work to Collaboration in Long-Term Investigations

Four girls, Molly, Raven, Halley, and Melia, came together to investigate how people become friends. During the six-month investigation, we often turned to representational drawing to express and clarify children's individual ideas about friendship. After many rounds of individual work, we came together to craft a collective statement about friendship.

March 21

Melia, Raven, Molly, Halley, and I met in the studio this morning to continue our exploration of how people get to be friends. Over the last weeks, the children had drawn about how they've developed friendships with other children. Their sketches captured specific moments that they've shared with particular friends: walking hand-in-hand to the wading pool, for example, and the first playdate at a new friend's home. Today, we began exploring the common themes underneath these individual experiences, developing a list of principles for how people become friends.

I greeted the children with an invitation: "Let's draw about friends today, but in a new way. I have some questions for you to think about. Your drawings about these questions will help us know more about how people are friends to each other."

I posed my questions, one at a time, with time for children to mull them over and draw their ideas: "What do friends do with their hands to show that they're friends?" "What do friends do with their mouths to show that they're friends?" "What do friends see with their eyes?"

Raven, Halley, Molly, and Melia answered my questions with eloquent sketches.

<u>What do friends do with their hands to show that they're friends?</u>

Two friends are holding a bag of candy. One friend is giving the other friend a handful, and the other friend is giving the first friend a handful.

He's happy and she's sad, and he's giving her flowers because she's sad.

<u>What do friends do with their mouths to show that they're friends?</u>

Friends make funny faces at each other because they're happy and they like to make each other laugh.

Two friends playing T. rex and growling and grinning at the same time.

<u>What do friends see with their eyes?</u>

She's mad because he laughed at her. A friend sees what a friend is feeling.

Friends see a garden when they're together.

As we looked at and talked about the drawings together, the children generated principles for becoming friends:

- When a person meets another person, they're not exactly friends right away. They see each other a hundred times, then they see each other one more time and they become friends.

- We get to be friends by getting to know each other. We get to know that we like to be with each other. To be a friend with someone, you play together lots and lots, for a lot of time.

- Friends hold hands when they go for walks together.

- A friend hugs you when you're hurt or sad, and says, "What can I do to help you?"

- Who I'm friends with and who you're friends with, we can be friends together.

- When people get to be good, good friends, they don't forget about each other.

The principles reflect the wise insights that the children have developed from their tender experiences of friendship. They capture the intersections and parallels among the children's experiences, allowing us to move from individual to collective understandings.

## Stay Connected to the Full Group During an Investigation

As a small group of children explores the question that most engages them, ask them to share their discoveries and new questions with the full group. The process of telling the story of their work challenges children to consolidate their understandings. As they hear the comments and questions of folks who haven't been part of their work, children encounter new ways to think about their work, new questions to explore, and new strategies to try.

These fundamental principles can guide us as we grow in-depth, long-term investigations with children. We ground our investigation in careful attention to children's theories and questions, following the slow, steady rhythm of observation, study, and planning. Moment by moment, step by step, a long-term exploration unfolds, like stringing beads on a necklace. In chapter 8, we will look at a long-term investigation in practice, guided by the principles listed here.

# TO SEE TAKES TIME: A LONG-TERM INVESTIGATION INTO THE LIVES OF LEAVES

The story of a long-term, in-depth investigation brings the teaching principles from the previous chapter to life. This study of leaves carried a group of four children, their teachers, and me, the mentor teacher, from the vivid color of fall through the starkness of winter into the lively blossoms of spring, a seven-month investigation in which art was the language for our learning.

Use this chapter not as a model to be replicated, but as an illustration of how you, too, might bring these principles into your own program, nurturing children's inquiries to build a long-term investigation.

## WHY DO LEAVES CHANGE COLOR?

Early in October, four-year-old Madeline asked her mom, "Why do leaves change color?" Her mom, Leslie, brought Madeline's question to us, wondering what resources we would recommend that would answer Madeline's question for her. As we talked together, we decided to hold off on science books and information and, instead, to use Madeline's query as a jumping-off point for collaborative investigation. We did some initial planning about how we might approach this work; all of us—teachers and mom—acknowledged that our primary goal was to foster in the children the spirit of inquiry—asking questions, proposing and testing hypotheses, exploring a range of perspectives—rather than to teach the children about the science of leaves. (Principle: Build your investigation on the underlying questions and theories in children's play.)

Madeline's teachers, Sandra, Megan, and Flint, and I talked during a staff meeting about which children ought to be on this research team. We considered what sort of work we imagined the investigation would hold for children. We didn't know yet what we'd *do* during the course of the study; we'd plan that step-by-step, in response to the ideas and questions that emerged during our work. But we expected that the investigation would involve lots of articulating and critiquing hypotheses, and careful observation and recording. Which children might be most interested in the scientific bent of Madeline's question? Who among the children seemed ready to dive into a long-term undertaking? Which children were ready for collaborative work that would likely involve some conflict and debate? As we mulled over these questions, we also thought about how to bring a range of skills and perspectives to the study. We eventually settled on four children: Madeline, of course—the provocateur of the study; Ana, masterful with representational drawing, in need of a pursuit that would engage her, and ready for the challenge of collaborative work;

Alex, steady and calm, ready to step into leadership and comfortable with the give-and-take of conflict; and Beck, oriented to movement and physicality, and skillful with three-dimensional representation. We formed this tentative group, and we were ready to take up Madeline's question together with these children. (Principle: Work in small groups to focus an investigation.)

## PORTRAITS OF LEAVES

When we first gathered the four children, Sandra and I told them about Madeline's question, explaining, "We think you four kids could think together about why leaves change color. Each of you is a scientist and an artist; we expect you'll be a strong team to study Madeline's question." Right away, the children had ideas and stories to share about the autumn leaves: the bright-colored leaves they'd been noticing as they climbed trees at the park; weekends of raking leaves at home—and jumping into the mounded piles; awareness of the new coolness to the air, the change in the sunlight, the coming of rain.

Sandra and I had brought leaves to this first meeting: red, gold, orange, green, and brown. They spilled across the table around which we sat, and we turned our attention to them. "It seems important to really know leaves before we can start thinking about why they change color. Let's look up close at these leaves and see what we notice about them."

We each gathered up a few leaves and dove into close observation. The children called each other's attention to what they were noticing in their leaves, already starting to hypothesize about the mysterious change happening in the leaves.

Beck: "This one's all orange and a little bit green. The green's what it used to be and the orange is what it is."

Alex: "There are lines in my leaf!"

Ann: "Why do you think those lines are there?"

Alex: "These white lines hold the leaf together."

Ana: "Yeah, they are the things that hold the color part."

Beck: "This brown leaf changed color before the green one. The green one is changing slow and the brown one is changing fast."

Ann: "Why do you think that is?"

Beck: "Because smaller leaves change faster than big leaves."

Ann: "Why do you think that smaller leaves change faster than big leaves?"

Beck: "Because big leaves have more space—because it makes them slower to change if they have more space."

We lingered in this intimate study of the leaves, looking, touching, smelling, coming to know the contours and coloring, the shape and textures of the leaves. Eventually, I asked the children to consider how they might create a portrait of one of the leaves they'd been exploring.

"To help us notice the tiniest details of these leaves, we'll create portraits of them," I said. "First we'll use the drawing pens to sketch the shape and lines of the leaves, then we'll add color to the portraits with watercolor paints. Your portraits will be a way to tell about these leaves that you've come to know so well."

Sandra and I had chosen black drawing pens and watercolor paints to call the children's attention to the specific identities of the leaves, expressed in their form and color. When children sketch, they look closely, capturing what they see, bit by bit, in a line drawing. When they work with watercolor paints, they notice color and the ways in which one color blends and gives way to another. By using these media, we wanted to focus the way the children saw the leaves. (Principle: Match the question to the art medium.)

## RESEARCH IN THE NEIGHBORHOOD

A week passed before the study group met again. During that week, Sandra and I met to plan our next step. We studied the notes that we'd made as the children described what they noticed about their leaves. A couple of the children's comments leaped out: the children's attention to the lines of the leaf, and their efforts to understand the purpose of the lines, and Beck's comment that small leaves change color more quickly than big leaves. Each of these presented possible lines of inquiry that we could pursue. Before making a decision about how to proceed, though, we studied the children's leaf portraits. The subtlety in the children's use of color caught our attention. The children had worked to capture the movement of color through a leaf, the dissolution of green and the emergence of orange, yellow, and brown. None of their leaf portraits was a solid color; each used a subtle range of shades or a dramatic shift from one hue to another to describe the changing colors. The children's paintings refocused us on Beck's hypothesis. We decided that our next step would be to explore the process of change, setting aside the children's questions about structure for now.

The next time we met with the children, we revisited our earlier meeting by looking at the leaf portraits and by reviewing our discussion. "Last time we met, we started thinking about how leaves change color," I said. "Beck suggested that small leaves change color before big leaves. Sandra and I are curious to think more about that idea with you. We thought we'd all go for a walk in our neighborhood to notice how the leaves are changing color on the trees." (Principle: Revisit and revise work often.)

We bundled up and headed outside. It was definitely becoming autumn, with an edge to the air and the sun pale and translucent. As we walked through the neighborhood, we called each other's attention to details on the trees. We noticed patterns in the way that color spread across leaves and through trees: the outer edges of leaves turned red, gold, and yellow while the center was still green, and the outer branches of trees changed color before the branches in the center. This was an unexpected discovery for all of us, teachers and children. We hurried back to the studio to begin to make sense of what we'd noticed.

Beck reiterated his earlier statement. "Smaller leaves change before bigger leaves. Smaller trees change quicker than bigger trees."

Ana: "Yeah, there are fewer parts."

Alex began to tease out the nuances. "Yeah, because they're smaller. Smaller leaves have less room than bigger leaves. Big leaves don't fill in so quick."

Ann: "I wonder why the edges of leaves turn color before the middle of the leaves."

Beck added an element to his hypothesis, linking it to structural aspects of leaves. "The skin of the leaves changes faster. If you take the leaves off, there's bones."

During our conversation, the children began to weave their observations about the patterns of color

change into theories about why the leaves change color in the fall. We paused in our conversation, asking the children to draw their ideas about how leaves change color. Our intention was to provide a way for the children to give their thinking form, to make their thinking visible to themselves and to each other.

After drawing their theories, the children presented them to each other, pointing out elements in their drawings that illustrated their thinking.

Beck's theory was full of movement. "Color came from the sky, out of the clouds. The color inside the cloud pushed hard on the clouds and then it came outside of the cloud, down, down, down. If a leaf was hanging out, it came on the edge and moved quickly along the whole leaf. It only happens if a leaf is hanging out."

Alex gave voice to his theory in the language of poetry. "First when it was fall, they were all green. Then just a teeny bit of color—a dot of color came on the edge. It moved slowly around the leaf. It very quietly tiptoed into the middle."

Ana turned to spirituality in her theory. "God came along with a special paint and put a tiny dot of paint on the leaf."

Madeline stayed anchored in the realm of observation. "It came from the tree. I don't know how."

As the children shared their theories, they offered critiques of each other's thinking.

Alex: "Beck, if color came from the sky, it might drip down onto the leaves and then onto the grass. And I don't see color on the grass."

Ana: "If the color came from the clouds, then the clouds wouldn't be white."

Alex: "Well, the clouds could still be white because the color would go fast, it would drip down quickly—zoom! It would go so fast you couldn't see it."

Ana: "I don't think so. You could probably feel it. I went under a cloud before and I didn't feel color dripping onto me."

Beck: "Well, the color in the clouds comes from the sky god, like you said, Ana."

The children began to see their individual thinking in new perspectives, because of the challenges offered by their companions. This process represented the first steps toward a shared understanding woven from their individual theories. (Principle: Move from individual to collaborative work.)

In his theory, Alex had explicitly linked the leaves' changing colors to the season. I wanted to call attention to that, anchoring our study in the context of autumn.

Ann: "Alex, you said that color comes to the leaves in the fall. I'm curious about that. Let's think about what we know about fall. That might help us understand why leaves change color in the fall."

Alex: "In fall, the trees begin to get naked, because the leaves fall off and the leaves are like clothes."

Madeline: "It's cold in fall. You can wear short sleeves in summer and long sleeves in fall."

Ana: "It's cloudy and it gets rainy."

Alex: "There's storms and lots of gray clouds and hard rain."

Ann: "So in fall it's cold and cloudy and rainy and stormy. Is there a connection between these things and the leaves changing color?"

Ana: "More things are happening to leaves, so they're changing. The leaves would have to comfort themselves. God puts coats on the leaves, because it gets colder."

Alex: "I don't agree. Color doesn't do anything. It just decorates the leaves. It just makes things pretty."

Ann: "I'm confused about your ideas. Alex, you say that trees take off their 'clothes' in the cold fall. But Ana, you say that the color is like a coat for leaves. So I'm confused: Are leaves getting coats? Or are trees getting naked?"

Ana: "Leaves huddle together on the ground to get warm."

We had to stop here, as we delayed lunch as long as we could. Food was ready, we were hungry, and though the conversation was gripping, we called it a day.

## THE BONES OF LEAVES: DRAWING

After this meeting, Sandra and I again studied our notes about the children's thinking. We talked with the other teachers on the teaching team about possibilities for next steps—ways to invite the children to deepen their theory work about leaves' changing colors. One of the teachers commented on the similarity between the skeletal structure of human hands and of leaves. His remark reminded us of the children's observations about the structural elements of leaves, in which they'd described a leaf's color as skin over the bones, or lines, of a leaf.

Intrigued by the possibilities of this new approach, we brought magnifying glasses and simple photographs of hand skeletons to our next meeting with the children. The children compared the photographs and the leaves, and right away, they saw the connections.

Alex: "The lines of the leaf feel like human bones, because they're hard like human bones."

Ana: "Some parts of a leaf are like fingers."

Beck: "Like human bones—the bones of a leaf exist because the bones make the leaf hang or turn on the tree."

I suggested that we use oil pastels to make rubbings of the leaves, so that we could see the bones of the leaves more clearly. The oil pastels would offer us a new way of seeing the skeleton of the leaf. (Principle: Match the question to the art medium.)

I didn't expect the leap that the children made next. After creating an image of a leaf skeleton, Beck set up his work space to create an image of the skeleton in his hand, laying a piece of paper over the back of his hand and making a rubbing with an oil pastel! Other children followed his lead, creating hand rubbings. Clearly, the children saw the connection between the bones of their hands and the bones of leaves.

We then invited the children to sketch the leaf skeletons with black drawing pens and paper, moving between close observation and careful drawing. "Let's look and draw, look and draw, to make a sketch of a leaf skeleton. It'll be another way to pay attention to the bones of the leaf."

These simple black line drawings emphasized the structural composition of leaves. The drawings were quite different from the children's original leaf portraits, though they'd used black drawing pens for that work, as well. The children's original line drawings

emphasized the basic shape and structure of leaves. Their attention was focused more on the color of the leaves than the internal framework. With their skeleton drawings, the children focused on the inner details of the leaves. They looked through the leaves' color to the complexities of the leaves' structures. (Principle: Match the question to the art medium.)

Unsurprisingly, yet delightfully, the children again added another layer to their study: Alex suggested that they sketch the lines in their hands!

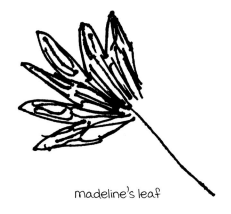

madeline's leaf

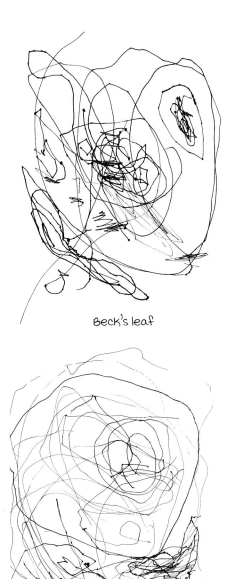

Beck's leaf

madeline's hand

Beck's hand

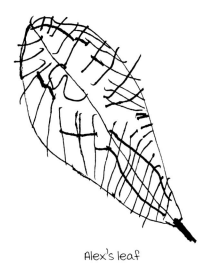

Alex's leaf

Ana's hand

Alex's hand

## THE BONES OF LEAVES: CLAY

Sandra and I decided to pursue the children's interest in structural element of leaves. With the focus on the leaves' skeletons—a textural focus—we needed textural media. We turned to clay.

We had the children craft tiles with the clay, first wedging it, then flattening it into a smooth surface. We pressed leaves into the soft tiles, using rolling pins. Then we slowly, carefully, pulled the leaves out of the clay, revealing fossil-like impressions in the clay tiles.

Ana's leaf

This work combined held-breath anticipation with whoop-out-loud exultation. The clay allowed us to revisit our earlier work with the oil pastel rubbings and black line drawings. (Principle: Revisit and revise work often.) With clay, we looked at leaf skeletons from the perspective of an impression rather than a rubbing. The lines were clear and bold in the clay, without any color to distract us from them. (Principle: Match the question to art medium.)

## THE BONES OF LEAVES: WIRE

We turned next to wire to explore the structural elements of leaves. Wire would closely mimic the delicate lines inside the leaves. Just as the clay impression echoed the rubbings, the wire sculptures would echo the sketches. (Principle: Match the question to the art medium.)

We offered the children their black line drawings to guide their work; they worked with these and with real leaves as models. They first shaped the wire into silhouettes, and then added the intricate weaving of internal lines. "Look and bend, look and bend," Alex murmured, in an echo of the "look and draw" refrain we used when making the black line drawings.

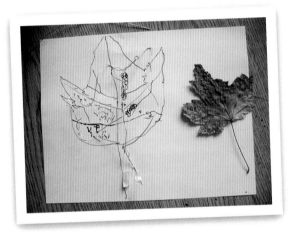

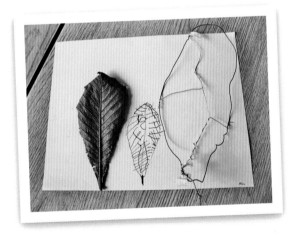

Sandra and I hung the finished wire sculptures on a graceful, bare branch that we had found in the neighborhood and brought into the classroom. Our intention was to emphasize the children's shared undertaking by hanging the sculptures as a group rather than displaying them in a more individual format. (Principle: Move from individual to collaborative work.)

# THE EMOTIONAL LIFE OF LEAVES

When we set out into this investigation, our attention was centered on Madeline's original question about why leaves change color. We hadn't anticipated the importance that the lines of leaves would hold. As we reflected on the children's engaged study of leaves' skeletons, we turned to our notes from early in the investigation, reading again the children's comments that "lines help the leaf stay together" and "if leaves didn't have lines, they would be little crumbs." We revisited Beck's comment that the color was an overlay, like skin covering bones. And that comment carried us full circle, back to the questions we'd taken up initially.

We realized that the children were working to know leaves intimately—that this intimate knowledge of their skin and bones was essential before they could pursue study about the change in leaves' colors. The portrait work had allowed the children to know the skin of the leaves; the rubbing, clay, and wire work allowed them to know the bones of the leaves. This made good sense when we stepped back to reflect: before investigating *why,* it is important to know *who.*

What else might the children need to know about leaves' identities before turning again to the questions about their mysterious change of color? We remembered Ana's comment, early in this investigation. "More things are happening to leaves, so they're changing. The leaves would have to comfort themselves." We decided to take up the emotional identity of leaves with the children, to follow this thread that Ana had set out for us: what do leaves feel as they change color?

Ann: "I wonder what it feels like to be a leaf in autumn."

Madeline: "Leaves get sad when they start to die."

Ana: "Like we give comfort to others when they are sad, the plant also needs comfort. When I feel sad I want a hug and I want an ice pack when I am hurt."

Madeline: "I think a hug would help a leaf, and being with the leaf, but not an ice pack."

Ana: "Maybe you could stay with it. You just give it comfort before it dies."

Madeline: "When it drops on the ground, it feels sad. That's when it needs you."

I'd brought a poem by E. E. Cummings to the meeting, inspired by Ana's initial comment about the leaves' need for comfort. I read a portion of it aloud.

who found you in the green forest
and were you very sorry to come away?
see      i will comfort you
. . . . . . . . . . . . .
i will kiss your cool bark
and hug you safe and tight
just as your mother would,
only don't be afraid

The children's dialogue about the emotional aspect of leaves' color change, with their grand burst of color before death, sparked a bittersweet conversation about dying.

Ann: "You've talked about leaves dying when they fall off the tree. Can you say more about why leaves die?"

Ana: "The coldness. And the rain is kind of dirty."

Madeline: "But rain helps the leaf grow a little bit. The leaf gets very, very old, and it dies by itself."

Ann: "Why do leaves die in the fall, not in the spring or summer?"

Madeline: "Because they stay up in the summer and in the winter they fall down. And in the coldness they fall down, and in the darkness they fall down. And it starts to turn green when it's lying down on the ground and it grows and grows and when it's morning it goes back up on the branch. First a plant or leaf dies, then you give it water and it grows. The leaf starts to be green again and a person puts the green leaf back up, if they can reach."

Ana: "When the snow melts, Mother Nature will come in the middle of the night and put the leaf back on the branch."

Madeline: "When all the leaves fall down, new leaves grow on the tree."

Ann: "I hear a couple of ideas about how green leaves come onto trees after old leaves die. Could you draw your ideas, so that we can see them?"

Ana: "Let's make a *story* of it."

## THE LIFE CYCLE OF LEAVES

Ana's proposal invited us to turn to a new art form, that of story and poetry. Ana, Beck, Madeline, and Alex worked together to create a story about the life cycle of a leaf. (Principle: Move from individual to collaborative work.)

> Once upon a time, Ana, Beck, Madeline, and Alex were searching for dead leaves. They found a dead leaf! Then they found some soil and some water and they put water on the leaf and put it in soil and they waited for it to grow. They poured water on it and then they all walked away and waited to see what would happen. They saw a dead leaf, and the next day, they saw how it worked. It growed to the top of the ceiling and then they took it outside and they worked on it together to put it back on the tree.

Though enthusiastic about helping to write the story, Beck was unconvinced by Ana's and Madeline's theories that brown, dead leaves are renewed by water, becoming living, green leaves reattached to trees. His skepticism inspired a research project: "Let's try it and see if it really happens," said Beck. "Let's put dead leaves in water and see if they turn green." We hurried outside to gather a handful of brown, fallen leaves. Back in the studio, we put them in a little pot of water. Ana wrote a note to alert the other children in the group about our experiment. "WE ARE DOING AN EXPRMNT." (Principle: Move from individual to collaborative work.)

The next day, we brought the pot of leaves to our program's daily meeting with the full group of children. The researchers explained the experiment to the other children and passed around the pot of leaves. (Principle: Stay connected to the full group during an investigation.) The conversation with the whole group sparked some new debate about the viability of the research project: Would the leaves *really* become green again? Who *is* Mother Nature, and how could she keep track of all the leaves in one neighborhood, much less across the whole earth? Would water from a faucet have the same effect on the dead leaves as rain water? How long would this take? If it worked, who would hang the leaves back on the tree? Did the leaves have to go back on the same tree they'd fallen from? Did the researchers know which tree the leaves came from?

Alex, Madeline, Beck, and Ana mostly listened to the questions, not having answers yet. I jotted down the questions for us to revisit later, excited by the possibilities they held for nudging the children's thinking. As the meeting ended, we put the pot of leaves and the note on the windowsill of our studio, agreeing to check the leaves daily, watching for green to appear.

## "WE ARE DOING AN EXPRMNT"

The children checked the leaves in the pot each day. But at the end of the week, no green had appeared. We met as a group to evaluate the progress of the experiment.

Madeline: "The experiment is a little bit getting lighter and a little darker. Maybe we need to change the water."

Ana: "The leaves are definitely getting lighter."

Madeline: "Maybe you wait ten more days. And we can see if it growed green again."

Ana: "It may take more time. You also have to wait till summer or spring."

Alex: "You might need fresh water and sunlight."

Madeline: "Maybe the leaves have to go in the water till summer or spring, and maybe see if it turns green again."

The children were becoming more attentive to the seasonal aspect of leaves' cycle, though their thinking was still a little unclear. They'd begun to link their research to the seasons, however, hypothesizing that the leaves would not change back to green until spring or summer. This helped us choose our course.

Beck: "We have to see springtime."

Ann: "Let's keep watch on the leaves in the experiment and on the branches on trees. We can watch until we see springtime. If you see a change on the branches or on the leaves in the experiment, tell everyone on the work team!"

Alex: "If I see even the tiniest baby leaf on a tree, I'll tell everyone!"

Madeline: "And every day, we'll check on the leaves in the jar."

Ana: "I'll check on it morning and night."

## A CELEBRATION TO SUSTAIN US

Spring was still a couple of months away, and it seemed like a long time to wait before meeting together as a group. So in late January, Sandra and I gathered the work team for a festive meeting in the studio. We had a new art medium for them to explore: cookies and frosting!

We revisited the work we'd done during the fall, looking through the journal that held our written documentation about the children's investigation. We pulled out the leaf portraits that the children had made months earlier. "Here are the portraits that tell the story of the lines and color of leaves," I said. "We're going to make portraits of leaves today—but we're not going to use paper or paint. We're going to use frosting, and paint it onto cookies that Sandra made for us!"

After a moment of surprised silence, the children whooped and ran around the room. Cookies and frosting—the art medium they'd been waiting for!

We set a work space for each of the children around the table: a sheet of wax paper; bowls of red, yellow, orange, green, and brown frosting, each with a knife; and their leaf portraits propped into clear plastic display stands. We put the cookies on a tray in the center of the table. After their joyful laps around the room, the children made their way to the table and settled into the careful work of painting color onto the cookies. They moved between looking closely at their portraits and drizzling and spreading frosting onto the cookies: look and frost, look and frost. (Principle: Revisit and revise work often.) The cookies were vibrant and rich with detail, like carefully painted ceramic sculpture.

The cleanup from this studio work was a delight: spoons to lick, frosting to stir together into swirls of color before rinsing it down the drain, bowls to clean. We took our cookies to the daily meeting of the full group, to share with the children after we reported on the status of the experiment. (Principle: Stay connected to the full group during an investigation.)

## STUDYING SPRING

Spring arrived. Buds appeared on trees, blossoms sifted onto the ground. One morning in early March, Alex joyfully ran into the classroom. "I saw a tiny, tiny leaf on a tree at my house. I think it's time for us to meet again!"

That morning, we slipped on our jackets and headed outside. We walked through the neighborhood, following the same route we'd taken months earlier to study the autumn leaves. Now our senses were captured by the emerging blossoms, the pale green buds, and the scents of springtime.

Madeline: "I think they won't stay like this. I think they'll show more leaves."

Ana: "That's what I think too. I remember that in the middle of summer the trees have a lot of leaves and they're all green. They probably turn green in the middle of spring."

Beck: "And red and orange in the fall."

Alex: "Then dead."

The children's simple exchange underlined their increasingly clear understandings of the cyclical rhythm of the life of leaves. They'd begun to construct a shared answer to the question about why leaves change color.

Beck lingered quite awhile with a branch full of tiny pink buds. He looked and looked at the buds and the tiny leaves around them, pulling the branch close to his face, leaning down to examine the underside of the branch, running his fingers along its length. He studied the ground around the small tree, poking through the dead leaves lying there. After several minutes of silent observation, he exclaimed, "Now I know about how leaves come onto branches. They come from *inside* the branches. They don't come from the ground. Those dead leaves are just on the ground. There are really, really, really little leaves on the branch."

Ann: "That's a big discovery! How can you tell that the leaves come from inside the branch?"

Beck: "Because they're attached."

Madeline: "Because they grow out of the branch. Because they are stuck together."

Ann: "Beck and Madeline have an idea that may help us answer our question about the life of leaves. We'll want to remember what they saw on the branch, because that gave them their idea about the leaves coming from inside the branch. Let's draw what we see, so that we can remember it when we get back to the studio."

We'd brought clipboards with us on our walk, which the children used to sketch the branches covered in buds. Then, in the chilly air of early spring, we headed back to the studio to continue our work in a warmer setting.

## THE LIFE CYCLE OF LEAVES REVISITED

On the walk back to school, Sandra and I talked together about what we'd do when we got there. We decided to ask the children to draw their understandings of the life cycle of leaves. Our intention was to help them consolidate their thinking about the relationship between seasonal cycles and the life of leaves. We thought that drawing the life cycle of leaves would help them articulate the context in which leaves change color, reconnecting the children to the question that launched their work in October. (Principle: Revisit and revise work often.) The following drawings represent their conclusions:

Beck's drawing located the leaf inside the branch, almost womb-like.

Ana's drawing told the tree's story, beginning with the incubation of leaves inside branches, through spring, summer, fall, and winter.

Madeline, who had recently become a big sister with the birth of a baby brother, wove together her experience with the lives of leaves. Her drawings reflect a leaf inside a branch, then being born, then lying dead at the end of its life.

In his drawing, Alex created a detailed portrait of the transformation of a tree through the seasons, from the new buds in spring, to the fullness of summer, the winnowing of fall, and the starkness of winter. Alex's final drawing represents the movement of new life up from the ground, flowing into the tree, as winter slips into spring.

## WHY DO LEAVES CHANGE COLOR?

The children's exploration carried them into a strong awareness of seasonal cycles. The approach of the cold, rainy darkness of fall—heralded by cool air and pale sun—pulls a blanket of color over the leaves, then drops them to the ground. Leaves die, trees are bare; winter is a time of quiet waiting, when we hold our breath in hope and wonder. Spring calls new leaves out of the bare branches. And summer's heat and sunlight expand the leaves into their full green density—until the air changes and rain begins and the leaves blaze with color before they die.

Their investigation carried the children from a casual awareness of bright-colored leaves to an intimate knowledge of leaves. This was the tender culmination of our investigation: no great scientific discoveries, but instead a new understanding of the rhythms of our earth.

This awareness brought us full circle to the question that had launched our work. Why do leaves change color? They change color because it's autumn, and that's what happens in autumn. For the children, this conclusion was not a statement of the obvious, or a circular argument leading nowhere, but rather a deeply felt and simply stated summation of life's beauty and mystery. Scott Russell Sanders writes that "our role is to witness and celebrate the beauty of things, the elegance and order in the world." (1998, 165) This is what the children did during the seven months of our investigation—and it is what we all carried with us from our study: a newfound ability to bear witness to the earth and to delight with others in what we see.

This was worthy of celebration indeed! Late in the spring, the children, their families, Sandra, and I gathered for a morning of stories and slides, telling each other the story of the year's work. We uncorked a bottle of sparkling cider and toasted the children's work. "To Ana, Madeline, Beck, and Alex, scientists, artists, good friends to each other and to leaves."

## INVENTING OUR WAY

This story is not a template or a lesson plan; it's an example of how we can use art media to grow in-depth investigations that lead us into intellectually and emotionally engaging terrain. Sandra and I didn't have a preset plan for the investigation. We were committed to growing the study step-by-step. While we didn't have a plan, we did have clear intentions for our work: we wanted to foster in the children the dispositions to ask questions, to pose hypotheses, and to offer and receive feedback on their thinking. We wanted them to see learning as a journey, not a static exchange of questions and answers—a journey they could undertake with companions, in a spirit of eager curiosity and confidence. Some of the art media were less familiar to us than others. Neither Sandra nor I had worked much with wire until the day we used it with the children. But we wanted to experience the investigation as a learning journey for ourselves, as well as for the children, and, so, we dove in.

This is what I hope you carry from this book: This work can be a joy, a grand adventure into sensuality, inquiry, reflection, and relationship. The only way to begin it is to begin it. May you delight in the unexpected gifts you'll find as you invent your way into this work.

# REFERENCES

Burrington, Barbara. 2005. Melting geography: Reggio Emilia, memories, and place. In *In the spirit of the studio: Learning from the atelier of Reggio Emilia,* ed. Lella Gandini, Lynn Hill, Louise Cadwell, and Charles Schwall. New York: Teachers College Press.

Cummings, E. E. 1987. *Little tree.* New York: Crown Publishers.

Forman, George. 1996. Negotiating with art media to deepen learning. *Child Care Information Exchange.* March.

Gandini, Lella, and Judith Allen Kaminsky. 2005. Remida, the creative recycling center in Reggio Emilia: An interview with Elena Giacopini, Graziella Brighenti, Arturo Bertoldi, and Alba Ferrari. *Innovations in Early Education* 12, no. 3: 1–13.

Malaguzzi, Loris. 2005. From the beginning of the atelier to materials as languages: Conversations from Reggio Emilia. In *In the spirit of the studio: Learning from the atelier of Reggio Emilia,* ed. Lella Gandini, Lynn Hill, Louise Cadwell, and Charles Schwall. New York: Teachers College Press.

O'Keeffe, Georgia. Source unknown.

Rinaldi, Carla. 2005. The whole school as an atelier: Reflections by Carla Rinaldi. In *In the spirit of the studio: Learning from the atelier of Reggio Emilia,* ed. Lella Gandini, Lynn Hill, Louise Cadwell, and Charles Schwall. New York: Teachers College Press.

Saint-Exupery, Antoine de. 1943. *The little prince.* Trans. Katherine Woods. New York: Harcourt Brace and Company.

Sanders, Scott Russell. 1998. *Hunting for hope: A father's journeys.* Boston: Beacon Press.